Ancient Persian Bronzes

in the Adam Collection

by the same author

CATALOGUE OF THE ANCIENT PERSIAN BRONZES
IN THE ASHMOLEAN MUSEUM
(Oxford)

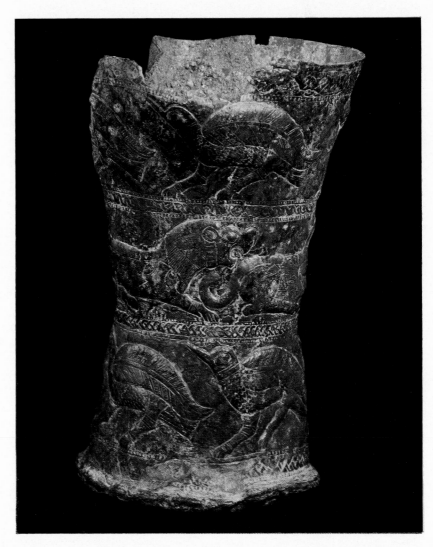

136. Bronze goblet with birds and lions (*see page 154*).

Ancient Persian Bronzes
IN THE ADAM COLLECTION

P. R. S. MOOREY

Department of Antiquities
Ashmolean Museum, Oxford

with a foreword by

Dr. R. D. BARNETT

Former Keeper, Department of
Western Asiatic Antiquities,
British Museum

FABER & FABER
3 Queen Square London

First published in 1974
by Faber and Faber Limited
3 Queen Square London WC1
Printed in Great Britain by
R. MacLehose and Company Limited
The University Press Glasgow

ISBN 0 571 10216 6

Foreword

by Dr. R. D. Barnett

Former Keeper, Department of Western Asiatic Antiquities, British Museum

The subject of private collecting and the private collector, especially the collector of antiquities, might have formed an interesting and attractive subject to which Lord Bacon or Montaigne might have devoted one of their essays, and lavished on it their taste for epigrams. There were great collectors even in Tudor times, even in Bacon's day—the Earl of Arundel, Sir Robert Cotton, Archbishop Parker. Collecting has a long history in England, for collectors are of many kinds. In the past they performed a role similar to that of the art patron, now performed by museums, and were usually wealthy aristocrats. Today, this is all changed and collectors are few. In my view, they are a valuable asset to the world, which they seek to make more interesting by what they bring together. With their support and involvement, they can be of great help to the national museums of their country, and scholars can owe much to them. Mr. Peter Adam is a collector who is unusual in this generation in combining the true discrimination of a connoisseur, skill as a photographer, and a sustained enthusiasm and rare consistency of purpose. His remarkable and outstanding private collection of Persian antiquities is a considerable cultural asset which has already helped many students to know ancient Persia better, and the fine and scholarly catalogue he has invited Dr. Moorey to prepare of it, has added greatly to its value. It would indeed be a good thing if this country today held more such private collections and other genuine *cognoscenti* of ancient art such as Mr. and Mrs. Peter Adam.

Dr. Moorey, an acknowledged expert in the field of ancient Persian bronzes, has summarized in his introduction the interest, variety, importance and history of the so-called Luristan and Amlash bronzes in the context of ancient Near

Eastern art and archaeology—a matter which has been rendered very obscure by wreckage of the sites in Persia by illicit excavation. Those who wish to study these objects further may most profitably consult his *Catalogue of Ancient Persian Bronzes in the Ashmolean Museum*, 1971, which constitutes a leading contribution to the subject.

Note

by Peter Adam

Collectors of antiquities have not always proved popular and the fallacy is widespread that they are largely responsible for the illicit digs being carried out in many parts of the world. In fact, serious collectors are as interested as any specialists in the provenance and context of objects they own. The fault lies largely with the attitudes of certain governments, notably excepting that of Iran, who by clamping down completely on the export of antiquities inevitably encourage illegal digging and trading, to the detriment of all. I have believed for a long time that a more enlightened policy which would give governments the right of pre-emption of any outstanding finds in their territory but would otherwise allow the export of, say, half of what is found, would kill the illegitimate trade and infinitely enhance our knowledge of the past.

Antiquities are part of the cultural heritage of the civilized world and are, in many cases, works of art of great beauty. Originally collectors of contemporary art, my wife and I became attracted in about 1957 to primitive art because of its amazing 'modernity' and its relevance to our interest in history and pre-history. The collection was built up over a number of years and we decided eventually to concentrate on pre-Christian bronzes, mainly of the Mediterranean and the Middle East. The Persian bronzes form the mainstay of the collection, due to the amazing variety and fertility of the art of copper and bronze artisans in Iran during the three millennia before our era. Most of us have been brought up with a knowledge of our debt to the Graeco-Roman and Palestinian civilizations, but I believe that the influence of the Persian civilization on the West has hitherto been underrated. Anyone who has seen the magnificent ruins of Persepolis must stand in awe at the high standard of

culture and civilization achieved at the height of the Persian Empire. One cannot help but wonder whether the world would not be a more civilized and tolerant place today if Alexander had been unsuccessful in his destruction of Achaemenian power.

I am immensely grateful to Dr. Roger Moorey of the Ashmolean for undertaking the gargantuan task of cataloguing this part of the collection. His great and profound knowledge and scholarship have put into proper perspective the various groups of objects in both their historical and artistic contexts and should help to clarify what is still a fairly new field of archaeology. I am also deeply indebted to my friend Dr. Richard Barnett of the British Museum for his foreword, and his advice and help were unstintingly given when I was building up the collection. Finally, I must express my thanks to Miss Raymonde Enderly of the Conservation Department of the British Museum who made it her task to repair, conserve and maintain the bronzes in her spare time and who, I am glad to say, seems to be winning the perpetual battle against 'bronze disease'. Her deep knowledge of the underlying processes has helped to keep me a step ahead of the growing number of skilful forgers.

I must personally accept responsibility for the black and white photographs which have given me, and my daughter Nicky, many hours of happy work. They will, I trust, give the reader a better appreciation of the beauty and refinement of objects fashioned at the dawn of history, some of them nearly 5000 years ago. Lastly, I am indebted to Mr. Gates of A. C. Cooper Limited for his magnificent colour photographs.

Contents

Colour Plates, Drawings and Maps

Preface

For those already familiar with the study of ancient Persian metalwork I trust the form of this catalogue will need no apology; for those fresh to the subject a short explanation may be appropriate. Owing to the unfortunate circumstances through which most of this material has become known to us in the last fifty years—fully explained here in the Introduction—its study is in the first instance a salvage operation, a slow process of assembling, sorting and sifting, which is still very much in the initial stages. Thus there is, as yet, no standard system of classification. Here the objects are arranged primarily by function, with brief general introductions to each category, followed by more detailed notes on each object to point its special interest and place in the metal industry of western Persia. In all this I have striven to be as concise as possible without, I hope, becoming enigmatic. The reader in quest of more detailed discussions of ancient Persian metalwork will find a select list of published sources on page 193. In a field so vast, no single collection may hope to be comprehensive. Mr. Peter Adam's is, however, notably representative, being outstanding for its range of decorated horse-bits and such fine individual pieces as nos. 8, 18, 20–22, 25, 56, 134–6, 181.

I am most grateful to Mr. Adam for inviting me to write this catalogue of his collection, composed during the course of 1970–1, and to him and his wife for their kind hospitality as the work proceeded; to Dr. R. D. Barnett, Former Keeper of Western Asiatic Antiquities in the British Museum, for his introduction to Mr. Adam and most generous foreword; and to Dr. I. Gershevitch, Professor W. G. Lambert and Dr. E. Sollberger, who have assisted in the interpretation of the inscribed objects, as noted in the relevant parts of

the text. Mrs. Pat Clarke did the drawings and Mr. Adam himself the photography.

Oxford, April 1972 P. R. S. MOOREY

Abbreviations

AA	*Artibus Asiae*, Ascona
AAAO	H. Frankfort, *The Art and Architecture of the Ancient Orient*, London, 1958
AANE (Boston)	E. L. B. Terrace, *The Art of the Ancient Near East in the Boston Museum of Fine Art*, Boston, 1962
AArch	*Acta Archaeologica*, Copenhagen
ABSB	P. Calmeyer, *Altiranische Bronzen der Sammlung Bröckelschen*, Berlin, 1964
AFO	*Archiv für Orientforschung*, Graz
AJA	*The American Journal of Archaeology*, Cambridge (Mass.)
AK	*Antike Kunst*, Basle
AMI	*Archäologische Mitteilungen aus Iran*, Berlin
Amiet	P. Amiet, *Les Antiquités du Louristan de la Collection David-Weill* (in preparation)
Archéologie	Vanden Berghe, *L'Archéologie de l'Iran ancien*, Leiden, 1959
BABesch	*Bulletin Antieke Beschaving orgaan van de Vereeniging Antieke Beschaving*, Leiden
Barbier	C. Ratton, *Bronzes Antiques de la Perse: Collection Jean Paul Barbier*, Sale Catalogue Hotel Drouot, Paris, 1970
BBV, V	W. Nagel, *Altorientalisches Kunsthandwerk*, Berlin, 1963
BCHI	*Bastan Chenassi va Honar-e Iran*, Teheran
BJ	*Berliner Jahrbuch*, Berlin
BL	A. Godard, *Les Bronzes du Luristan*, Paris, 1931
BMMA	*Bulletin of the Metropolitan Museum of Art*, New York

BMRAH	*Bulletin des musées royaux d'art et d'histoire*, Brussels
Bomford	*Antiquities from the Bomford Collection* (Exhibition Catalogue), Ashmolean Museum, Oxford, 1966
Calmeyer	P. Calmeyer, *Datierbare Bronzen aus Luristan und Kirmanshah*, Berlin, 1969
Dailaman	N. Egami, *Dailaman*, I–III, Tokyo, 1965, 1966, 1968
Dark Ages	M. Mellink (ed.), *Dark Ages and Nomads*, Istanbul, 1964
Découvertes Fortuites	H. Samadi, *Les découvertes fortuites Klardasht, Garmabak, Emam et Tomadjan*, Teheran, 1959
Festschrift Fremersdorf	*Analecta Archaeologica*, Cologne, 1960
Giyan	G. Contenau and R. Ghirshman, *Fouilles du Tépé Giyan . . . 1931, 1932*, Paris, 1935
Godin Tepe	T. Cuyler Young Jnr., *Excavations at Godin Tepe: First Progress Report*, Royal Ontario Museum, Toronto, 1969
Graeffe Collection	Y. and A. Godard, *Bronzes du Luristan*, La Haye
Hissar	E. F. Schmidt, *Excavations at Tepe Hissar, Damghan*, Philadelphia, 1937
IA	*Iranica Antiqua*, Leiden
IitAE	E. Herzfeld, *Iran in the Ancient East*, London, 1941
JC	Jacobsthal Corpus of Luristan Bronze Photographs, Griffith Institute, Oxford
JNES	*Journal of Near Eastern Studies*, Chicago
Khurvin	L. Vanden Berghe, *La Nécropole du Khurvin*, Istanbul, 1964
LPO	de Morgan, *La Préhistoire orientale*, I–III, Paris, 1925–7
Marlik	E. O. Negahban, *Preliminary Report on Marlik Excavation*, Teheran, 1964
MDP	*Mémoires de la Délégation en Perse*, Paris
Mon.	A. H. Layard, *The Monuments of Nineveh*, I–II, London, 1853
Moortgat	A. Moortgat, *Bronzegerät aus Luristan*, Berlin, 1932
MSP, IV	de Morgan, *Mission scientifique en Perse*, IV, Paris, 1896
Nimrud	M. E. L. Mallowan, *Nimrud and its Remains*, I–II, London, 1966
Ostas. Zeit.	*Ostasiatische Zeitschrift*, Berlin, 1912–43

Outils	J. Deshayes, *Les Outils de bronze de l'Indus au Danube*, I–II, Paris, 1960
Oxford	P. R. S. Moorey, *Catalogue of the Ancient Persian Bronzes in the Ashmolean Museum*, Oxford, 1971
Persepolis	E. F. Schmidt, *Persepolis*, I–III, Chicago, 1953, 1957, 1970
Persia	R. Ghirshman, *Persia from the Origins to Alexander the Great*, London, 1964
Pferdetrensen	J. A. H. Potratz, *Die Pferdetrensen des Alten Orient*, Rome, 1966
Philadelphia	L. Legrain, *Luristan Bronzes in the University Museum*, Philadelphia, 1934
Schimmel	H. Hoffmann (ed.), *The Beauty of Ancient Art: Norbert Schimmel Collection*, Mainz, 1964
Sept Mille Ans	*Sept Mille Ans d'art en Iran*, Paris, 1961
Sialk	R. Ghirshman, *Fouilles de Sialk . . .*, I–II, Paris, 1938–9
SPA	*A Survey of Persian Art . . .*, Oxford, 1938
TZ	R. Ghirshman, *Tchoga Zanbil*, I–II, Paris, 1966
UE	C. L. Woolley, *Ur Excavation Reports*, London
Weill	*Collection D. David-Weill: Bronzes antiques des Steppes et de l'Iran*, 1972 (fully illustrated sale catalogue, Hotel Drouot, Paris)

Note on Dimensions, Materials and Chronological Terminology

(a) For DIMENSIONS the following abbreviations apply:

H—height/high
L—length/long
W—width/wide
D—diameter/in diameter

(b) MATERIALS

Throughout the book the term 'bronze' is used conventionally. None of the objects have been analysed. As is noted in the relevant part of the text, some tests were carried out on certain of the silver objects catalogued here in Appendix A.

(c) CHRONOLOGICAL TERMINOLOGY

So far, there is no agreed terminology for the stages of cultural development in western Persia. I have used here the Mesopotamian terminology until about 1200 B.C., then the scheme proposed by R. Dyson and T. Cuyler Young, Jnr., for the pre-Achaemenian Iron Age. In terms of absolute chronology the following general scheme applies:

Early Dynastic	c. 3000–2300 B.C.
Akkadian	c. 2300–2100 B.C.
Neo-Sumerian	c. 2100–1900 B.C.
Old Babylonian	c. 1900–1600 B.C.

Kassite (Late Bronze Age)	*c.* 1600–1200 B.C.
Iron Age I	*c.* 1200–1000 B.C.
Iron Age II	*c.* 1000–800 B.C.
Iron Age III	*c.* 800–650 B.C.
Median/Achaemenian	*c.* 650–330 B.C.
Seleucid Period	*c.* 330–150 B.C.
Parthian Period	*c.* 150 B.C.–A.D. 250
Sassanian Period	*c.* A.D. 250–A.D. 650

Introduction

With the exception of the magnificent sculptured reliefs found in the palaces of Assyrian kings at sites like Nimrud and Nineveh in north Iraq and brought back to museums in Europe by their excavators in the nineteenth century, the arts and crafts of the ancient Near East are little known in the West. Of the smaller groups of antiquities which have reached public and private collections in Europe and America from this region in the last hundred years the metalwork of western Persia is among the commonest and most striking. The copper or bronze objects from the area are often out-standingly well preserved, almost always finely made and, when decorated, vigorous and eye-catching.

In west Persia since the later nineteen-twenties and occasionally before that clandestine digging by local tribesmen in ancient graveyards, more rarely on settlement sites and in shrines, has revealed an enormous amount of metalwork —primarily in copper and bronze. It is clear that up till now by far the greater number of these bronzes come either from the general region of Luristan and south Kurdistan (Luristan bronzes) in central western Persia, or from Gilan in the north on the shores of the Caspian Sea, where the town of Amlash has played a vital role in the local antiquities trade (Amlash bronzes). Unfortu-nately neither the description 'Luristan' nor 'Amlash', as commonly used, has any exact geographical or chronological significance. At worst, because of their established commercial value, they are now regularly applied by dealers to bronzes from freshly exploited regions in Persia, often unrelated geographically or archaeologically to Luristan or Gilan. Even when they are used more exactly to describe objects which really do come from the two regions they denote a

heterogeneous collection of artefacts torn from the ground in circumstances that preserve neither evidence of their original context, be it a tomb, house or cave, nor any information of the other things, perhaps pottery, jewellery or seals, which might have been found with them. In a word they always come without any of the evidence upon which scholars normally rely in establishing date and place of manufacture.

In the last forty years what little evidence there is about early illicit excavations has been sifted, the objects grouped by form and function for comparison with better dated relatives elsewhere, and vital new information gleaned from the results of controlled excavations and systematic field surveys throughout western Persia. Such work is vital if we are to reconstruct the society that supported the smiths who created these objects in such profusion. But still the history of metalworking in western Persia which emerges is little better than a shadow of the whole story. It is only possible to offer a bird's eye-view that in broad outlines is probably correct, but in details open to constant modification. Everything which follows here, and in the main body of the book, must be taken as a concise summary of research in progress, not as a résumé of well established facts.

1. LURISTAN BRONZES

Luristan, the central province on Persia's western frontier, is a region of open plains intersected by the treeless ranges of the Zagros mountains. The eastern ridges are generally the higher, more rugged and intricately aligned. To the west the ranges are lower and less compressed, declining into lines of foothills at the edge of the Mesopotamian plain. The province is separated from Iraq by the formidable barrier of the Kebir Kuh which forces those who seek entry to come either upstream from the south-east, or downstream from the north-west. Within the province the warm, low-lying pastures of the west are separated from the cooler, higher plains of the east by the Kuh-i-Sefid which offers passage through its central ranges for seasonally migrating tribes. There is evidence to show that in antiquity Luristan was more extensively settled than is today the case; that areas were then farmed which are no longer cultivated. Although the formidable topography encouraged the separate development of local communities, at least by the later second millennium B.C.

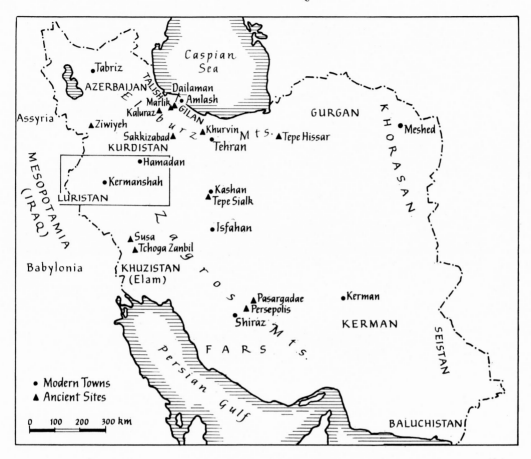

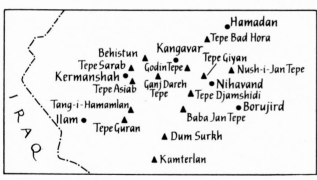

Above: Map of Iran in Antiquity.

Left: Diagram of the main sites in South Kurdistan and Luristan.

widespread semi-nomadism forestalled complete isolation. Although in such a region old beliefs and traditions were resilient and enduring, they were not totally immune to the fresh influences that trade, migration and brigandage brought with them (see map on page 23).

For the whole of the period with which this catalogue is primarily concerned, from about 2600 to 650 B.C., Luristan was inhabited by illiterate tribesmen whose history may only be reconstructed from the written records of their southern neighbours, the Elamites of Khuzistan with their capital at Susa, and those of the Babylonians in southern Iraq. These powerful urban civilizations, which had developed in the previous thousand years through skilful exploitation of irrigation agriculture, were in constant conflict with one another. Mountain tribesmen from the Zagros sometimes served as mercenaries in their armies; at other times, when the cities of the plain were weak and disunited, they raided them on their own account. Unfortunately, since contact was irregular and western penetration into the mountainous region slight, even on the rare occasions when relevant texts survive the records of Elam and Mesopotamia have little to say of these tribesmen. What they do say is generally cryptic and abusive. Geographical references are few and obscure, perhaps as much to the writers as to us, for with regularly migrating tribes exact descriptions would be difficult. Bronze weapons and vessels found in Luristan inscribed with the names of Babylonian, and much more rarely Elamite, kings indicate the two periods when links were especially close. Between about 2350 B.C. and 2150 B.C. when Iraq was ruled by the Dynasty of Akkad, its rulers campaigned successfully against Elam and well into the Zagros. Then again, about a thousand years later, a succession of powerful and energetic Babylonian kings overthrew the Elamite Empire and established strong links with Luristan. These campaigns served to stabilize Babylonia's eastern frontier, but may have been as much directed to commercial advantages as to security, and aimed at ensuring supplies of raw materials, notably metals and stone, which central and southern Iraq entirely lacked.

From about 2500 to 1200 B.C. the local smiths of Luristan, even more anonymous than the patrons they served, produced metalwork which is often indistinguishable from that made in Elam and Mesopotamia. Only in a growing tendency after about 2000 B.C. to use animal decoration on their cast bronze tools, weapons and pinheads is a local style apparent, and even this

seems to have been shared by Elamite smiths, who may indeed have been its original creators. Sadly the fine metalwork produced in Elam is only known to us through scattered small objects and a few outstanding pieces, mainly of the thirteenth and twelfth centuries B.C., found in French excavations at Susa and now to be seen in the Louvre.[1] These indicate extensive production and fine skill in casting bronze objects, some of considerable size. Throughout this time Luristan fell generally under the tutelage of Elam whose armies were regularly employed in controlling the marauding instincts of mountain tribesmen on their northern border.

In the last decade of the twelfth century B.C. Elam suffered a crushing defeat at the hands of the Babylonian armies from which she did not recover for about three hundred years. This event seems to have had important repercussions in Luristan which, though it now found itself in contact with Babylonian armies, had escaped the much closer and more oppressive Elamite presence. Objects from controlled excavations make it increasingly clear that sometime between about 1150 and 1050 B.C. (Iron Age I) the smiths of Luristan began to expand their repertory to include many artefacts unparalleled in form and decoration outside the region. At the same time, they show a growing mastery of iron, which was now used for the first time on any scale in the Near East. It is unlikely that this is mere coincidence.

After a period during the eleventh and earlier tenth centuries B.C. following on the eclipse of Elam, when increased Babylonian political influence is reflected in Luristan by the regular occurrence of daggers and arrowheads with Babylonian royal inscriptions (see nos. 20 and 21 here), Luristan enjoyed relative independence until the intrusion of the Iranian tribes. From about 1000 to 700 B.C. (Iron Age II–IIIB) when to the west the Assyrian Empire was pressing towards the Mediterranean, and in the east making more tentative incursions in north-west Persia, the local aristocracy of Luristan patronized an exceptionally productive group of smiths. These men produced the richly decorated bronzes which most commonly spring to mind when 'Luristan bronzes' are mentioned. But who these patrons were and whence came the wealth which supported this industry are intractable questions.

In the absence of written records the patrons cannot be named, though a variety of peoples known from Mesopotamian written records and later

[1] P. Amiet, *Elam*, Paris, 1966, *passim*.

accounts by Greek historians, like the Kassites and Cimmerians, have been suggested. To all such candidates there are strong historical and archaeological objections. Two facts indicate that initially at least there was a resurgence of local culture rather than migration or invasion from outside. The iconography of the decorated bronzes, so distinctive of this whole episode in the history of Near Eastern metallurgy, has its roots deep in the age-old common tradition of Elam and Mesopotamia, but with distinctive traits, such as nature-demons, half man, half beast, which had first appeared two or three thousand years earlier on stamp-seals in Luristan. There is no sign of major new influences from the north or east before the eighth century B.C. Equally significant, neither the artefacts most characteristic of Luristan's bronze industry at this time nor any certain relatives have been found outside the region, as would be expected if intruders had stimulated the industry's sudden expansion.

If the industry is essentially local, where did the wealth of its patrons come from? Primarily, it rested on herding. The plains of western Persia were an important source for the horses needed by the Assyrian armies by at least the ninth century B.C., as is well attested by administrative documents from Assyrian royal palaces in northern Iraq. Though the Assyrians did not themselves penetrate far into Luristan, and then only briefly in the later eighth century and just after, it is more than likely that horses reared in the region travelled westwards. At Susa, the provinces north of Elam had a reputation for textiles and there is clear evidence amongst the decorated bronzes of Luristan for the importance there of sheep and goats. To what extent trade through the Zagros in metals like copper, tin and iron, so vital to Assyria, involved the tribesmen of Luristan at the time is an intriguing question to which no sound answer may yet be given.

The character of life in Luristan may only be surmised for the moment through correlating modern ways of life in the region with the evidence for ancient settlement patterns revealed by archaeological field surveys.[1] In the highland region of eastern Luristan the ancient sites are relatively small, probably villages or tented encampments clustered seasonally round small citadels. In the lower plains of western Luristan settlements were more permanent and larger, though none has yet been systematically excavated. Although the main metal workshops were probably sited in these larger

[1] See especially C. L. Goff, *Iran*, IX, 1971, 131–52.

settlements, because in antiquity metal industries were already closely super-
vised and centrally controlled, the established pattern of life in Luristan from
time immemorial would have carried their products regularly into the eastern
highlands. Into modern times a large section of the Lur tribes north of the
Kashgan river migrated annually with their herds of sheep, goats and horses
between summer pastures in the rich, fertile high plains in the east of the
province (Sard Sir) and winter grazing in the lower valleys in the west (Garm
Sir), where more settled agriculturalists and pastoralists lived. The structure
of ancient society in the region is very much harder to establish even in the
most basic way. The complexity of modern nomadic communities in Persia[1]
indicates that it will probably remain veiled in mystery until written records
turn up. Only one point might be cautiously noted in the light of the archaeo-
logical evidence. Most metal industries in antiquity, especially those producing
very elaborate artefacts, were supported by a small minority among the ruling
group. In Luristan these seem to have been warrior horsemen, amply provided
in their graves with the weapons and harness-trappings to which they had been
accustomed in life. Nothing but careful analysis of results from scientific
excavations of complete cemeteries is likely to yield more information.

At Baba Jan in eastern Luristan, near modern Nurabad, recent excavations
have revealed one of the homes of these Lur aristocrats in the eighth century
B.C.[2] On the site of an earlier village a large fortified dwelling, about thirty-
three by thirty-four metres in area, was well built round a central courtyard
flanked to east and west by long rectangular rooms, and surrounded by nine
towers placed at the corners and along each wall. The building was subsequently
redesigned to include a colonnaded central hall with buttressed porticoes on
east and west. The pottery found here, and one very distinctive bronze pin,
indicate that its owners were amongst the patrons of the bronze industry which
produced the more characteristic of the decorated Luristan bronzes. To the
east of this fortified house was another, even more like a fort, with a square
central hall, its flat roof supported by wooden columns, surrounded by long
rectangular living rooms, domestic offices and kitchens. To the east was a
remarkable T-shaped room, its lower walls decorated with layers of red and

[1] See for example F. Barth, *Nomads of South Persia*, Oslo, 1964.
[2] See preliminary reports by C. L. Goff, *Iran*, VI, 1968, 105–34; VII, 1969, 115–30; VIII, 1970,
141–56.

white plaster, its floor strewn with large baked clay tiles painted with geometric designs in red-on-cream which seem to have fallen from the upper walls of this chamber. The fortified aspect of both these buildings illustrates the insecurity of the age. When the fort was destroyed early in the seventh century B.C. squatters turned its ruins into workshops and stables, burying a horse with its harnessing and two bronze vessels in the adjacent mound.

By the end of the eighth century, if not before, Luristan had felt the impact of the intrusive Iranian tribes coming from the north or north-east. Within the next fifty years these Iranians absorbed most of the local peoples of the region. Although excavations in a shrine at Dum Surkh and the iconography of some bronzes indicate a revival of Elamite influence at least in southern Luristan in about 725 to 700 B.C., this was relatively short-lived. Elam was crushed in the middle of the next century by the armies of Assyria, themselves to be victims of the combined assault of Babylonians and Medes little over a generation later, and the way into south and west Luristan was open to the Iranians. Increasing Iranian political unity radically changed the centres of power in western Iran, with the Medes and their associates established round a capital at Hamadan. Luristan's local tribal aristocracy lost its political authority, and also its sources of wealth, whilst the smiths lost their rich patrons and access to their raw materials, too. Although the bronze and iron artefacts manufactured in Iran under the Achaemenid kings are not so well known as the fine gold and silver work of the time, there is enough evidence to show little or no legacy from the workshops of Luristan. Sometime in the seventh century Luristan's metal industry suffered a blow from which it never recovered. Its independence and originality were snuffed out together.

2. AMLASH BRONZES

If there is much still to be discovered about the society which produced and used the bronzes so liberally deposited in the cemeteries of Luristan from about 2600 to 650 B.C., there is even more to be learnt about the circumstances in which the metal industries of Gilan developed and flourished. Here neither the level of clandestine excavation, fortunately, nor yet the pace of controlled scientific exploration has been so intense or so lengthy. Illicit excavations do not appear to have begun in earnest much before the later nineteen-fifties,

although isolated discoveries before that had revealed the wealth of grave-goods to be expected in local graveyards. As early as 1901 the French brothers de Morgan had excavated graves in the Talish hills on the south-western shores of the Caspian Sea, just to the north-west of Gilan. In the main these belonged to a period from about 1450 to 800 B.C. with some sporadic later graves. They yielded evidence for an active bronze industry with a full repertory of tools and weapons, but virtually without the elaborate cast decoration found to the south in Luristan. Iron was used in the region by the end of the second millennium B.C., though it was two or three centuries before large-scale production was fully established. In Gilan, moreover, the metals were far more easily accessible than they were in Luristan.

The primary zone of exploitation by illicit excavators in recent years has lain more to the east among the foothills of Gilan, chiefly along the Safid Rud and adjacent valleys. Controlled survey work followed by excavation of a few selected sites, notably by the Iranian archaeological authorities at Marlik and Kaluraz, and by a Japanese expedition in Dailaman, have revealed a number of cemeteries, the earliest contemporary with those already known in Talish at the end of the Bronze Age, the most recent of the fourth and fifth centuries A.D., well into the Sassanian period. Gold and silver, virtually unknown on sites in Luristan, are not uncommon here and there is an extensive repertory of bronze objects, distinct from those of Luristan and rarely so richly decorated, but evidence of an equally virile and accomplished industry.

Gilan lies between mountains and sea, the Elburz and the Caspian. Through it flows the Safid Rud which provides in its valley a major route from central Persia to the Caspian coast. The very fertile lowland region of the province enjoys a climate allowing the year-long cultivation of crops normally restricted to the monsoon regions of the world. As a result it is today one of the most densely populated regions of Persia. Although communications were extremely difficult in the past they have never fundamentally hindered access to this region from the Caucasus to the west, or from the plains of central Asia through north-eastern Persia. It is an area where natural barriers have allowed failing regimes to take refuge and survive long after their authority in the rest of Persia had passed. Two main groups of peoples now live in Gilan and there may be little doubt that a comparable division existed in antiquity. Settled communities in the lowlands harvest the rich plain and marshes of the river delta, whilst

transhumant pastoralists move between summer pasture in the mountains and winter grazing in the foothills (see map on page 23).

This region, remote from links with literate peoples, has no history in the period with which this book is mainly concerned. Amid the darkness the rich equipment of those buried in the cemetery at Marlik between about 1350 and 1000 B.C. is an isolated light which for the moment offers little guidance. Here obviously are the members of a rich and powerful aristocracy, who, whatever their origins, had the services of gold and silversmiths, jewellers and bronze-smiths highly skilled in their crafts. The superb designs with which they ornamented gold bowls and beakers are reminiscent of contemporary icono-graphy in Assyria away to the west and, more rarely, of Caucasian products. Such fine metalwork was not confined to this region, for comparable objects have been found at Kalardasht in Mazanderan to the east, and at Hasanlu in Azerbaijan away to the south-west. It has been suggested, on the basis of ceramic evidence, that all these sites were inhabited by members of the intrusive Iranian tribes recently arrived either from eastern Persia or by infiltration down the west Caspian shores. Such may indeed be true of the industry's patrons, but the men employed owed much to a local legacy of skills and designs whose ancestry is still totally unknown. It is not yet possible to trace the history of the industry back much beyond 1400 B.C. Compared to Luristan the imagery of the cast bronzework is extremely restricted. Animals appear, many used also in Luristan, but the stag and zebu are fresh and by far the most common. Here the animals are primarily used to decorate pendants, not as embellishments for tools, weapons and votive objects. The human figure is used in statuettes and little models of chariots, wagons or ploughs, not in scenes of ritual or myth. Indeed in bronzework it is daily life not the netherworld which inspired the modeller. In this aspect of the industry, by contrast with objects in gold and silver, influences from Mesopotamia are absent. Even the harness-trappings, and particularly the horse-bits, are plainer and more clearly functional, though no less common than in Luristan, for the horse played a vital role in the Iranian migrations.

3. Techniques, Alloys and Ores

It only needs a rapid glance through the book to reveal the bronze technique at which the smiths of western Iran in the early Iron Age excelled.[1] They were established masters of casting by the *cire-perdue* or lost-wax process, a technique of great versatility which allowed the local smiths to develop their love of zoomorphic decoration. In this method, a model of the object to be cast is first made in wax, sometimes over a clay core, and then covered with clay. That is baked to harden the clay and melt out the wax through prepared vents. Molten metal is poured into the cavity left and allowed to cool. The clay mould is then broken away and the surface finished as required. Such castings were unique, as the almost infinite variations on simple themes among the Luristan bronzes make clear. All the rich detailing was either built up on, or cut into, the wax model before casting. The sinuous ridges so often used are the most direct examples of applied wax coils, the punched circles and linear decoration the clearest evidence of the cutting technique, in which a harder wax than usual may have been used for the original model. The undecorated tools and weapons, more particularly the axes, adzes and picks, were made in simple bivalve moulds of clay or stone with a core placed in the mould to form a cavity for the weapon's handle. Many of the daggers and swords were manufactured by making the blade first, sometimes in iron not bronze, then manufacturing a mould for the hilt shaped so as to fit over the tang of the blade, gripping its shoulders, a technique known as 'casting on'.

Sheetmetal objects were made by hammering and annealing—the process of reheating to make the metal soft and workable if it became brittle by too much hammering—from large cast sheets of copper and bronze. Vessels were either raised, by hammering from outside over a specially shaped anvil (stake), or sunk, by hammering the metal down into a suitably shaped depression cut into a block of wood. Surface decoration, whether worked from the back (repoussé) of from the front (tracing), was done with bronze tools.

Apart from copper, the smiths used the stronger bronze, an alloy of tin and

[1] For ancient metal technology see: H. H. Coghlan, *Notes on the Prehistoric Metallurgy of Copper and Bronze in the Old World* (Oxford 1951); R. J. Forbes, *Studies in Ancient Technology*, VIII (Leiden, 2nd edition 1971), IX (Leiden, 1964).

copper, though they had experimented earlier with a less successful alloy of arsenic and copper. The tin-bronze alloys were erratic. Analyses have shown that the daggers and swords are normally of uniform standard, but pins and standard-finials, for which hardness and strength were not necessarily prime requisites, have equal, if not higher, percentages of tin than tools and weapons. Iron objects were hand forged from wrought iron. The parts worked over became carburized during the frequent heating process and took on the pattern of mild steel.

There is no certain evidence whence the smiths of Luristan and Gilan obtained their supplies of metal. Evidence on the exact location of ancient mines and ore sources in Persia is wholly inadequate and all conclusions are still based to a very large extent on the location of modern mining areas in the country. No evidence which bears close scrutiny has yet been offered for ore sources in Luristan itself. Copper probably came from mines along the southern fringes of the Elburz mountains; Luristan might also have drawn on sources in the Anarak region. Both these areas also contain deposits of iron ore. Although there is an increasing amount of documentary evidence that tin was travelling from east to west through Iraq and Syria in the second millennium B.C. its ultimate source in Iran is still very obscure. Somewhere in Khurasan seems most likely.

I
Weapons and Tools

———

The prime function of any metal industry in antiquity was the production of weapons and tools. In Luristan and Gilan, as elsewhere, they form the majority of objects found in excavations and provide the basic framework for any reconstruction of local industries. There is, however, one important qualification. Tools which might have been used by peasant farmers, carpenters or other specialist craftsmen rarely find their way into graves. Their owners were not among those whose social status entitled them to richly equipped graves. Once proved unserviceable, tools went back into the melting pot. They are only found occasionally on settlement sites or in metalsmiths' hoards, which are very rare in the Near East. Since clandestine excavations in Persia concentrate on cemeteries, the absence of tools is readily explicable. Only the decorated handles of whetstones are common, since this tool was vital to all users of bronze weapons, which need constant whetting to maintain a keen cutting edge.

Knives and dagger blades occur in the earliest gallery graves, of the mid third millennium B.C., so far excavated systematically in Luristan. At this time the blade generally had a short tang to which was riveted a wooden handle now lost. Very rarely fine daggers are found with bronze or copper hilts cast separately from the blade and then riveted to its tang. Sometime in the middle of the second millennium B.C. a new type of dagger was introduced from the west with the hilt cast in one with the blade and flanged to take inlays of bone or wood secured by a combination of metal flaps and rivets. These are generally bronzes of good quality and include some with Babylonian and Elamite royal inscriptions. In the early first millennium B.C. such daggers were amongst the

earliest objects to be copied exactly in iron at a time when the new metal was treated as nearly as possible like the old. By about 1200 B.C. some bronze daggers were made with hilts which copied exactly in metal, including imitation rivet heads, the form of a flange-hilted dagger with bone inlay plates. Many of these have a distinctive split pommel with two wing-like projections (see no. 25). Sometimes the blade was made separately and then the hilt cast on (see page 31). Developments in Gilan until the end of the second millennium paralleled those in Luristan generally, but during Iron Age I a slightly different tradition emerged with close Caucasian affinities. Here the Syro-Mesopotamian flange-hilted dagger was never as influential as in Luristan and a whole series of distinct cast bronze hilts were developed. They are much more elaborate than those of Luristan, with ornamented pommels, often also with openwork grips, which must often have been cast, in part at least, by the lost-wax process. In Iron Age I–II such weapons appear first with iron blades and bronze hilts, then entirely in iron closely following bronze forms. It is only in the north also that such weapons reach the length of a sword (over 50 cm long). In Luristan daggers (up to 36 cm) and short swords (36–50 cm) were the rule.

Axeheads, and their close relatives *pick-* and *adzeheads*, are very common. It is often impossible to decide by inspection in individual cases whether they are more correctly described as tools or weapons. Often totally impractical forms or unsharpened edges indicate that they were probably votives, perhaps made specially for deposit in graves. Reported in great numbers and a wide variety of forms, they provide an excellent guide to the chronology of bronze and copper metallurgy in the region, since when no example is yet known from controlled excavations in Persia, they may frequently be dated by comparison with exactly comparable axes from Iraq or Syria.[1] But the animal decoration found on examples from Persia is almost without parallel to the west and particularly characteristic of west Persian metalwork. Its appearance on axes provides the student with a most instructive guide to the chronological development of such decoration in Luristan. There, by at least 2500 B.C., good shaft-hole axes of copper were in use and already placed in graves in some quantity. A series of gradually changing forms may be traced until Iron Age I, when the very distinctive spike-butted bronze axes supersede all other forms and remain in

[1] For a full discussion of these tools and weapons see J. Deshayes, *Les Outils de bronze de l'Indus au Danube (IVe au IIe millénaire)*, Paris, 1960.

use into Iron Age II. By this point the bronze axe was passing out of use, but little is yet known of its iron successors. Equally distinctive of this time are a group of halberds or large crescentic axes, often with iron blades (no. 9). So far axes are much more rarely reported among the Amlash bronzes, though fine axe-adzes were found in the Marlik cemetery with certain distinctive axes. Here again, as with the daggers, Caucasian forms were probably more influential than Mesopotamian ones.

Shafted or tanged *spearheads* were produced from the third millennium on-wards, though they do not seem to find their way onto the antiquities market as readily as other weapons. Particularly fine examples, with long bronze blades engraved with geometric patterns, were produced in Gilan and Talish in Iron Age I. Such spearheads were no doubt used as much by huntsmen as by warriors. It is only after the middle of the second millennium B.C. that solid tanged *arrowheads* became a regular aspect of the bronze industries of western Iran, but thereafter they were buried in graves in great quantity until the small socketed bronze trilobe arrowhead and iron leaf-shaped arrows replaced them after the seventh century B.C. The history of their changing forms will only be securely established when many more are published from scientifically con-trolled excavations.

Maceheads, again varying much in form, were an important aspect of the local metalworkers' repertory in Luristan from the third millennium onwards. The same is probably true of Gilan where examples occurred in the cemetery at Marlik. The simplest follow exactly forms produced in stone, notably haema-tite (see nos. 13 and 14). The most elaborate have cruelly faceted heads. In Mesopotamia maceheads played an important role as votive offerings in shrines. As the same was also true of Elam, it is possible that Luristan produced them as much for piety as for war. Certainly a group of cudgels, represented by no. 18 here, with richly modelled decoration have every appearance of being votive rather than practical weapons.

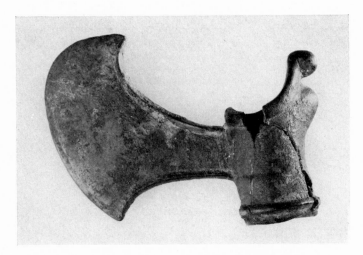

1. Bronze, cast. Short cylindrical shaft-hole (slightly damaged) with straight lower edge re-inforced by a circular moulding; upper edge rises sharply at the back and the collar curls over above a marked protuberance in the butt. The blade springs from the upper half of the shaft-hole and flares upwards, and more slightly downwards to form a convex edge, which has never been ground down for use.

 10 cm H. 10·8 cm L.

 cf. Calmeyer, Gp. 23, pp. 46 ff; *Outils*, II, pp. 172–3, Type B3 a, b.

This distinctive type of axehead has become closely associated with the name of Attakhushu, ruler of Elam in the nineteenth century B.C., on account of a number of examples inscribed for him (*Oxford*, pp. 30–1). But such axeheads, almost certainly of Elamite origin, were used for a very long period of time in western Iran. Although it is not yet clear whether they appeared first right at the end of the third or early in the second millennium B.C., there seems little doubt that they remained in production for the best part of six hundred years (*Outils*, I, p. 173; Calmeyer, p. 47). Examples are reported in archaeological contexts of the thirteenth century B.C. both at Susa and Tchoga Zanbil (*MDP*, VII, p. 81, fig. 184; *TZ*, I, pl. LIII. 5, LXXXIII G.T.Z. 166). No. 1 is more like the later examples.

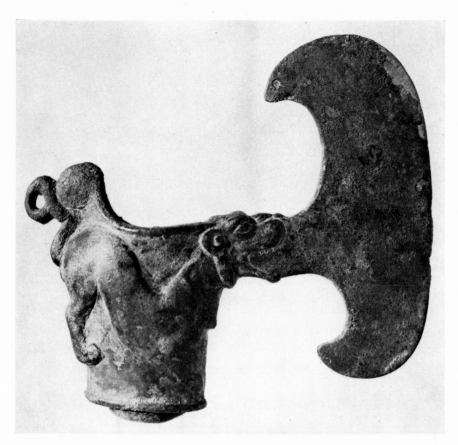

2. Bronze, cast. Short cylindrical shaft-hole with a straight lower edge reinforced by a circular moulding; the upper edge rises sharply at the back and curls round. A leonine creature is cast in low relief on the shaft-hole as if kneeling on its lower front edge. The blade flares out in a crescent from its jaws and its tail forms a loop below the upper rear corner of the shaft-hole.

10·4 cm H. 11·1 cm L.

In form this axehead belongs to the same group as no. 1, but it is extremely unusual in having zoomorphic decoration on the shaft-hole. Although the blades of axes from Luristan not uncommonly spring from a lion's jaws, the whole animal is rarely represented. In the only other similar published axehead there is a small caprid cast in relief on the side of the shaft-hole (Calmeyer, pl. 8.2). It is probably to be dated in the fourteenth or thirteenth century B.C.

37

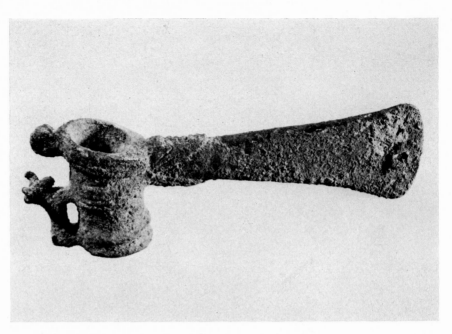

3. Bronze, cast. Cylindrical shaft-hole: the upper edge has a ridged collar which curls round at the back; the lower is plain. There is a second broad ridged collar half way up the shaft-hole. A zebu stands on the lower butt. Both ridged collars extend forwards to frame the base of the blade, which is narrow, flaring slightly at the cutting edge.

17·5 cm L. 6·2 cm H.

cf. *Outils*, I, p. 440, Type B5; Calmeyer, pp. 132 ff, Gp. 65.

This axehead may not be directly associated with any example from a controlled excavation. The zebu suggests northern Iran rather than Elam or Luristan as the area of origin, as this beast is more commonly represented in northern bronzework. Plain twirls rather than zoomorphic decoration are normally found on similar axes which have been attributed to the eighteenth or seventeenth century B.C. on typological grounds. Among them is one axe cast with an elaborate openwork blade. Where it would normally be plain and flat, two lions are shown with a zebu standing in their open jaws as if to form the edge of the blade (*SPA*, IV, pl. 52B).

The ridging on the upper part of the shaft-hole and at the base of the blade suggest the binding cords by which a more primitive flat axe-blade would have been secured to a wooden shaft.

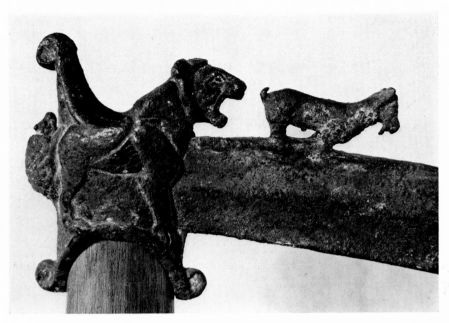

4. Bronze, cast. Straight rectangular blade with central ridge; short
shaft-hole cut away at the top and bottom with collar-ridge rolled in spiral
curls at each end. Hedgehog modelled on the butt; standing lion cast in
low relief on the shaft-hole with head modelled in three dimensions, jaws
agape, as the forepart of the upper collar; goat modelled standing on the
top of the blade just in front of the lion's head.

8·1 cm H. 20·2 cm L.

The basic form of this axehead associates it with a group attributed by
Deshayes to the first quarter of the second millennium B.C. (*Outils*, II, p. 72,
B2b; add now *IA*, IV, 1964, pl. VI.1, left). The exotic decoration and clearly
non-functional form recall an axe of slightly different shape, said to be from
Sakkiz in Azerbaijan, with elaborate decoration combining men and animals
(*Archéologie*, pl. 144a). The hedgehog is not an animal generally found on
Persian bronzes, but it appears sporadically in the art of Mesopotamia from
prehistoric times (Van Buren, *The Fauna of Ancient Mesopotamia*, 1939, pp. 24–5).
Hedgehog figurines were included in the Inshushinak deposit at Susa, where
lion and goat statuettes also appeared, during the thirteenth or twelfth century
B.C. (*MDP*, VII, p. 100, pl. XXIII (8); P. Amiet, *Elam*, fig. 330) and one
appears at Susa on a third millennium copper linch-pin (*Revue Ass.*, XIX (1922),
p. 138, fig. 16).

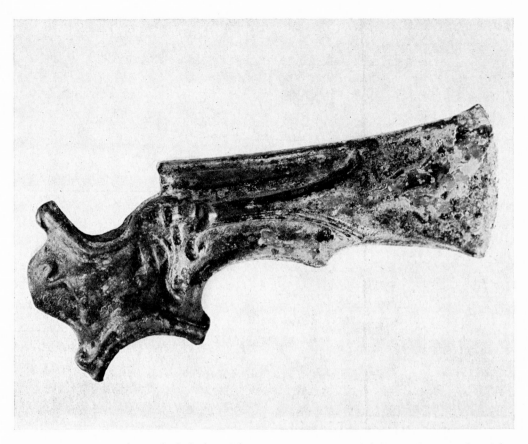

5. Bronze, cast. Short shaft-hole with concave upper and lower edges, each with a collar; the butt bulges regularly. The upper edge of the blade rises slightly above the top of the shaft-hole and then runs straight, rising slightly towards the cutting edge; the lower edge has a pointed protuberance halfway along. A lion is cast in low relief on the side of the shaft-hole, the head set at the base of the blade with forked ridges extending from its nose.

15 cm L. 6 cm H.

cf. Calmeyer, Gp. 19, pp. 39 ff; *Oxford*, No. 13.

A number of axes exactly like this have been reported from Luristan. The undecorated form appears first in Iraq late in the third millennium B.C. Such axes with leonine decoration, perhaps Elamite in origin, were manufactured in the first quarter of the second millennium B.C.

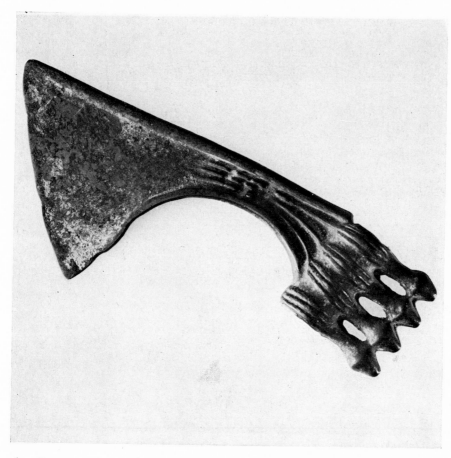

6. Bronze, cast. Cylindrical shaft-hole with four conically tipped butt-spikes not cleaned down after casting in a two-piece mould. Four triple ridges set at regular intervals up to the shaft-hole; all save the lower one running into single lines on the surface of the blade. The reinforced upper edge of the blade extends downwards at a slight angle from the top of the shaft-hole; the lower edge springs from the shaft-hole in a sweeping downward curve. Slightly dented straight cutting edge.

20·5 cm L.

cf. *Outils*, I, p. 182, Type D1a; Calmeyer, Gp. 33, pp. 66 ff; *Oxford*, Nos. 14–16.

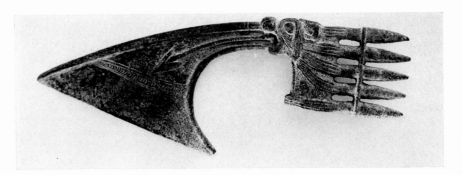

7. Bronze, cast. Cylindrical shaft-hole with five butt-spikes, each with a long conical point; a line joins them all at the base. Incised ridges extend from the base of each spike across the shaft-hole; that at top and bottom forming collars for the shaft-hole, the other three sweeping up into the back of the lion's head, modelled in low relief, from which springs the blade. The blade has a very narrow base, gently downward curving upper side, very concave lower side, and a straight cutting edge. An arrow in low relief, decorated with incised lines, springs from the lion's jaws towards a band of incised decoration across the blade.

19 cm L.

cf. *Outils*, I, p. 182, Type D2B; Calmeyer, Gp. 33, pp. 69 ff.

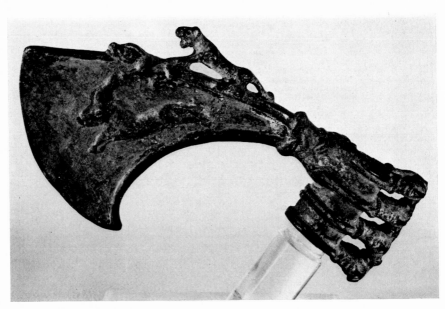

Spike-butted axes were one of the hallmarks of Luristan's bronze industry in Iron Age I. At present, evidence for their chronology rests on a series of examples, all completely made of bronze: two with twelfth-century royal inscriptions, one Elamite, one Babylonian (*Oxford*, pp. 31, 33), a simple thirteenth-century example found at Tchoga Zanbil in Elam (*TZ*, I, pl. LIII. 4), a number, some fragmentary, from graves excavated by the Belgian Luristan expedition in western Luristan which largely date to the later part of Iron Age I (Vanden Berghe, *Archeologia*, 36, 1970, p. 13, figure; *BCHI*, 6, 1971, figs. 11, 13, 28) and a single example, perhaps made earlier than the eighth century context in which it was found in the shrine at Dum Surkh (van Loon, *Bibliotheca Orientalis*, XXIV, 1967, p. 24).

Nos. 6 and 7 are typical examples of the form and decoration of spike-butted axes during the period of their major production in Luristan. As one of the most elaborately decorated, no. 8 is much more unusual. An axe in the Foroughi Collection has anthropomorphic butt-spikes and animals on the top edge of the blade (*Sept Mille Ans*, No. 197, pl. XXVI). The simpler, spike-butted axe of the thirteenth century B.C., found in the East Temple of Karirisha at Tchoga Zanbil in Elam has an animal cast in low relief on the blade (*TZ*, I, pl. LIII. 4, G.T.Z. 248); another, in the Foroughi Collection, has a goat in this position (Calmeyer, fig. 69).

CRESCENTIC AXEHEADS

9. *See colour plate facing page 44.*

This distinctive type of crescentic axehead with blades of bronze or iron has often been reported from Luristan, where they appear to have been used primarily from about 1100 to 800 B.C. Their decoration associates them

8. Bronze, cast. Cylindrical, regularly ribbed shaft-hole with four butt-projections each modelled as a bearded semi-human 'Janus' head, facing forwards and backwards, possibly horned. The blade springs from an animal's jaws, superficially that of a lion, though it appears to have a crescentic set of horns laid flat on the top edge of the shaft-hole. On the top of the blade a rearing lion, modelled in three dimensions has its front paws set upon the haunches of a goat crushed down onto the blade. A goat leaping forward is cast in low relief on both sides of the blade.

19·4 cm L. 9·2 cm W.

See opposite.

directly with the spike-butted axes and adzes in use there at the same time (see nos. 6 to 8). Indeed there are rare examples with spiked rather than zoomorphic butts. The transition from shaft-hole to blade is almost always cast as a lion's head varying only in the degree of stylization. Although a full-face 'lion-mask' does appear with iron blades, it is more common when the blade is of iron to have a profile head, as here, with jaws in emphatic relief. It is possible, as was first suggested by Frankfort (*AAAO*, pp. 211–12), that the spread of feathers shown emerging from the lion's jaw onto the blade is the final vestige of a representation of the Sumerian lion-headed eagle Imdugud. Be that as it may, there is little doubt that this type of axehead is ultimately of Elamite, or possibly Mesopotamian, origin. The iron-bladed examples from Luristan may be dated on the meagre evidence at present available to a century or so on either side of 1000 B.C. (for a technical discussion of the iron-bladed crescentic axes see J. C. Waldbaum in *Studies Presented to George M. A. Hanfmann*, Mainz, 1971, pp. 197–205).

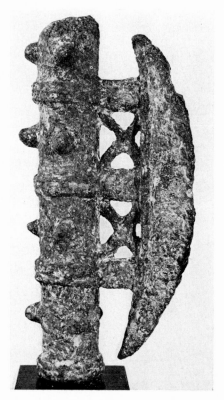

10. Bronze, cast. Tall cylindrical shaft-hole, broken at one end, divided by regularly set bands of ridges. A row of low spikes is set in the centre of each panel. Narrow crescentic blade joined at three points to the shaft-hole by narrow bars with metal crosses set in the intervening spaces.

20 cm L. Shaft-hole: 2 cm D.

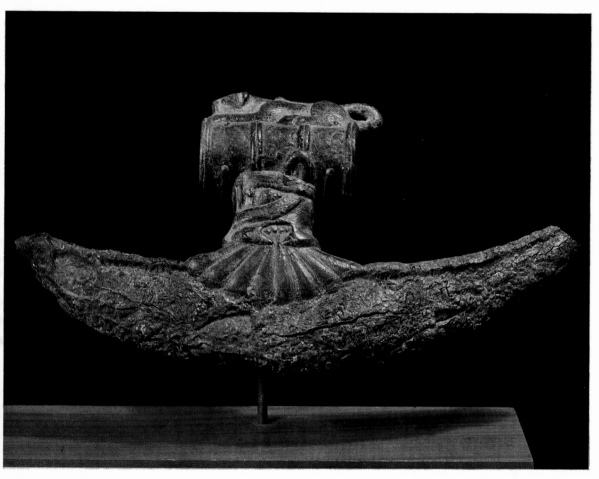

9. Cast bronze shaft-hole and iron blade, now heavily corroded. The short cylindrical shaft-hole is ridged at intervals and has a crouching lion rendered in the round along the butt. The junction of the blade and shaft-hole is modelled as a profile lion's head with prominent angular eye-ridges and open jaws from which emerge a fan of feathers.

Blade: 18·5 cm L. Shaft-hole: 5·5 cm L.

Calmeyer, Gp. 34, G on p. 71 (then on the Teheran art market).

Axeheads such as this have not previously been published from western Persia. The closest parallel, exhibited in Paris in 1961, when it was attributed to Luristan and dated in the eighth or seventh century B.C., has no spikes and the blade is longer than the shaft-hole (*Sept Mille Ans*, No. 221; Calmeyer, fig. 74). The two main groups of crescentic axes so far reported from Iran, one from Luristan (Calmeyer, Gp. 34; see no. 9 here), the other from northern Iran (*Oxford*, Nos. 25–6), belong to Iron Age I and are characterized by a shaft-hole very much shorter than the blade.

This axehead is almost certainly earlier, perhaps by as much as a millennium. The resemblance of the shaft-hole to the spiked cudgels used at Susa and Ur in the middle and later third millennium, and reported also from Luristan (*Oxford*, No. 97), is close and for the moment the only clue to its place in west Persian metalwork.

PICKAXE

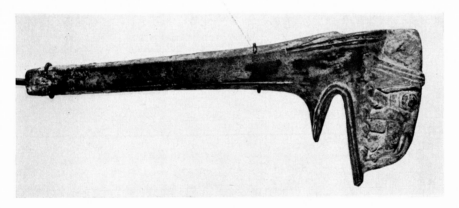

11. Bronze, cast. Short shaft-hole sharply cut away at the base; ridges frame the upper and lower openings; butt protrudes and a lion passant is cast in low relief on the lower part just below a double ridge.
 18·5 cm L. 6·5 cm H.
 cf. *Outils*, II, p. 166, Type A5c.; Calmeyer, Gp. 15, pp. 34–6; *Oxford*, No. 32.

Although pickaxes such as this, produced over a wide area of Syria, Iraq and western Iran in the later third millennium B.C. (cf. Vanden Berghe, *Archeologia*,

32, 1970, p. 72, fig. at top—excavated example from western Iran), occasionally have a stylized eye at the junction of blade and shaft-hole, there seem so far to be no other published examples with similar zoomorphic decoration. The simple, yet boldly effective modelling is matched by similar creatures on contemporary cudgels (cf. no. 18) and some adze-blades with such animals standing on the butt of a long shaft-hole (cf. for example, *SPA*, IV, pl. 51D).

ADZEHEAD

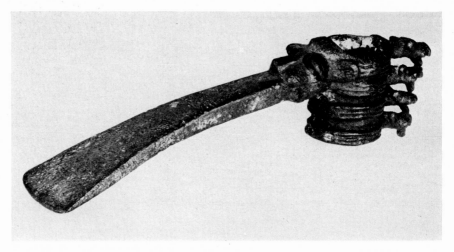

12. Bronze, cast. Blade springing from the jaws of a lion modelled in relief at the top of the cylindrical shaft-hole, which has four evenly spaced ridges, each terminating on the butt in a projecting animal head.
 12 cm L.
 cf. *Oxford*, No. 31.

As the distinctive decoration indicates, this adze belongs to the same family as the axes nos. 6 to 8. Such tools, perhaps again votive rather than functional, were manufactured first in the last quarter of the second millennium B.C. but since they were also made with iron blades production probably extended into the earlier first millennium.

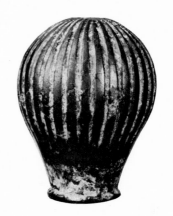

13. Haematite. Ellipsoid with regular vertical grooving over most of the surface; ridge round the base.
 7 cm H. 5·3 cm D.
 cf. *Oxford*, No. 91.

This basic form of macehead in stone and metal has a long history in Persia extending well back into the third millennium B.C. The example is probably nearest in date to those found in the East Kiririsha Temple at Tchoga Zanbil in Khuzistan (*TZ*, I, pls. LVIII. 4b, XCI G.T.Z. 132), which belong to the thirteenth century B.C. Comparable maceheads have also been reported from Tepe Giyan in Luristan.

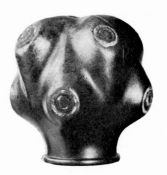

14. Haematite. Spherical with diamond-shaped protuberances; each incised with a double circle; moulding at the base.
 6 cm H. 5·2 cm D.
 cf. *Oxford*, No. 90.

Very similar maceheads, in bronze, have been found at Tchoga Zanbil and Marlik (*TZ*, I, pl. XCI G.T.Z. 171, pl. LVIII. 8B; *Marlik*, fig. 58) in the last quarter of the second millennium B.C. At Tchoga Zanbil they are contemporary with no. 13 above.

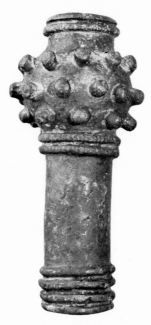

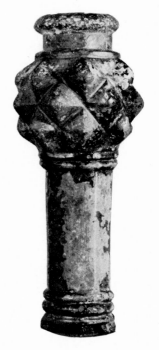

15. Bronze, cast. Cylindrical shaft with ribbed base; swelling at the top between double ridges fortified with three horizontal rows of projecting knobs.

 12 cm H. Shaft-hole: 2 cm D.

 cf. Calmeyer, Gp. 49.

16. Bronze, cast. Hexagonal shaft with ribbed base equipped with two square flanges; swelling at the top, between double-ridges, with a facetted surface.

 13 cm H. Shafthole: 2·3 cm D.

17. Bronze, cast. Cylindrical shaft with ribbed base; indented projecting ridge round the top set between ridges.

 9·2 cm H. 8 cm D.

 cf. Calmeyer, Gp. 41.

Maceheads exactly like these were found by the Belgian Luristan expedition in the cemetery at War Kabud in western Luristan, where they were dated to the late eighth or early seventh century B.C. (Vanden Berghe, *Opgravingen in Pusht-i Kuh*, 1968, pl. 30). Stray examples had earlier been reported from clandestine excavations (*ABSB*, pl. 4. 8–9).

CUDGELS

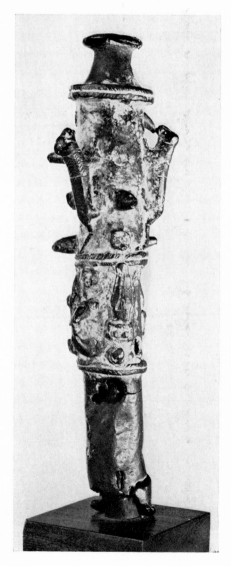

18. Cudgel, bronze; tapering to a flanged opening at one end. One end of the tube, divided into two horizontal panels by double ridges with chased designs, has relief decoration set between vertical rows of spikes. In the larger panel, nearest the end, three resting quadrupeds, possibly lions, are set one between each row of spikes; in the smaller panel three naked figures stand at intervals between rows of spikes. The order of figures and spikes alternates in the two registers. Two of the figures with long hair clasp their hands just below their breasts; in one case, a woman is clearly intended; the other may be men, one with his hands held lower on the abdomen.

21·4 cm L.

cf. Calmeyer, pp. 20 ff, Gp. 7.

About a dozen tubes decorated like this one have been published from Luristan. This is distinctive in having one opening narrower than the other in a way more common on less elaborately decorated objects of the same kind (cf. Calmeyer, Gp. 8, fig. 22c; Gp. 55, fig. 121). Two decorated tubes found during excavations at Susa (*MDP*, XXIX, 1943, fig. 75.3, p. 92; fig. 75.1, p. 90) indicate that they were already manufactured there by the middle of the third millennium B.C.

The function of such objects is not immediately apparent. The rows of spikes suggest that they were originally designed to be mounted on wooden shafts as cudgels. The addition of crude relief decoration may perhaps be taken to indicate that they were designed primarily as votive or parade weapons. The iconography would seem to endorse this role. In some cases, lions are shown threatening caprids or mouflon, on others, as here, the animals are associated with nude men and women. In one case (Calmeyer, Gp. 7G) the men and women are grouped in pairs in explicit sexual relationship. The direct association of the lion and a naked woman (whether a fertility goddess or a temple prostitute is never clear) is a very pervasive theme in the art of western Persia, as in much of Iraq and Syria from the third millennium onwards, but exactly what this combination implied is not known (*Oxford*, pp. 203–4).

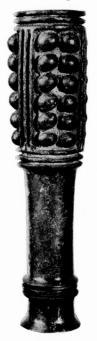

19. Bronze, cast. Slender hollow tube with slightly flanged base. On the upper end bands of three ridges frame panels of domed bosses set in two vertical lines; band of triple ridges just above the base.

16 cm H. Shafthole: 2·1 cm D.

cf. Calmeyer, Gp. 8; *Oxford*, Nos. 95–6.

Evidence at present available suggests that this object, a cudgel or bludgeon rather than a 'handle' as they are sometimes described, is much earlier than the shafted maceheads nos. 15 to 17. An example from Susa in Khuzistan may be dated about 2600 to 2400 B.C. (Le Breton, *Iraq*, XIX, 1957, p. 119, fig. 41). They were also manufactured about the same time in the adjacent part of Iraq (G. Cros, *Nouvelles Fouilles de Tello*, Paris, 1910–14, p. 77, figure).

ARROWHEADS

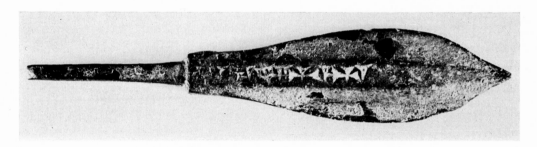

20. Bronze, cast. Ovate blade with broad, flat midrib, short square-sectioned stem and tang. Inscription in the cuneiform script down the midrib on both faces.
6·5 cm L.

Dr. Edmond Sollberger of the British Museum has kindly provided the following copy and comment:

𒀭𒁯𒈦𒁹𒌋𒑱 *šá si-im-bar-ši-ḫu*

𒁯𒑱𒈦𒁹𒌋𒑱 DUMU ^m^*eri-ba-*^d^30

'(Property) of Simbar-Šīḫu, son of Erība-Sîn'

'There is still no general agreement on the reading of the royal name, the second element being read either Šīḫu or Šipak. The problem is succinctly summed up by Brinkman, *A Political History of Post-Kassite Babylonia 1158–722 B.C.*, Rome, 1968, p. 150, n. 901, who decides in favour of Šipak while this writer still prefers to follow Goetze in reading Šīḫu.

'Only two contemporary written documents from Simbar-Šīḫu's reign were hitherto known, but one is only a late copy of a royal inscription and the other a legal deed drawn up in the king's twelfth year (Brinkman, op. cit., p. 340). The arrowhead published here is therefore of special interest not only because it is, strictly speaking, the only truly contemporary inscription, but also because it gives us the name of the king's father which had so far appeared only in two late chronicles. The new arrowhead, while not adding to our knowledge, at least confirms the authenticity of the chroniclers' sources.'

It is the earliest inscribed arrowhead yet reported from western Iran. They now run from Simbar-Šīḫu (about 1024 to 1007 B.C.) to Nabū-mukīn-apli (about 977 to 942 B.C.). The earliest inscribed arrowheads are contemporary with the latest in a long series of inscribed daggers from Luristan, which first appeared in the late thirteenth century B.C. (*Oxford*, pp. 31 ff).

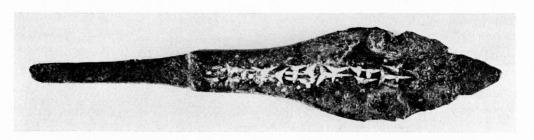

21. Bronze, cast. Pointed ovate blade, with broad, flat midrib, short square-sectioned stem and tang; inscribed in the cuneiform script on both faces.
 6·4 cm L.

The following copy and reading is again by Dr. E. Sollberger:

šá é-ul-maš-GAR-MU

LUGAL ŠÁR

'(Property) of E-ulmaš-šākin-šumi, king of the world'

Arrowheads inscribed for this man, who was ruler of Babylonia about 1003 to 987 B.C., have already been reported a number of times from Luristan (*Oxford*, p. 33).

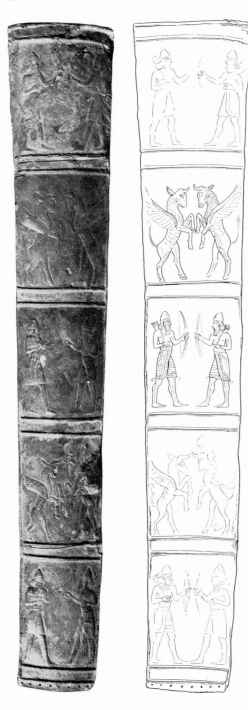

22. Bronze, sheetmetal. Tapering rectangular quiver plaque divided into five horizontal registers: the upper, centre and lower chased with human figures, the remaining two with winged bulls. Well preserved, with fragment missing in second panel from bottom. The human figures are two bowmen standing face to face, proffering their bows one to the other. Each wears a conical helmet, a shoulder quiver and a belted kilt with fringed edge, patterned surface and tassels on the lower corners. The winged bulls are shown rampant, forelegs hanging loosely. Each has a prominent forelock or horn, patterned body and wings.

 60·5 cm L. 10 cm wide at top. 7·5 cm wide at bottom.

 cf. Calmeyer, Gp. 43, pp. 81 ff.

The plaque is associated by its decoration with a number of others, first reported from clandestine excavations at Gilan near Qasr-i-Shirin in western Luristan about 1959 (*IA*, IV, 1964, pp. 2 ff). Calmeyer has assembled a number of examples which he divided into two main stylistic groups, the first generally well executed with distinctive Babylonian features, of the tenth or ninth century B.C.; the other, cruder in style and workmanship, whose affiliations are less clear. It is to the second group

that the example belongs. The bowmen in exactly this pose appear on a number of others (Calmeyer, pl. 6.2, figs. 86–8) juxtaposed to various scenes of siege and hunting, including at least one other on which they are combined, as here, with winged, rampant bulls (Calmeyer, fig. 88). If the evidence of Assyrian reliefs, and with this group comparisons with Assyria are closer, may be taken as a guide the dress and armament of the bowmen places them in the later eighth century, a time when Assyrian military penetration of Luristan was increasing.

This plaque was stitched to the quiver through holes along the upper and lower edges and through holes pierced regularly in a flange on each of the long sides.

DISK

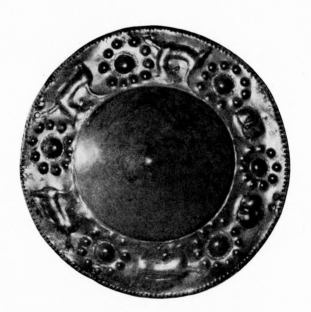

22A. Bronze, sheet. Circular disk of hammered sheetmetal with a sub-conical, plain central umbo. The broad flange has a perimeter margin of tiny repoussé blobs and is decorated in repoussé with four quadrupeds and two lion-masks alternating with 'rosettes' (a broad central umbo with incised hatched border surrounded by blobs, usually ten, each with stippled margins). Incised lines mark details on the animals' bodies, notably claws which may mean they are intended to be lions; the large oval eyes are not unlike those of some lions on the standard-finials. Two pairs of holes are pierced on opposite sides of the flange towards the edge.

17·5 cm D. 4·5 cm H.

This disk, a particularly well preserved example, was originally either a shield-boss or more probably a piece of body armour designed to be sewn onto leather or fabric crossing-straps on the chest. Such disks are worn by some of the soldiers shown on reliefs from Neo-Assyrian palaces in northern Iraq (cf. Y. Yadin, *The Art of Warfare in Biblical Lands*, 1963, p. 294, figures). A number of such disks have been reported from Luristan, with and without decoration. The style of decoration indicates that they were mainly produced there in Iron Age II–IIIB. The decorated examples are so homogenous in style and design that they probably derive from a single group of closely associated craftsmen (for example: *BBV*, V, No. 44, pls. XXIV–V; *BL*, pl. XXV. 75). The very distinctive lion-mask with chubby, unwrinkled jowls and small, closely set beady eyes under arching linear eyebrows may be used as a diagnostic trait linking a number of objects on all of which it appears variously combined with 'rosettes' and quadrupeds, as on this disk. They include the disk in Berlin listed above, a sheetmetal torc (*Persia*, fig. 380B), a quiver plaque and a shorter, broader decorated plaque, both in the Ashmolean Museum (*Oxford*, No. 489; 1971. 958: unpublished).

SHORT-SWORDS

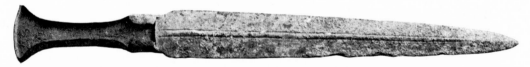

23. Bronze, cast. Flat pommel, flanged hilt with rectangular lappets on the guard; narrow ricasso; blade slightly broadening out and then tapering gently towards its point. Slight midrib marked by parallel incised lines.
 45 cm L.
 cf. Calmeyer, pp. 59–60, Gp. 31.

Bronze flange-hilted short-swords were manufactured widely in western Iran in the period from about 1400 to 800 B.C. The relatively small number so far found in controlled archaeological excavation at sites as widely spaced in time and region as Tchoga Zanbil, Godin Tepe, Sialk, Hasanlu and Marlik Tepe (*TZ*, I, fig. 55, pl. XCII, pp. 93–4, 100–1; *Godin Tepe*, p. 97, fig. 25.11; *Sialk*, II, pl. LXXV, Tb. 74—cem. B; Dyson, *Dark Ages*, pp. 32 ff; *Marlik*,

fig. 47; Vanden Berghe, *Archeologia*, 36, 1970, p. 13, fig. 4, p. 14, fig. 6; *BCHI*, 6, 1971, fig. 11, 27) indicate that much more must be known in detail about their typology before it will be possible to attribute uncontexted examples with confidence to any particular region or period. Though basically like some of the inscribed short-swords (about 1200 to 1000 B.C.), this weapon has a wider blade and a different type of lappets for securing hilt inlays.

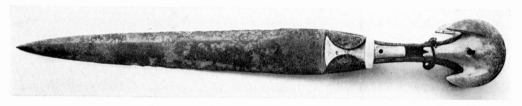

24. Bronze, cast. Flanged hilt still retaining its limestone inlays in part; the pommel inlays are secured by a rivet and cut to form two projecting 'ears'. The central portion of the inlays are lost; the lower part is still secured in place by a pair of semicircular flanges; rivet hole, but no rivet. The blade with broad, flat midrib, tapers gradually to a point. There is a band of traced linear decoration round the hilt edges.

 34 cm L.
 cf. *Oxford*, No. 50; Calmeyer, Gp. 56, fig. 122.

Flange-hilted daggers with inlay plaques exactly like this still in position were found in the Ishnikarab Temple at Tchoga Zanbil in Elam (*TZ*, I, pl. LIV. 1a, 5). In this context the weapons probably date to the later thirteenth or twelfth century B.C. A number of short-swords very like this one, but usually without their original inlay plaques, have been reported from Luristan, where they were manufactured during Iron Age I.

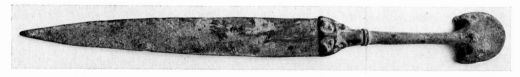

25. Bronze, cast. Winged pommel with solid cylindrical grip; guard in the form of a lion-mask from whose jaws the blade springs.
 38·2 cm L.

The hilt, of solid bronze, copies the bone and limestone inlay plaques (see no. 24) commonly set into a flanged hilt. In Luristan during Iron Age I–II it was common for such hilts to be copied exactly in bronze even including dummy rivet heads as on this example, though the grip is normally not so slender and cylindrical (*BCHI*, 6, 1971, fig. 13.10). This short-sword is quite exceptional, however, in having the guard cast as a lion's head. It was a conceit greatly favoured by weapon makers in western Asia (cf. axe-blade no. 8). Such hilts are shown on Neo-Assyrian palace reliefs (Hrouda, *Die Kulturgeschichte des assyrischen Flachbildes*, 1965, pl. 21.16–22) and four limestone orthostats each carved in the form of a lion's head with a dagger blade protruding in the place of a tongue were found in the Neo-Assyrian temple at Tell Rimah in northern Iraq (D. Oates, *Iraq*, XXX, 1968, pp. 124–5, pl. XXXVII). Two of these orthostats were found in their original positions flanking the entrance to the Temple's *cella*. So far, only one comparable short-sword has been published from Luristan and that came from the primary phase of clandestine excavation in the region (*BL*, pl. IX. 20). It differs slightly in the form of the hilt and is more like the dagger hilts shown on Assyrian reliefs than this one is. This example might well be earlier, dating to the eleventh or tenth, rather than to the ninth, century B.C.

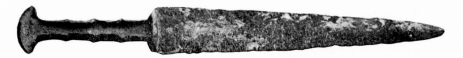

26. Bronze, cast. Crescentic pommel with flanged hilt; narrow grip with three sets of raised ridges at regular intervals; narrow solid-cast guard, no ricasso.
 37·5 cm L.

A flange-hilted short-sword with this type of indented hilt grip, though with much more pronounced crescentic pommel and broader blade was found at Marlik (*Marlik*, fig. 47 rt.). This dirk may then be attributed to a north-west Persian workshop of the later second millennium B.C.

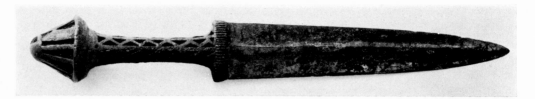

27. Bronze, cast. Triangular shaped blade tapering to a point; prominent midrib; conical pommel cast as a cage with bars; grip cast *ajouré* with a pattern of open triangles and zig-zag bars; rectangular guard decorated with closely incised vertical lines.
 33·5 cm L.

In the absence of exact parallels for the fine hilt of this short-sword it may only be attributed, on the strength of the shape of guard, blade and pommel, to a workshop in northern Iran during Iron Age I (cf. *Khurvin,* pl. XXXIV. 225).

SWORD

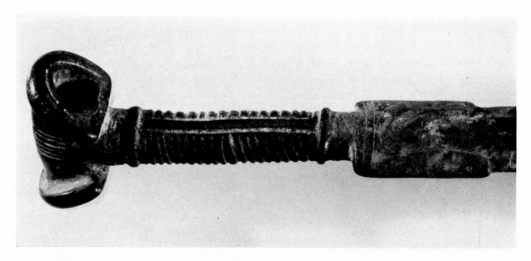

28. Bronze, cast. Long tapering blade with a broad midrib; hollow cast winged pommel; cylindrical grip with incised ribs; rectangular guard with crescentic horns extending down to grip the upper end of the blade; band of incised lines across the guard.
 67·5 cm L.

This is a north-west Persian type of sword, with solid grip and winged pommel, manufactured sometime at the very end of the second millennium B.C. or slightly later (cf. *Oxford*, No. 63; also *Expedition*, 12, 1969, p. 26, fig. c, from level IV at Hasanlu).

SHORT-SWORDS

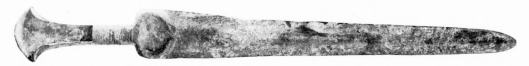

29. Bronze, cast. Blade tapering regularly to a point; broad, flat midrib. Crescentic pommel, which like the grip is flanged to take inlays; the lower part of the grip is cylindrical and decorated with a pattern of incised spiral lines; penannular guard.

34·1 cm L.

Typical of the bronze short-swords used in northern Persia during Iron Age I (*Oxford*, No. 49), this example is interesting in having the lower part of the grip cast in imitation of a fabric binding.

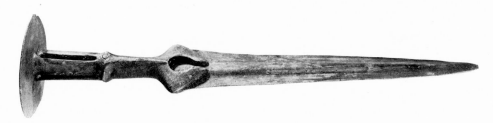

30. Bronze, cast. Blade tapering regularly to a point; rounded midrib; flat, disc pommel; the grip is cast solid in the lower part, *ajouré* in the upper with alternating bars and openings; triangular guard with horned crescent extending onto the upper part of the blade.

32 cm L.

cf. *Festschrift Fremersdorf*, pl. 61 b.

The flat, disc pommel appears on bronze dirks in Talish during Iron Age I (*BL*, pl. VII. 13, with an example said to be from Luristan, pl. VII. 14). The open cast grip on this weapon associates it with a small group of swords reported from 'Amlash', also with flat disc pommels, which have the hilt case as an openwork frieze of human figures moving to the right (Louvre AO 21069: A. Parrot, *Syria*, XL, 1963, p. 242, fig. 7; Israel Museum: unpublished).

WHETSTONE SOCKETS

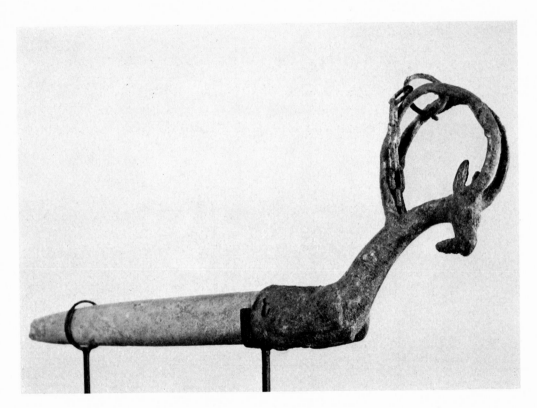

31. Socket, bronze. Hone surviving in it; socket cast as the forepart of a *capra aegagrus* with the horns curving back to touch the neck well below the ears. Some links of a chain for suspending the whetstone remain attached to the horns.
26 cm L. 8·5 cm H.

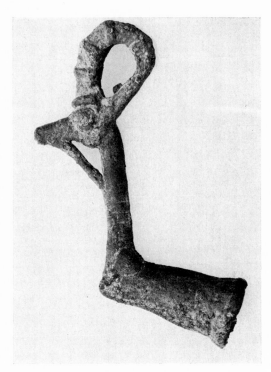

32. Socket, bronze. Socket cast as the forepart of a *capra aegagrus* with long stylized beard and horns curving round to touch the ear tips.

10 cm H. 8 cm L.

This is the simplest type of zoomorphic whetstone socket to be reported from Luristan. Such tools were vital for the recurrent sharpening bronze blades require. The animals are akin to the simplest type of wild goat finial (see no. 76) and in many cases these objects were probably contemporary. The earliest zoomorphic whetstone socket so far reported from western Iran was found in the thirteenth or twelfth century Inshushinak deposit at Susa. It is a masterpiece of the Elamite goldsmith's art, cast as a lion's head (*MDP*, VII, pl. XXIV. 3a–c). A bronze example, cast as the forepart of an ibex, was in use at Susa during the earlier first millennium B.C. (Ghirshman, *AJA*, 74, 1970, p. 223). At Bard-i Bal in western Luristan bronze whetstone sockets in the form of wild goats' heads have been found in the same eleventh-century graves as spike-butted axeheads (see nos. 6 to 8) and flange-hilted daggers (see no. 23) (Vanden Berghe, *Archeologia*, 36, 1970, pp. 12 ff; *BCHI*, 6, 1971, figs. 13, 29–30). It is possible that these were the earliest type of decorated whetstone handle commonly used in the region and that those decorated with an exotic or fantastic zoomorphic style belong to the floruit of the local Luristan bronze industry, about 900 to 700 B.C.

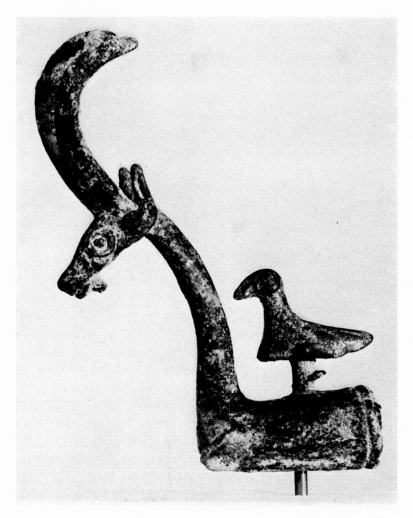

33. Socket, bronze. Socket cast as the forepart of a bearded ibex with smooth, regularly rising and slightly curved, free-standing horns; a stylized bird is perched on the goat's back.
11·2 cm H. 8 cm L.

The Luristan metalsmith, despite the recurrent fantasy of his religious imagery, was ever an acute observer of nature. Here he catches in slightly stylized form the common sight of a bird perched upon a goat's back browsing through its coat for insects (cf. *SPA*, IV, pl. 53f; *BMRAH*, 1931, p. 59, fig. 26, left).

CYMBAL (?)

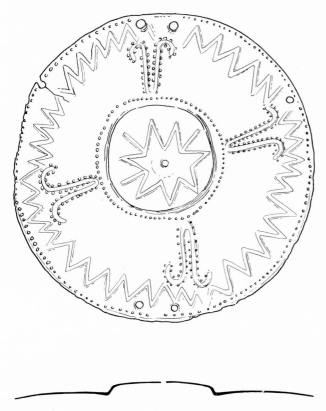

34. Bronze, hammered. Disk with low central umbo: repoussé decoration; outer margin of zig-zags; within it four evenly spaced loop motifs; crude six-pointed star on the umbo. Hole in the centre; two pairs of holes at opposite sides of the perimeter and two single perimeter holes.

14·3 cm D.

cf. *Oxford*, Nos. 468–73.

Though a number of disks like this one have been reported from clandestine excavations in northern Iran, the only indication that they were normally used as cymbals was found by the Japanese excavators in Dailaman. In tomb B–V at Noruzmahale a pair of these disks were found lying on the skeleton's left shoulder together with traces of the goatskin thong which had originally held them together (*Dailaman*, II, pls. XVIII. 2, XLIV. 1, 2; fig. 2 in Japanese text; see also *Dailaman*, III, pl. XLV. 7, pp. 42–3). Although the chronological evidence for these graves is still sparse, they seem to be either late Parthian or early Sassanian.

II

Horse-Harness

———

The domesticated horse is first mentioned in the ancient Near East in texts from Iraq at the end of the third millennium B.C., when it was described as 'of the (caravan) route' and 'with flowing tail' to mark its domestication and to distinguish it from the already long domesticated ass and half-ass (onager) which both have stalk-like tails with tufted ends. The horse was sporadically ridden, primarily by peoples living in the desert fringes of Babylonia, but it was more often harnessed in pairs to draw the recently introduced light chariot with spoked wheels. This superseded the cumbersome solid or block-wheeled chariots drawn by asses and onagers which had been used for the previous thousand years or more. From about 1700 B.C. the use of the horse and light chariot, if not indeed their original association, is particularly linked with the Indo-Aryan Mitanni. They were a warrior aristocracy among the Hurrians of the Syrian steppe, who may originally have brought the domesticated horse across the Caucasus from south Russia or through northern Persia from Turkestan. Western Persia may already have been—as it was certainly to be by about 1000 B.C.—renowned for its horses. The earliest horse burial so far excavated in western Persia, at Godin Tepe near Hamadan, may be dated somewhere between about 1500 and 1250 B.C. Thereafter they become more common occurring at Marlik in Gilan during Iron Age I, at Hasanlu in Azerbaijan in Iron Age II and at Baba Jan in Luristan during Iron Age III. At Tepe Giyan in Luristan and at Tepe Sialk on the plateau harness-trappings were buried in the graves of human beings in the ninth and eighth centuries B.C., though no horse bones were reported. In Luristan, where a great variety of harness-trappings have been reported from illicit excavations,

64

they seem to have been placed both in horse burials, like that at Baba Jan, and in human burials from the tenth to seventh centuries B.C.

The presence of the domesticated horse either for riding or draught does not necessarily pre-suppose the use of metal horse-bits. Indeed in the earliest representations both of ridden onagers and horses they are harnessed with a nose-ring. Even for chariots they are not vital and for the moment archaeo-logical evidence indicates that for at least two or three hundred years horses were harnessed to light chariots without them. The earliest metal horse-bits, found in Egypt, Syria and Palestine in the late fifteenth and fourteenth centuries B.C., appear at a time when chariotry as a military weapon had become vital to the armies of Egypt and her main opponents in western Asia. The metal bit greatly aided the control and manoeuvrability of a light war-chariot moving at speed. Even so, costly and elaborate metal bits were confined to military usage. It was in the armies of Assyria from the ninth century B.C. onwards that cavalry developed as a vital military force and progressively superseded chariotry. Here again metal bits, also the introduction of saddle-cloths and castration, ensured greater control over the heavy, strong horses required to carry archers into battle. Saddles and stirrups were introduced much later.

The major production of metal harness-trappings in Luristan in Iron Age I–II coincides with the gradual decline of chariotry and the growing importance of ridden horses in war among countries to the west. About the same time the migrating Iranians began to penetrate the Zagros area accelerating the growth of the importance of the horse in the daily life of the region, though to judge from finds in Gilan and Azerbaijan Iranian horse-trappings were much less elaborately decorated than those of Luristan. Even to a society where metal was so readily available as that of Luristan, metal horse-bits were probably used only as military and ceremonial equipment. The metal horse-bits used in Luristan until about 1000 B.C. differed not at all, so far as present evidence goes, from those used in the rest of western Asia. But thereafter the Luristan tradition diverged either by richly decorating forms used plain elsewhere or by creating horse-bits with unusually elaborate and heavy cheekpieces on rigid mouthpieces. Indeed many have doubted whether some of these bits were ever more than funerary equipment. Horse-bits, it appears, are often found under the skulls of buried men and called 'head-rests' as a result by the local Lurs. This should not be taken as a guide to their ancient function.

Despite a marked distinction between rigid and jointed mouthpieces, the action and fitting of the Luristan metal horse-bits to harness was the same in all cases and exactly that shown on sculptured reliefs from Assyrian palaces between the ninth and seventh centuries B.C. Nearly all the cheekpieces are provided with two loops, usually fairly small, for suspension and a central hole through which pass the ends of the mouthpiece; this terminates in rings or loops, almost invariably turned in opposite directions on a rigid mouthpiece. On either side of the horse's mouth the cheekstraps divided into two branches, one fastened to each end of the cheekpiece, to hold it at approximately right-angles to the animal's mouth. The reins were attached to small rings moving freely in the larger rings or loops at the ends of the mouthpiece. Spikes regularly set on the inner sides of the cheekpieces would have reinforced the effect when pressed against the horse's mouth.

Despite recurrent doubts these Luristan horse-bits were, with few exceptions, designed to be used. It has been argued that a general absence of wear and the excessively elaborate form of some cheekpieces indicate votive, or, at most, exclusively ceremonial objects. Neither argument bears close examination. Many of the bits do show, by wear at the point of contact between mouthpiece and cheekpiece, that they were used regularly. It may also be assumed that the plainer horse-bits most closely paralleled on Assyrian palace reliefs, where they are shown in use, were functional. Even on bits which have large, richly ornamented cheekpieces set on rigid mouthpieces, enough examples show signs of wear, some of it hard enough for the mouthpiece to have broken through the collar round the hole in the cheekpieces, to indicate use. Exactly what this use was is less easy to establish. There may be little doubt that the heavier bits were primarily used to control driven, not ridden, horses. Indeed there is a small group of cheekpieces from Luristan cast as a chariot with four-spoked wheels. They may also have been used on horses drawing funerary carts, before they were placed in the grave. During the seventh century these bits were superseded by a form which spread throughout the Near East in the sixth century. It had plain bar cheekpieces, each cast in one with half of the jointed mouthpiece. The two sections of the mouthpiece interlock, or are joined by a large ring, and are often covered with tiny spikes (see no. 52).

In Luristan objects, designed to be used like the more modern 'horse-brass', were made to decorate the animal's headstall. Flat plaques of sheet bronze with

geometric decoration were fitted onto the horse's brow, and variously shaped sheet bronze cutouts were sewn in rows round its collar harnessing. Buckles had not yet been invented so straps were either tied or knotted round plain harness-rings set at their junctions. Bells, jingles or animal figurines were suspended from the collar. These seem to have been far more ornate in Gilan, where in the cemetery at Kaluraz elaborate bronze ceremonial horse-collars have been found with a whole variety of figurines and models wired to them.

The exact destination of many of these harness-trappings is still largely a matter of surmise using the evidence for horse-harness shown on Assyrian palace reliefs from Aššurnasirpal II (about 883 to 859 B.C.) to Ashurbanipal (about 668 to 627 B.C.)[1] and the ceremonial trappings of Scythian horses recovered from the unique frozen burials at Pazyryk in Siberia.[2] None of the horse burials so far scientifically excavated in Persia have been elaborately equipped with harnessing; that at Baba Jan included an iron bit, a bronze brow-plaque and a few domed studs with loops for fitting them to a headstall. The most outstanding find of near contemporary horse burials are those from the approaches to tombs in the archaic necropolis at Salamis in Cyprus, where chariots with yoked pairs of horses were found fully equipped with bronze and iron trappings.[3] In Cyprus, as also in Syria and Assyria, the decorated blinkers, frontlets, brow-pieces etc. were of sheet bronze decorated in repoussé. Although such trappings are sporadically found in Luristan and south Kurdistan, whither they may have come through Assyrian military activity, the local Luristan smiths favoured cast bronze, with decoration modelled in relief, for harness-trappings as for so much else in their metal repertory.

The cheekpieces here are classified in the manner proposed by Potratz.[4]

[1] T. A. Madhloom, *The Chronology of Neo-Assyrian Art*, London, 1970, pls. I–VIII.

[2] S. I. Rudenko, *Frozen Tombs of Siberia: the Pazyryk burials of Iron Age Horsemen*, London, 1970.

[3] V. Karageorghis, *Excavations in the Necropolis at Salamis*, I, Nicosia, 1967.

[4] *Pferdetrensen, passim*.

HORSE-BITS

POTRATZ GROUP I: Cheekpieces in the form of rectangular or sub-rectangular openwork plaques, almost invariably mounted on rigid mouthpieces.

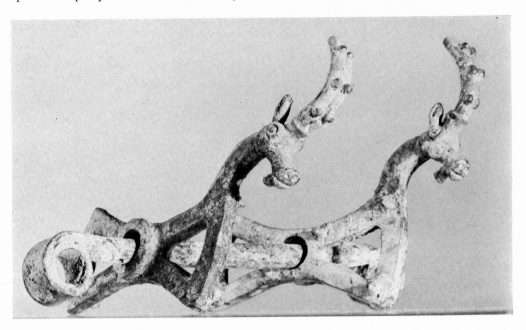

35. Bronze, complete. Rigid mouthpiece of circular section, curled over in opposite directions at either end. Both cheekpieces cast as openwork rectangular plaques with very concave upper and lower edges, convex ends; the upper front corner in each case is cast as an ibex head with finely rendered horns. Pointed studs inside each cheekpiece at the corners and flanking the mouthpiece hole. No loops for cheekstraps.

Cheekpieces: 13 cm W. 10·3 cm H. Across mouthpiece: 11·8 cm.

cf. *Pferdetrensen*, pp. 102 ff; Calmeyer, Gp. 38, pp. 76 ff; *Oxford*, Nos. 108–9.

No decorated horse-bit of this form has yet been found in a controlled excavation in Luristan. They are for the present dated through the appearance of undecorated examples on Neo-Assyrian palace reliefs of the ninth century B.C. In Luristan their use persisted well into the next century. Though other animals, and even on occasion human heads, are used to decorate this type of cheekpiece, goats' heads are used most often.

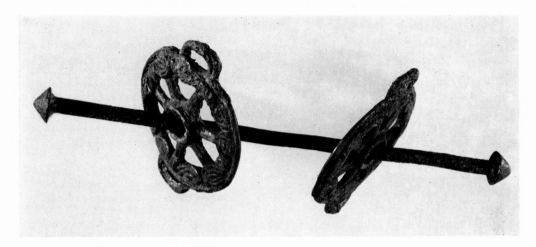

36. Bronze, cast. The mouthpiece is a straight rod with a conical knob at each end. Mounted on it are a pair of circular cheekpieces, each cast with seven spokes and a loop projecting on either side to take the cheekstraps. The upper surface of the ferrule is decorated in low relief with pairs of facing profile lion-heads in the exaggerated linear style characteristic of Luristan.

Cheekpieces: 5·7 cm D. Across mouthpiece: 20·5 cm.

This bit is of considerable interest as one of the rare examples reported from Luristan with circular cheekpieces. There is no reason to doubt the authenticity of the assemblage or its function as a light horse-bit. Exactly comparable cheekpieces, though detached from a mouthpiece, were reported from Luristan among the earliest bronzes to be found in systematic clandestine excavations there (*BMRAH*, 1933, p. 86, figs. 16, 17; *SPA*, IV, pl. 41B; *ESA*, IX, 1934, p. 279, fig. 8). Although round cheekpieces were one of the earliest forms to be used on metal bits in the ancient Near East, they are not shown on Neo-Assyrian palace reliefs and may have passed out of use in Iraq and the Levant after the end of the Bronze Age (*Oxford*, Nos. 110–11; *Iran*, IX, 1971, pp. 121–2). As the example indicates, they survived in western Persia considerably longer, at least into Iron Age II.

The decoration of these cheekpieces employs a motif widely used in Luristan at that time. A very similar arrangement of detached profile heads was used on

cast bronze pinheads (*BMRAH,* 1933, p. 88, figure 22; *Philadelphia,* pl. V, 16). The complete creature may be seen on nos. 96 to 98 in this collection.

In one striking respect this bit differs from all others reported from Luristan. They invariably have loops at the ends of the mouthpiece for rein-rings, commonly turned in opposite directions (see nos. 38 ff). In this case either the reins, if simple cords, were knotted round the mouthpiece just inside the knobs or, if leather straps, split at an appropriate point and fitted over the knob which then retained them.

POTRATZ GROUP III: Bar cheekpieces, cast separately from the mouthpiece which passes through a hole in the centre of the cheekpiece; jointed mouthpiece.

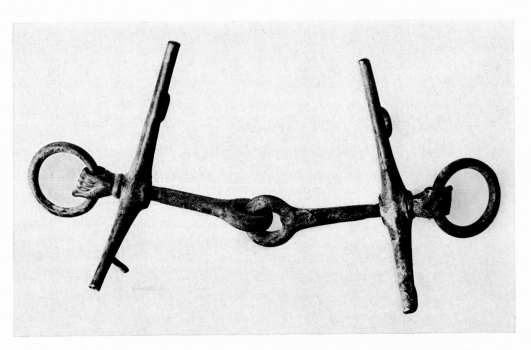

37. Bronze, complete. Jointed mouthpiece of circular section; in each case the canon terminal, through which a circular rein-ring passes, is modelled as a human hand. Slightly arched plain bar cheekpieces have an upright loop towards each end for cheek-straps (one broken).

Cheekpieces: 14 cm L. Across mouthpiece: 13·7 cm.

cf. *Pferdetrensen,* pp. 135 ff; *Oxford,* Nos. 112–14.

Horse-bits of this form were widely used in western Persia in the later ninth and eighth centuries B.C. Many have been reported from Luristan, and examples exactly like this were found in cemetery 'B' at Tepe Sialk on the central plateau. Though normally undecorated there are rare examples from Luristan with zoomorphic terminals to the cheekpieces.

POTRATZ GROUP IV: V-shaped cheekpieces with zoomorphic terminals.

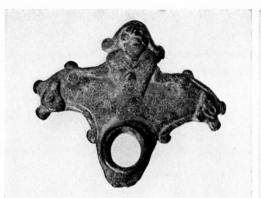

37A. Bronze, cast. Two cheekpieces from a horsebit; they are clearly a pair, though varying slightly in details as each is an independent lost-wax casting. The torso of a bearded male figure, with his hair falling in heavy locks to the shoulders, is set between the necks of a pair of bovids, each with a trailing, curled mane along its neck, front and back. The holes, through which the mouthpiece passed, show clear signs of wear on their lower edges. A pair of loops, for the cheekstraps, and just below them two small spikes on the back of each cheekpiece.
8·7 cm H. 10 cm W.
BL, pl. XLVII. 178; *SPA*, IV, pl. 27A; Potratz, *Orientalia*, 21 (1952), pl. XIII. 49; *Pferdetrensen*, p. 139, pl. LVI. 135; *Weill*, No. 289 (*Amiet*, 108).

There is so far no archaeological evidence from western Iran for the date of cheekpieces in this form nor do they appear among the horse-bits illustrated on Neo-Assyrian palace reliefs. A group of very distant relatives, stemming from some unknown intermediary source, perhaps in Assyria or Syria, have been found in Greece, where they first appear sometime in the seventh century B.C.

(H-V. Herrmann, *Jahrbuch des Deutschen Archäologischen Instituts*, 83 (1968), 1ff; esp. figs. 1, 14). Examples so far reported from Luristan fall into two main groups, one consisting of addorsed animals heads only, the other of heads with a human figure, or part of a human figure, set between them. One example with a human figure in position strongly suggests that this is a rigorously fore-shortened view of a driver standing in a chariot or cart to which a pair of beasts, or birds, are harnessed (*Pferdetrensen*, fig. 60), as in the fuller version represented by no. 41 in this collection.

The compact style of these cheekpieces and the relatively natural rendering of the man and flanking animals provide a contrast to the predominant style of decorated horse-bits from Luristan in Iron Age II–IIIB, as may be seen by comparison with other examples in the collection. But, as the animal heads may be matched on other bronzework of the period in the more distinctive Luristan manner, it is possible that the cheekpieces belong to the later phases of the independent bronze industry in Luristan, when strong influences from the north were introduced through Assyrian military campaigns and the Iranian migrations. Although the figures are not exactly comparable, the cast affixes of two spouted bronze jugs now in the Louvre, one from Luristan, the other from French excavations at Hamadan (*Persia*, pp. 94–5, figs. 122, 522–3), bear some affinity to the style of these cheekpieces. Both jugs were made in the later eighth or seventh centuries B.C. By then the fashion for such decoration on vessels was well established in Azerbaijan and Kurdistan, perhaps initially under the influence of Urartian metalworkers (O. Muscarella, *Metropolitan Museum Journal*, 1 (1968), 7ff.). A comparable bearded head with heavy side-locks also appears occasionally on the decorated diskheaded pins made about the same time in Luristan (R. Ghirshman, *Bichâpour*, II, fig. 12) (for the type see no. 101 here).

POTRATZ GROUP V: Openwork cheekpieces in the form of animals, real or imaginary, or groups combining sub-human figures and monsters; with rare exceptions mounted on rigid mouthpieces.

Zoomorphic cheekpieces, always a horse, only appear on Assyrian reliefs in the reign of Sennacherib (704 to 681 B.C.) and even then they are confined to the chariot horses of the king or the model horse's head at the end of the pole on his ceremonial wheeled chair (C. J. Gadd, *Stones of Assyria*, 1936, pp. 165, 216, pl. 23; A. Paterson, *The Palace of Sinacherib*, 1915, pl. 74–6). Such a cheekpiece, in electrum, was found in a well in the palace of Aššurnasirpal II at Nimrud, where it was probably dumped about 614 B.C. when the palace was sacked by the Medes. Similar Assyrian cheekpieces or fragments of them have been found on the islands of Rhodes and Samos in contexts of the seventh century B.C. It is likely that such cheekpieces had been used in Luristan for at least a century or more before the time of Sennacherib, but evidence for their chronology from Luristan is still entirely absent. The most elaborate here were probably contemporary with his reign, representing the last phase in a fashion which passed with the decline of the Luristan bronze industry in the course of the seventh century B.C.

A. *Ibex cheekpieces*

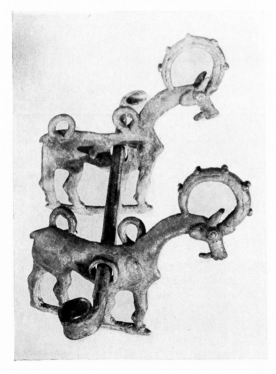

38. Bronze, complete. Rigid mouthpiece of square section with terminals curled in opposite directions. Each cheekpiece cast as an ibex passant set on a groundline with the loops for cheekstraps set on the rump and the base of the neck. The animal has a well modelled head with carefully rendered horns; the body is flat save for slight relief on the shoulder and haunches.

Cheekpieces: 12 cm H. 12 cm W.
Across the mouthpiece: 17 cm.

The use of this particular animal for cheekpieces is by no means as common as its regular appearance on whetstone sockets, standard-finials and pins from Luristan might suggest. The mouflon, rare elsewhere save on the large series of harness-rings (see nos. 53 to 55), is far commoner on cheekpieces (Potratz pp. 152 ff; *Oxford*, Nos. 121–3).

B. *Horse cheekpieces*

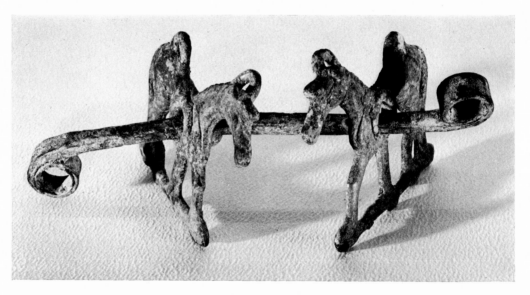

39. Bronze, complete. Rigid mouthpiece of square section with terminals curled over in opposite directions. Each cheekpiece cast as a horse passant on a groundline; loops for cheekstraps, one high on the neck, the other on the rump. The heads have a 'blunderbuss' profile with pronounced forelock and curled mane; the body is flat save for rudimentary modelling on neck and rump. Two small pointed studs on the inside of the cheekpieces. A short rectangular bar runs from the belly to the baseline.
 Cheekpiece: 8·1 cm H. 11·5 cm W. Across mouthpiece: 16 cm.
 cf. *Oxford*, Nos. 117–120.

A wide variety of the zoomorphic cheekpieces from Luristan are cast as horses; not surprisingly in view of their function. Though many differences may be explained by the vagaries of individual metalsmiths, there are certain

groups where it is clear that an attempt has been made to portray a particular breed of animal. In the absence of documentary evidence these may not be named, but the type represented here with lightly built, narrow body, long, slender legs, long back, thin neck and distinctively tapered head, has some affinity to Arab breeds of later periods (W. Ridgeway, *The Origin and Influence of the Thoroughbred Horse*, 1905, p. 173, fig. 57).

C. *Horse and rider cheekpieces*

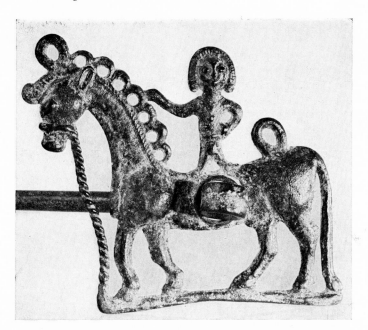

40. Bronze, complete. Rigid mouthpiece of rounded section with terminals curled over in opposite directions. Each cheekpiece is cast as a horse passant on a groundline with a semi-human figure standing in the centre of its back facing outwards. The horse is tethered by a twisted halter. Loops for cheekstraps on the head and rump; pointed studs on the inside of each cheekpiece. Openwork curly mane, squarish head; body flat save for slight modelling of shoulders, rump and haunches. Each figure holds one hand on its hip and grasps the horse's mane with the other.

Cheekpieces: 9·6 cm H. 10 cm W. Across the mouthpiece: 15·6 cm.

These cheekpieces may be compared with one reported long ago from Luristan, then in the David-Weill Collection, and widely reproduced ever since (*BL*, pl. XLV. 174). Though it differs slightly in style, the motif is the same. The fact that the horse is tethered and the figure stands may perhaps be taken to indicate that it is a demon associated particularly with horses. When human riders are intended, as on a Luristan cheekpiece in the British Museum (WA 134927), they sit astride grasping the reins in an orthodox manner.

D. *Double-headed horse and rider cheekpieces*

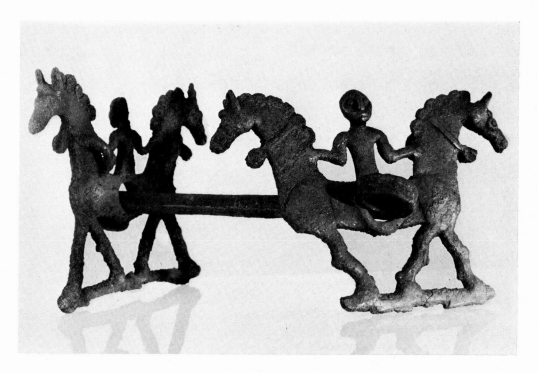

41. Bronze, complete. Rigid mouthpiece of rounded section. Each cheekpiece is cast as a single body with the forepart of a horse at either end, shown passant on a groundline. The foreleg of one horse is lost. The torso of a semi-human figure is represented facing forewards in the centre of each animal's back, grasping the horses' necks on either side. The horses have long, narrow heads, forelocks, tightly curled manes and bells pendant from a double cord round the upper neck. Loop for cheekstrap behind each animal's head; one cheekpiece retains two studs, one on either side of the mouthpiece.

Cheekpieces: 10·2 cm H. 13 cm W. Across the mouthpiece: 11 cm.

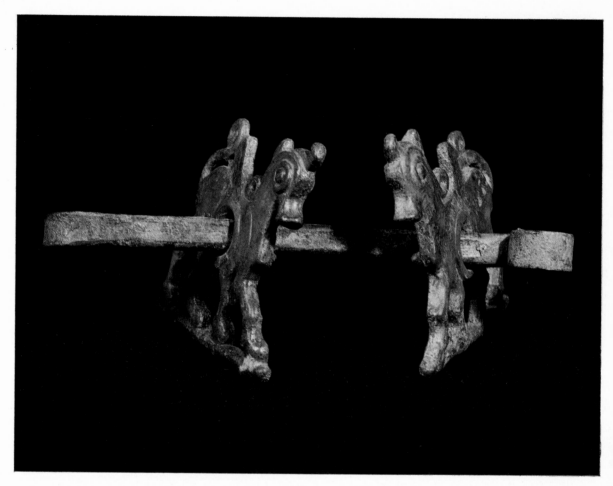

42. Bronze, complete. Rigid mouthpiece of square section with terminals curled over in opposite directions. Each cheekpiece is cast as a winged animal standing on a baseline. The tail is curled upwards to rest against the back of a tiny wing; a long curl falls down the back of the neck; a forelock and ear are prominently modelled. The eye is cast as a blob within a circular ridge. Two loops for cheekstraps and two studs on the back of each cheekpiece.

Cheekpieces: 8·2 cm H. 9·5 cm W. Across mouthpiece: 12·7 cm.

This striking motif appears on other cheekpieces from Luristan (*Pferdetrensen,* fig. 60). It may derive from the frontal view of a chariot with a pair of horses harnessed up and the charioteer standing in the carriage with the reins in his hands. It is an interesting, and relatively early attempt, to represent a complex three-dimensional scene in two dimensions. The motif was later to have a wide currency in the Near East, where it was often used in religious iconography to represent solar or lunar deities. Sometimes the chariot wheels were unrepresented, or united in a single wheel placed in the centre of the design. These few Luristan cheekpieces are the earliest Persian examples of a motif which appeared there later on Sassanian gems and silverwork (E. Herzfeld, *AMI,* 2, 1930, pp. 128 ff; H. Seyrig, *Syria,* XVIII, 1937, esp. pp. 43 ff; M. Bussagli, *East and West,* VI, 1955, pp. 9 ff).

E. *Winged wild bull cheekpieces*
 42. *See colour plate opposite.*

It may be that what is taken in the description here for an ear and a forelock is in fact a pair of horns set frontally on a profile head as on another cheekpiece from Luristan clearly representing a bovid (*Pferdetrensen,* pl. LVII. 138). The animal shown on these cheekpieces, probably a wild bovid of some kind, appears on other cheekpieces from Luristan. The closest parallels are on the cheekpieces of a complete bit, now in Tehran, which is unusual in having a flexible mouthpiece and rein-rings cast in one with the canons (S. Lloyd, *The Art of the Ancient Near East,* 1961, fig. 200). A very much more elaborate illustration of the same animal with wings and hair curls on its legs appears on a pair of cheekpieces now in Brussels (Graeffe Collection, fig. 23). The same animal, but without wings, is chased on a fine gold beaker from the excavations at Marlik (*Marlik,* pl. XVI) and on a cruder one from an unknown site in north-west Iran (Huot, *Persia,* 1965, pl. 138). In Luristan a similar creature appears on a bronze situla (Louvre AO 20.463) and on the Persian plateau among the motifs painted on pottery in cemetery 'B' at Tepe Sialk (*Sialk,* II, pl. XC. 1, pl. LXXXI.d; *SPA,* IV, pl. 6a).

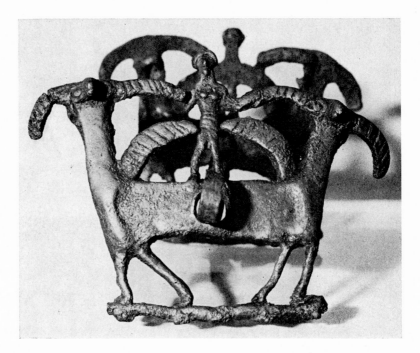

43. Bronze, complete. Rigid mouthpiece of rounded section curled over at each end in opposite directions. Each cheekpiece cast as a single body with the forepart of a winged mouflon, head turned sideways, at each end, shown passant on a groundline. A semi-human figure stands in the centre of each animal's back, its arms blending with the mouflon horns on either side. Poor casting; loops for cheekstraps behind the animals' heads. Two studs on each cheekpiece.

Cheekpieces: 12·5 cm H. 16 cm. W. Across mouthpiece: 11·5 cm.

The formal relation of the design of these cheekpieces to that of no. 41 is obvious; whether the suggestion about a chariot proposed there is also viable here it is impossible to judge. In the absence of literary evidence for the myths the cheekpieces illustrate, the possible existence of chariots drawn by winged mouflon may not be established.

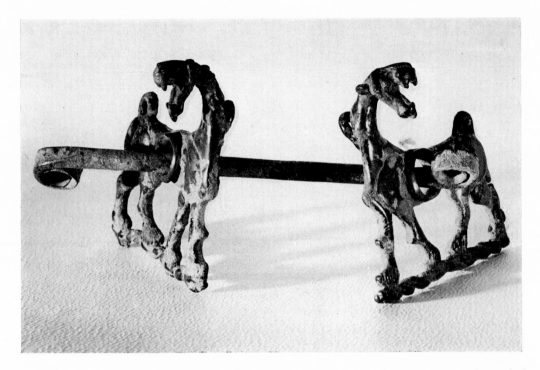

44. Bronze, complete. Rigid mouthpiece of rounded section with terminals curled over in opposite directions. Each cheekpiece is cast as a lion passant, head turned outwards, jaws agape and teeth bared. Each beast stands on a twisted groundline. There is a loop for a cheekstrap set on the rump and another hidden behind the neck. The body is flat, save for some modelling of the shoulders and haunches. Traced lines render details on the lower legs. Two studs on each cheekpiece.

Cheekpieces: 9·8 cm H. 10 cm W. Across mouthpiece: 14·1 cm.

The lion in the relatively natural rendering used here was not greatly favoured as a subject by the makers of zoomorphic cheekpieces in Luristan. It appears very occasionally on its own (*Pferdetrensen*, pl. LVIII. 141a), more commonly in its predatory role, winged and triumphant over wild goats (*Pferdetrensen*, pp. 176–7, pl. LXXII–III. 173–4; also Louvre AO 20.867).

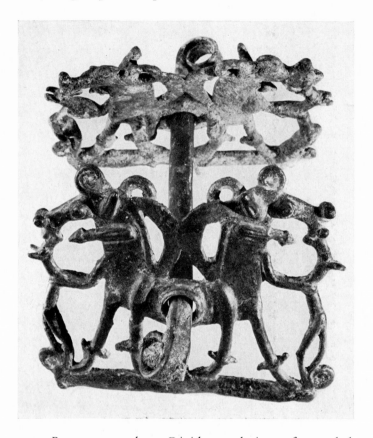

45. Bronze, complete. Rigid mouthpiece of rounded section with terminals curled over in opposite directions. Each cheekpiece is cast as a single body with the forepart of a winged equid at each end. The animal has a spirally curled forelock, prominent pointed ears, globular snout and bell or jingle round its upper neck. In front a lithe dog leaps upwards to the animals' heads. The dogs have prominent ears and long tails with ends spirally curled. There is a loop for cheekstraps behind each animal's head. Two studs on each cheekpiece flanking the mouthpiece collar.

Cheekpieces: 13 cm H. 16 cm W. Across mouthpiece: 14 cm.

This very unusual type of cheekpiece employs the double-headed theme of nos. 41 and 43 with the addition of dogs, which occur very rarely on Luristan bronzework. A similar motif is used on a standard-finial once in the David-Weill Collection (F. Hancar, *Ipek*, 1935, pl. 14.8), where a central human figure is shown between two horses' heads, as on cheekpiece no. 41. On each side a dog leaps up to lick the horse's nose. The scene is taken straight from nature. Such a blend of fantastic creatures and vividly natural action is typical of the Luristan smiths' art in the first half of the first millennium B.C.

I. *Triple figures cheekpieces*

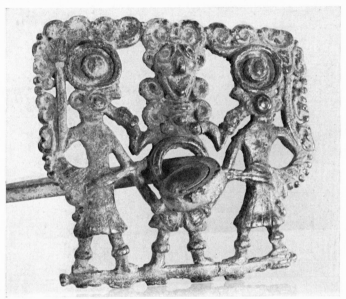

46. Bronze, complete. Rigid mouthpiece of square section with terminals curled over in opposite directions. Each cheekpiece is cast as winged animal-headed demons flanking a central sub-human creature, through whose body passes the mouthpiece. A loop for cheekstraps behind the head of each flanking demon; three studs on the inside of each cheekpiece. The flanking demons wear kilts and have prominent disk headdresses; the central figure is also skirted and has an elaborate headdress of double spiral curls running over the heads of the flanking figures and down their wing tips.

Cheekpieces: 9·7 cm H. 10·5 cm W. Across the mouth-
piece: 14·6 cm.

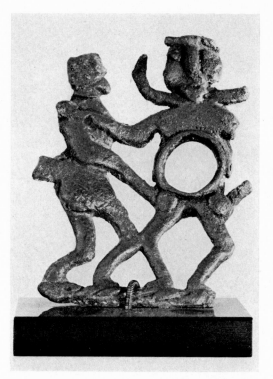

47. Bronze, fragment. Cast as a bow-legged central sub-human figure, with the hole for a mouthpiece in the centre of its body, flanked by human figures, of which only one survives.
8 cm H. 10·3 cm W.

The extraordinary cheekpieces of no. 46 have no close published parallels among the horse-bits so far reported from Luristan. An isolated cheekpiece in the Stora Collection (*Pferdetrensen*, pl. 170) is comparable in having a similar upper frame of spiral curls and central figure flanked by rampant monsters; but the central and the flanking figures are more like those on no. 47 here. Bull-headed creatures, rather like the flanking monsters of no. 46, are illustrated on various sheetmetal fragments from western Iran (*Bulletin of the Cleveland Museum of Art,* June 1964, p. 145, fig.; ibid, 1966, p. 42, fig. 6; *Ancient Art in American Private Collections,* Harvard, 1954, No. 97, pl. XXVII) and on a unique ivory plaque from Nimrud in Iraq (M.E.L. Mallowan, *Ivories in Assyrian Style,* 1970. pl. XXXII. 118).

is perhaps the most exotic horse-bit yet reported from Luristan. The cheek-pieces are cast as an inverted stag—extremely rare on other Luristan bronze-work—flanked by winged lions and topped by a weird winged female creature (B. Goldman, *Art Quarterly*, XXVII, 1964, figs. 5–6; the same or nearly identical object is illustrated in H. Thrane, *Nationalmuseets Arbejdsmark*, 1968, fig. 20, said to be from Tang-i-Hamamlan in Luristan). At the base there are two very stylized, addorsed goats or mouflon. The location of the workshop from which the objects derive and its period of activity must, in view of their present isolation, remain an open question.

OTHER FORMS OF HORSE-BIT

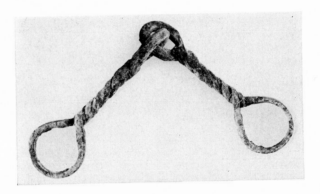

51. Bronze. Jointed mouthpiece for a horse-bit with twisted canons and large terminal rings through which the cheekpieces originally passed.
12·5 cm L.

This type of mouthpiece is reported from the cemetery at Kaluraz in Gilan (Iran Bastan Museum, Tehran) and occurred in a horse burial, probably of the eighth century B.C., found at Hasanlu in 1947 (R. Dyson, *JNES*, XXIV, 1965, pp. 208–11; *Persia*, fig. 338, left; see also *Sialk*, II, pl. 100.17 (Solduz)). An exactly comparable type of horse-bit, but of iron, was found in the seventh-century horse burial at Baba Jan in Luristan (G. Goff, *Iran*, VII, 1969, p. 123, fig. 7.5). Both at Tepe Giyan and in cemetery 'B' at Sialk the same type is represented, but the canons are straight, not twisted (*Giyan*, pl. V. 6; *Sialk*, II, pl. LVI. 588, 835, 841, LXVIII. 715).

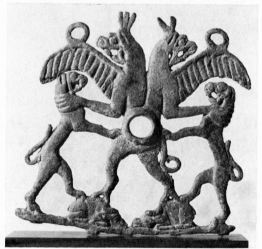

50. Bronze, cast. Pair of cheekpieces cast as an elaborate openwork design. In the centre a rampant, winged leonine creature with double profile body set on a single profile set of legs. Jaws agape; trefoil device on each head. More naturalistic rampant lion on either side grasped round the neck by the forepaws of the central monster. The central monster stands on a pair of facing crouched goats with their legs drawn up under their bodies. Narrow groundline; small circular loop on each wing for cheekstraps; butt spikes on the back.

14 cm square.

Both the style and rather bizarre character of the design on these two cheekpieces, not exactly alike in details, recall two others which have entered American collections in recent years. A single cheekpiece in the Heckett Collection has a similar creature in the centre, but holding caprids not lions, set on a baseline (*Ancient Bronzes: a selection from the Heckett Collection, Pittsburgh, Pennsylvania, 1964, No. 31, plate*). A complete bit in Cincinnati Art Museum, though not a parallel design, shares the same rather extravagant conception. It

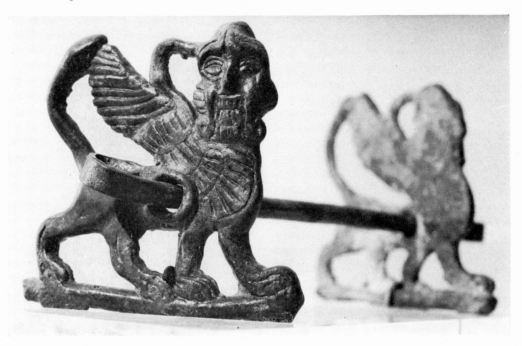

49. Bronze, cast, complete. Rigid mouthpiece of rounded section with terminals curled over in opposite directions. Each cheekpiece is cast as a winged male sphinx passant with leonine body and human head turned sideways. The human heads are male, wearing a horned crown and rectangular beards framed by pendant side-locks curled round at the bottom. Single loop (? for cheekstraps) on the side of the head; no studs on the back.

Cheekpiece: 9 cm H. 9·5 cm W. Across mouthpiece: 16·5 cm.

The absence of the normal loops for cheekstraps and the usual pointed goads raised doubts about the authenticity of these cheekpieces, particularly when the monster depicted does not appear elsewhere on Luristan bronzes. Indeed the closest parallel is a male sphinx carved on a ninth-century relief at Tell Halaf in Northern Syria (A. Moortgat, *Tell Halaf*, III, pl. 87a). Neither Elam nor Assyria knew a beast quite like this.

J. *Double-headed lion and sphinxes*

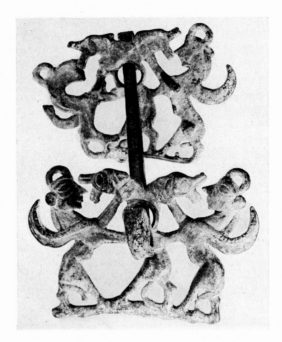

48. Bronze, cast, complete. Rigid mouthpiece of square section curled over at each end in opposite directions. Each cheekpiece is cast as a rampant double-headed lion flanked on each side by a rampant winged sphinx. A loop for a cheekstrap on the head of each sphinx; two pointed studs on the inside of each cheekpiece. One sphinx has every appearance of being a modern relpacement.

Cheekpieces: 7·5 cm H. 12 cm W.
Across mouthpiece: 13·3 cm.

No cheekpieces like this have so far been published from Luristan, though the style would be appropriate to the later phases of the local industry in Iron Age IIIB, about 700 B.C. The imagery owes more to an Elamite or Mesopotamian source than is common with these horse-bits and may reflect the revival of contact with those two areas at this time which is evident from other archaeological material.

Very similar contemporary or near contemporary sphinxes may be found in Assyria on the embroidered robes of Aššurnasirpal II shown on the palace reliefs at Nimrud in the ninth century B.C. (*Mon.*, I, pl. 6, 8), and on shell-inlay plaques found in Fort Shalmaneser at Nimrud (*Nimrud*, II, p. 399 figs.). A skirted female sphinx appears on a gold plaque from Ziwiyeh in Azerbaijan probably made about the same time as this bit (A. Godard, *Le Trésor de Ziwiyè*, fig. 15; cf. *BMMA*, April 1952, p. 233). But it is likely that the immediate ancestor of the female sphinx shown here is the beast depicted by makers of the decorated situlae (see nos. 134 and 135) in the tenth or ninth century B.C., working in western Luristan if not actually in Babylonia.

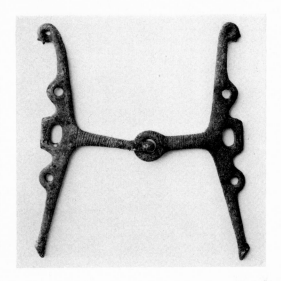

52. Bronze. Snaffle; linked canons each cast in one with the corresponding bar cheekpiece. Each canon is decorated with incised lines. The bar cheekpieces have a large rectangular aperture projecting from the centre flanked on either side by a smaller, round hole; one end is cast as a hoof, the other as a stylized bird head (?).

Cheekpiece: 18·5 cm L. Across the mouthpiece: 11 cm.

The bit above belongs to a family of bronze horse-bits which appeared in western Asia sometime in the early eighth century B.C. (G. Azarpay, *Urartian Art and Artifacts*, 1968, p. 15: inscribed for Sarduri II, about 764 to 735 B.C.). Each canon is cast in one with the adjoining cheekpiece and two loops or apertures in the cheekpiece flank the central hole or loop for the rein-rings (*Pferdetrensen*, pl. LII, pp. 116 ff). This type of bit, also in iron, seems to have been generally prevalent in the Achaemenian period. No exact parallel to no. 52 has yet been published, but some of the Achaemenian bits have a horse's hoof at the tip of the cheekpiece (*Pferdetrensen*, pl. LII. 124a). An isolated bone cheekpiece, said to be from Ziwiyeh, and now in the Metropolitan Museum, New York, has one end carved as an animal's head in the 'Scythian style', the other as a horse's hoof (Porada, *Ancient Iran*, p. 132, fig. 73).

HARNESS-RINGS

There is, as yet, no archaeological evidence from Luristan for either the date or the function of these rings. Their decoration associates them with the bronzework manufactured in the region during Iron Age II–IIIB. Their identification as trappings, like modern horse-brasses, suspended by the loops on the back from the straps of a horse's head-harnessing is still no more than the most reasonable hypothesis (see pages 66–7).

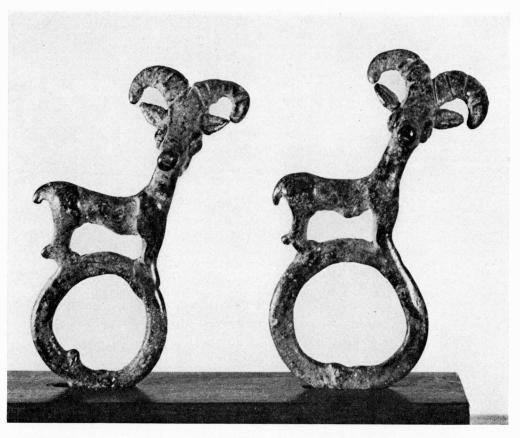

53. Bronze, cast. Two open rings with slightly distorted ferrules in each case. On the upper edge stands a mouflon with single suspension loop behind its head.
 7·5 cm H. 3·6 cm W.

Though clearly a pair, the two rings are not designed to be hung symmetrically as are other such pairs reported from Luristan (cf. *Oxford*, No. 135). Harness-rings as simple as these two have not so far been commonly published among the bronzes from Luristan (cf. *Ostas. Zeit.*, n.f. 8, 1932, pl. 42.10).

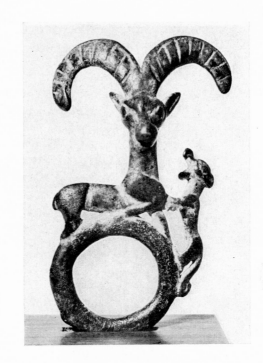

54. Bronze, cast. Open ring with a mouflon resting on the top; a feline creature climbs up the ring on the right side as if to attack the mouflon's head. Single suspension loop behind.

 8 cm H. 5 cm W.

This may be one of a pair of rings; the other would have had the mouflon with its head on the left and a predatory beast climbing up on the left side of the ring (cf. *Oxford*, No. 135).

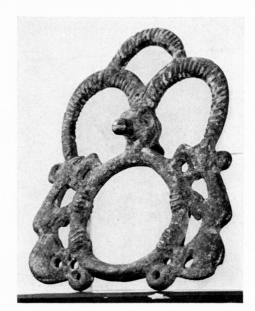

55. Bronze. Open ring with a mouflon head at the top, its horns curving round to touch the heads of a stylized lion creeping up the ferrule on either side towards it. A ridged semi-circular bar bridges the base of the mouflon's horns. Suspension loop behind the head.

 10 cm H. 9 cm W.

A number of harness-rings like this have been reported from Luristan (cf. *Oxford*, Nos. 137–9), but none have the top loop found here.

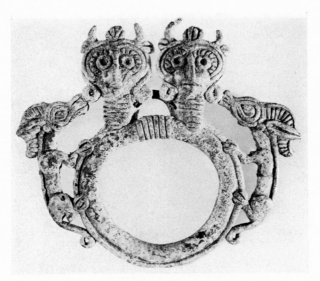

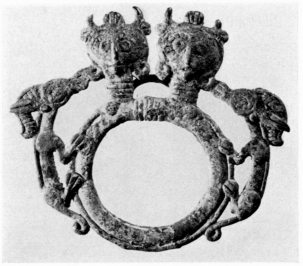

56. Bronze. A pair of open rings with two grotesque sub-human faces on the top flanked by a stylized mouflon climbing up the ferrule on either side towards them. The human heads have curling sidelocks and wear horned crowns. Single suspension loop behind.

10·7 cm D.

These are among the most exotically decorated of all harness-rings reported from Luristan (cf. *SPA*, IV, pl. 58D; *BL*, pl. XXXII. 117; with a spoked wheel: Moortgat, pl. IV. 8a; *BMRAH*, 1932, p. 103, fig. 30; Godard, *L'Art de l'Iran*, pl. 18). Similar grotesque heads are found on the open-cast pinheads ('wands') richly represented among finds in the shrine at Dum Surkh (see

nos. 96 to 98 here). More unusual are the flanking animals. They are normally the highly stylized lions used on no. 55, but here the creatures have the ribbed horns and ears of the mouflon.

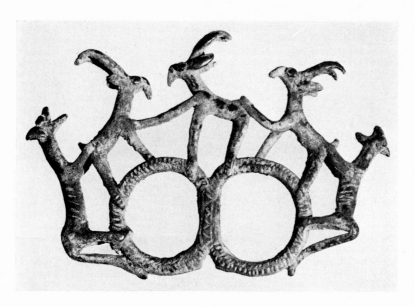

56A. Bronze, cast. Horizontal figure-of-eight with crudely incised linear patterns on the front surface. A mountain goat stands on the top in the centre, where the rings join, flanked on either side by another standing goat, each with a foreleg raised to touch the central animal. In turn the outer goats are each threatened from behind by a predatory beast, probably feline, jaws agape, which has its forepaws set on the goat's haunches, its long tail trailed onto the edge of the ring.

14 cm max. W. 4·9 cm max. H.

Although similar double rings are found among the harness-trappings of Luristan, they are usually decorated in exactly the same style as nos. 53 to 56 with mouflon and demons, not in this simpler, cruder style. Yet there may be little doubt this object derives from a workshop somewhere in central west Iran, active in the first quarter of the first millennium B.C., as such goats and lions appear on pins which may confidently be attributed to workshops in Luristan (cf. *SPA*, IV, pl. 47, F). More particularly, a pair of harness-rings,

with tiny side suspension loops, now in the Walters Art Gallery, Baltimore, have exactly comparable mountain goats standing on the upper edge. These two rings, each with a vertical division down the centre, were said to come from Baghdad when acquired just before the First World War (D. K. Hill, *Journal of Hellenic Studies*, LXXII, 1952, pp. 120–1, fig. 1). In this case a single aggressive feline creature is placed between two goats, seizing the throat of one in its jaws and anchoring itself to the other with its tail. On stylistic grounds Miss Hill attributed them to Luristan and pointed out that they have appeared on the market sometime before the major wave of clandestine excavations in the region. The great importance of the Baghdad–Hamadan road as a route in and out of Iran would facilitate the arrival of such objects in Iraq, where nothing remotely like them has yet been found in an excavation. Another rather similar fitting decorated in the same way, formerly in the Barbier Collection, was said to come from Luristan (*Barbier*, No. 55, pl. on p. 66).

As this object has no suspension loops it must have been used at strap junctions, as plain double rings were, with the tying thongs passed round the animals or through their legs.

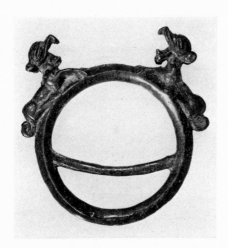

56B. Bronze, cast. Open ring with bevelled hoop; a slightly curved bar passes across the opening some way up from the base; a pair of lions with prominent eye coils and gaping jaws crouch on opposite sides of the hoop towards the top.

8 cm H.

BL, pl. XLVII, 180; *Weill*, no. 263 (*Amiet*, 133).

Two other rings of this distinctive form have been published as from Luristan (*SPA*, IV, pl. 39D; L. Legrain, *Luristan Bronzes in the University Museum, Philadelphia* (1934), pl. XXII. 59); all from the earliest phase of clandestine excavation in the region. The style of the lions denotes a product of a local

workshop active in Iron Age II–IIIB; its function is less certain. Wear on the lower edges indicates use as a strap fitting, probably on the headstall of a horse's harnessing.

VARIOUS HARNESS-TRAPPINGS

PENDANTS

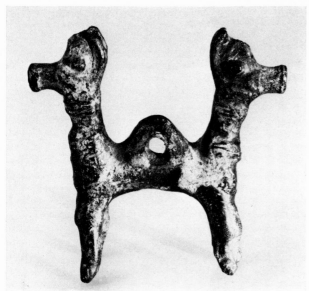

57. Bronze, cast. A single body with the forepart of a foal at either end; suspension loop in the centre.

7·4 cm H. 7·2 cm W.

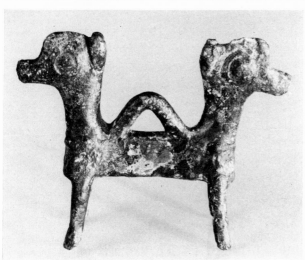

58. Bronze, cast. Single body with each end cast as the forepart of a foal; suspension loop in the centre. The animals appear to have some kind of decorative trapping on their chests.

5 cm H. 7 cm L.

A considerable number of pendants exactly like these two have been reported from Luristan (*Oxford*, No. 428 with references). Their appearance in excavations at Masjid-i Solaiman in Khuzistan indicates a date of manufacture in the later first millennium B.C.

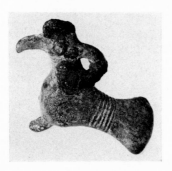

59. Bronze, cast. Heavy pendant in the form of a very stylized cock with splayed tail feathers. Loop on the back of the neck.
6 cm H. 8 cm L.

Pendants of the type, varying only in size, have been reported regularly from Luristan (cf. *Oxford*, Nos. 413–15). In the Dum Surkh Shrine they appeared in the eighth-century B.C. levels (van Loon, *Bibliotheca Orientalis*, XXIV, 1967, p. 24), but slightly earlier in graves at Bard-i Bal (*BCHI*, 6, 1971, fig. 41).

It is possible that a great many of the animal figurines catalogued in Chapter VI were from harness-trappings. However, as there is clear excavated evidence for the suspension of such pendants from human belts in northern Iran, whence most of these figurines come, it seemed best to discuss them separately and leave their original function an open question.

RING

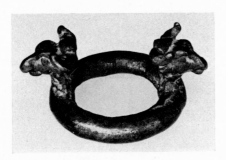

60. Bronze, cast. Open ring of circular section with animal heads, perhaps rams, modelled in relief at either end of the diameter.
3·7 cm D. 2 cm H.

Both the date and function of this object are obscure. It belongs with a varied range of such objects partially classified by Ghirshman, who identified them as bow-rings (*Syria,* XXXV, 1958, pp. 61 ff). In this, as in most other instances, the shape is not really suitable for this purpose (*Oxford,* Nos. 147–150). Most such rings were probably either decorative horse-trappings, which also served as strap junctions, or primitive buckles. There is an exactly similar object, of silver, in the Graeffe Collection, Brussels (Graeffe Collection, No. 295).

DECORATIVE DISK

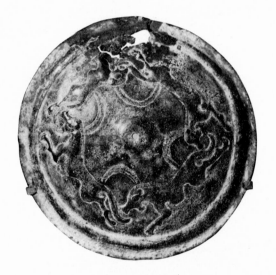

61. Bronze, sheetmetal. Slightly convex metal disk with marginal moulding and tiny central hole. Four animals chase round the central hole, each in hot pursuit of its predecessor. An arc, incised with a herring-bone pattern of lines, spans the rump and head of each adjoining beast. Each animal is maned, but so stylized otherwise as to make identification hazardous; lions are the most likely.

8·7 cm D.

There is another disk very like this, also reported to be from Luristan, in the British Museum (WA 130905). It retains a dome-headed rivet in the central hole. The design is closely comparable. A circle of four creatures, more readily recognized as lions, chase one another round and round. It is not clear

what the disks were for. A possible parallel is provided by much finer disks of the later eighth century B.C. which are made of silver with central rivets, some cast with floral decoration. The decoration varies, but a number of examples have finely chased goats or lions, four in number, set one behind the other (*IA*, VI, 1966, pl. XXVII). The associated material at Ziwiyeh suggests that the silver disks were harness-trappings, perhaps riveted to straps passing over the horse's head. The same may be the case with these cruder bronze examples from Luristan made in Iron Age II–IIIB. A link may be provided by a larger bronze disk, now in the Iran Bastan Museum, decorated in the same style as those from Ziwiyeh (Calmeyer, *BJ* 6, 1966, p. 66, pl. I) with a circle of six bulls.

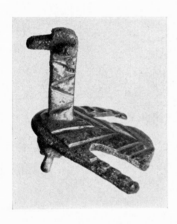

62. Cast, bronze. Very stylized, resting bird with tall neck, narrow, crescentic wings and hold, flared tail. Deeply incised chevron lines decorate the neck and body.
3 cm L. 3 cm H.

The function, and perhaps also the origin, of this object can be elucidated by reference to finds in the Scythian royal tombs of south Russia in the fifth century B.C. Among the bridle accessories found with horse burials in the 'Seven Brothers Barrow' on the lower reaches of the Kuban were bronze plaques cast as rather stylized birds with spread wings and fan-tails (M. I. Artamonov, *Treasures from Scythian Tombs*, 1969, p. 41, fig. 66 on p. 36). No. 62, probably from clandestine excavations in north Iran, is functionally and stylistically similar and may well be a stray vestige of 'Scythian' activity in the region in the second quarter of the first millennium B.C. (compare Louvre 21390–1: *La Revue du Louvre*, 1968, p. 333, fig. 11: 'Amlash').

63. Bronze, cast. Conical with straight solid sides, open at top and bottom with a small loop at the apex; plain save for incised lines round the top and the base.

11·5 cm H.

64. Bronze, cast. Domed top with gently flaring, solid sides; loop handle at the apex; incised design on the side.

10·3 cm H.

Examples of this type of bell have been found on sites in Assyria and Syria occupied in the eighth and seventh centuries B.C. and are shown in use, pendant from horse-collars, on contemporary Neo-Assyrian palace reliefs. Stray examples have been reported from Luristan, but they may well also occur further north where Assyrian military activity was more common (*Oxford*, No. 153 with references).

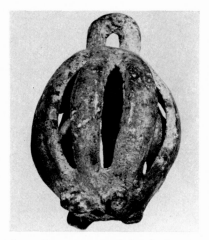

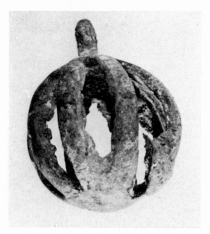

65. Bronze, cast. Spherical cage with 8 bars (one broken); top loop; base repaired, iron stain; single solid jingle.

7·5 cm H.

66. Bronze, cast. Spherical cage with 8 bars (one broken); top loop; no jingle.

6 cm H.

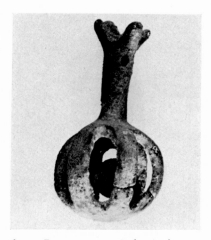

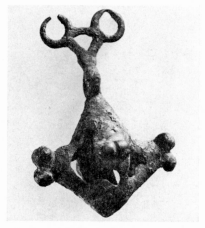

67. Bronze, cast. Spherical cage with 6 bars; solid ball jingle; vertical handle pierced through towards the top which is modelled as an open flower with four petals. (cf. no. 74).

5·5 cm H.

68. Bronze, cast. Triangular cage with stylized rams' (?) heads on each projection; double loop at apex.

5 cm L.

These are bell-shaped jingles designed to fit anywhere on horse-harness, not necessarily pendant from a neck-band like the larger bells. They were manufactured in Iron Age I–II, but whether in Gilan or Luristan is not clear, as simple jingles of this type were widely distributed at that time (cf. *Oxford*, Nos. 433–4).

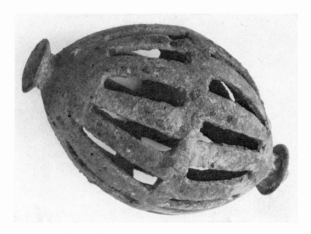

69. Bronze, cast. Large, heavy, oval cage with ribs alternating round a central bar; disk-headed terminal at each end, two solid balls; extensive traces of iron corrosion on the bars.

 17 cm L.

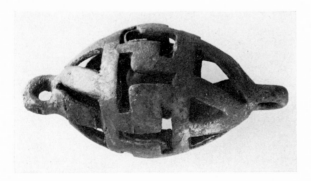

70. Bronze, cast. Oval cage with patterned open-cast sides; loop at each end.

 12·5 cm L.

The date and origin of these bells is not easy to establish. A not dissimilar form was found outside the area of the graves in the excavations at Tepe Giyan in Luristan (*Giyan*, pl. VI. 2, pl. 37.10) and at Zalu Ab in Kurdistan (Godard, *Gazette des Beaux Arts*, LXXV (2), 1933, p. 138, fig. 18). Two very similar bells have been reported, without exact context, as from Luristan (*Barbier*, Nos. 58–9) where this form may have been current during Iron Age II.

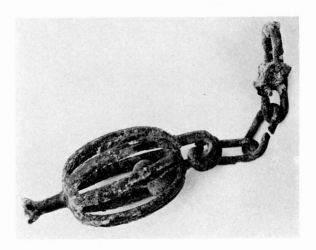

71. Bronze, cast. Open cage of 8 double bars with floral terminal; two solid balls in the cage; five links of suspension chain survive attached to a loop on the bell. Iron corrosion at the end of the chain.

24 cm total length. Bell: 12·5 cm L.

72. Bronze, cast. Oval cage with eight bars; bird-head protome at the front with a small loop at the base of the neck; single solid ball.

8 cm H. 7.4 L.

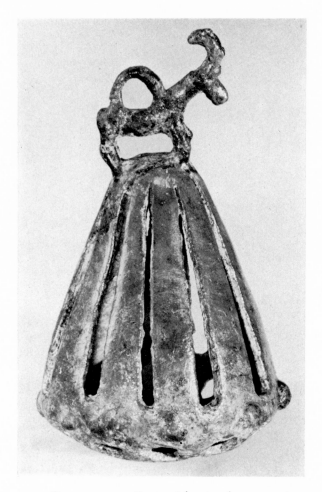

73. Bronze, cast. Cage with nine bars tapering towards the top; a row of knobs is cast round the base-line and the underside of the bell is regularly perforated with square openings; a wild goat stands on the apex with a loop cast on its back. Single solid ball.

10·2 cm H. 6·5 cm across base.

Nos. 72 and 73 were most probably manufactured somewhere in Luristan in the early first millennium B.C. (cf. *Oxford*, Nos. 154, 158); the source of no. 71 is less certain as it lacks zoomorphic decoration, but it is contemporary.

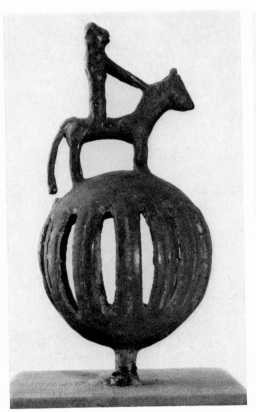
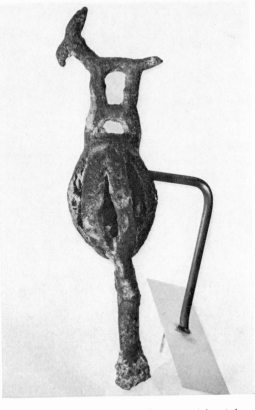

74. Bronze, cast. Spherical cage with twelve bars; solid spherical jingle; horse and rider cast on the top; vertical stem with floral top at the bottom broken off something longer (?). Three solid balls.
 12.5 cm H.

75. Bronze, cast. Oval cage with eight bars: no jingles; wild goat standing on the top; vertical stem at the bottom broken off something longer.
 20 cm H.

These bell-cages were clearly not designed as pendants. The vertical stems suggest terminals for elaborate harnessing in bronze, like the bronze horse collars from the Kaluraz cemetery (Iran Bastan Museum). The style of the decoration, particularly the rider (cf. no. 163), indicate a source in Gilan, probably in Iron Age I–II. They may be ancestral to the more elaborate objects used by the Scythians both in south Russia and eastern Europe (K. Balkay, *Scythian Rattles in the Carpathian Basin and their Eastern Connections*, Budapest, 1971).

III

Finials, Mounts and Decorated Tubes

Of all the bronzes from Luristan none are so distinctive or so striking as the small rampant animals and their more elaborate relatives known as *standard-finials*. These unusual objects have been reported in great numbers from various parts of Luristan since clandestine excavation began there and indeed long before; one such object entered the British Museum as long ago as 1854. They still remain unparalleled outside the region and only a handful have so far been found in controlled excavations within it.

Two main groups may be distinguished: confronted rampant animals with their upper and lower feet joined to form rings through which originally passed a sheetmetal mounting tube, and rampant animals conflated and cast in one with an anthropomorphic central tube, here known as 'master-of-animals' finials. The free-standing rampant animals are generally goats or a very stylized feline creature most akin to the Persian lion. Mesopotamian and Elamite iconography suggest that the goats were mounted with a pin having a floral head so that the animals would appear to be flanking a tree. By contrast the lions would have threatened a human or animal-headed pin. It was from this series that the 'master-of-animals' finials developed in which the central tube becomes a sub-human creature or a nature-demon, half man, half beast, flanked by monstrous feline heads. Each finial, cast by the lost-wax process (see page 31), is unique. This explains their apparently endless variation on the constant theme of 'conflict' between man and predatory beasts with a perplexing medley of multiple faces on the central tube, extra flanking necks and peripheral cocks' heads. The sex of the central figure is often ambiguous and there is no reason to associate it with the Mesopotamian hero Gilgamesh as has become

customary. Indeed even in Mesopotamian art it is far from certain that the hero who protects flocks from predatory animals is to be identified with the hero of local legend known as Gilgamesh.

Although many of the mounted standard-finials in modern collections are dealers' contrivances and easily recognizable as such, there may be little doubt they were originally intended to be set up on the bottle-shaped supports so commonly reported with them from Luristan in the last forty years (see no. 78). Examples have been found corroded together and the Belgian Luristan expedition has now found them closely associated in graves. The two were secured together with a pin passed down the central tube so that the pinhead appeared at the top of the finial. Flat circular-headed pins (see page 125) and cast pins with long shanks and richly decorated heads (see page 122) would have been used for this. The function of these objects may only be guessed at. Their presence in graves and shrines might be taken to indicate that they had a role akin to icons, serving as vehicles of public and private piety. No utilitarian role has ever been suggested for them or indeed seems likely.

Archaeological evidence for the date of the finials is still extremely sparse. At Tepe Tattulban (Chinan) in western Luristan the Belgian Luristan expedition found a 'master-of-animals' finial and its mount in a grave dated by the excavator about 750 to 700 B.C. It had three faces on the central tube.[1] This is almost certainly late in the series, for in the same region at Bard-i Bal, Chinar Bashi, they have found wild goat finials which may be two or three centuries earlier. The date is confused by the re-use of the graves over a period of time.[2] 'Master-of-animals' finials have been reported from clandestine excavations in shrines at Dum Surkh and Tang-i-Hamamlan, both flourishing during Iron Age II–IIIB. As far as it is possible to judge, clandestine excavations have not produced finials from cemeteries or settlements of the late Bronze Age, that is before about 1200 B.C. If, as a number of scholars have argued, there is a definite development over a period of time from the more open-cast, naturalistic caprid finials with separate sheetmetal mounting tubes to the most exotic 'masters-of-animals', cast solid with their central mounting tubes, it lies somewhere between about 1050 and 750 B.C. Much more detailed information from controlled excavations will be needed before we can chart the exact course

[1] Vanden Berghe, *Archeologia*, Sept. to Oct. 1968, p. 63.
[2] Vanden Berghe, *BCHI*, 6, 1971, 14–43.

of these stylistic changes.

Although something is known of Elamite religion, nothing is known—for literary sources are absent—about the myths and creeds of the prehistoric peoples living in Luristan. Most scholars who have tried to interpret the vivid imagery of these finials have assumed that they either illustrate the religious or mythical traditions of Babylonia or Elam, from which some of the iconography ultimately derives, or else of the Iranian tribes whose beliefs were akin to those of the Indo-Aryans. Consequently very divergent interpretations have been offered for the same theme or motif. Since there is as yet no evidence to decide which approach is the right one, if indeed either is truly applicable, it is best to take the objects at face value and not press too far with interpretation. It is often difficult enough to describe the imagery let alone define its religious inspiration. Local traditions, notably the hopes and fears of huntsmen and semi-nomadic pastoralists, may well have provided the essential spring for the myths and invocations which the objects illustrate, without any significant influence from urban civilizations to west and south. In regions like Luristan popular mythology has deep and very ancient roots, as the nature-demons of the Luristan smiths make clear. They had already appeared on seals by the fourth millennium B.C. It will be seen (nos. 96 to 99) that the more elaborate cast bronze pinheads of Luristan, many used as icons in shrines, share much of their imagery with these finials.

The *decorated tubes* are akin in form and function to the finials. They were mounted in the same way and are of the same date.[1] The most common, sub-human in form, reproduce in metal a theme common in baked clay throughout the ancient Near East. Naked female figures with their arms variously placed, modelled free-standing or cast in low relief on plaques, were common in Elam, Iraq and further to the west from pre-historic times. Apart from the universal use of bronze, two features distinguish this motif when used in Luristan. Sex is often ambiguous, perhaps deliberately so, and certain animals and birds, or their heads alone, are so closely associated with the figures as often to be physically a part of them. Although it was not uncommon elsewhere in the ancient Near East for deities to have 'familiar' animals, they are never shown as one with the deity. The regular appearance of the cock in this context, as

[1] For scientifically excavated examples see C. Goff, *Iran*, VIII, 1970, p. 176; Vanden Berghe, *BCHI*, 6, 1971, figure on p. 37.

also on the flanking necks of the 'master-of-animals' finials, is also a peculiarly Persian trait. This bird has a very ancient association with Iran and does not appear in the iconography of Iraq until the end of the second millennium B.C. and then is relatively rare.

FINIALS

CAPRIDS

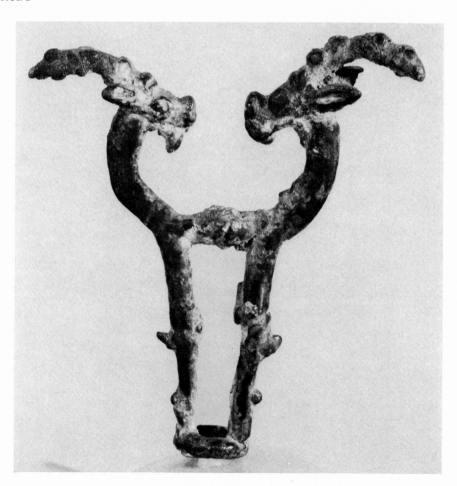

76. Bronze, cast. A pair of rampant wild goats of lithe, natural proportions; each animal is bearded and the characteristic horn protuberances are clearly marked by metal blobs. There is a ring between the forepaws and the base.

9 cm W. 9 cm H.

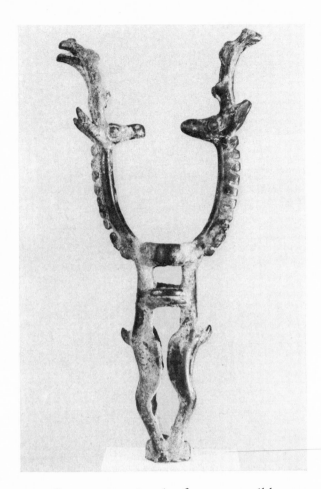

77. Bronze, cast. A pair of rampant wild goats
with attenuated necks. The animals are not
bearded, though the horns have clearly marked
protuberances. Each animal has a mane made up
of circular blobs running the length of the neck.
There are the usual open rings joining the forefeet
and the base; but also a third in the centre of the
bodies.

 15 cm H. 7 cm W.

 Calmeyer, Gp. 30, pp. 58 ff; *Oxford*, Nos.
 161–2 (with references).

 Both these finials conform to a type very commonly reported from Luristan;
the only feature in any way unusual is the third ring on no. 77.

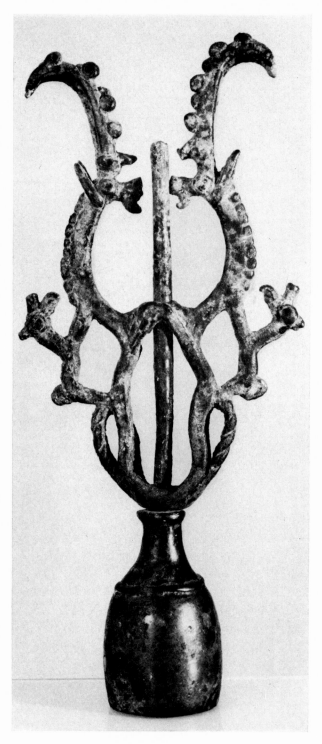

78. Bronze, cast. A pair of rampant ibexes with their fore and rear feet resting on horizontal rings. Short thin bodies with long hind legs, twisted rope-like tails and stubby forelegs. Long, upstanding ears, prominent eyes, elongated muzzle and beard; disproportionately long, curving horns with the natural ridges marked by blobs. Standing on each animal's back is a 'carnivore', roughly modelled with a curly tail.

Mounted with a piece of sheet-metal tubing to a bottle-shaped support. The pieces are all ancient and the assembly correct, but it is likely to be a modern one, as the parts are not corroded together.

21·5 cm total H. Finial: 15·2 cm H.

cf. *Oxford*, Nos. 163–4 with further comparisons.

Caprids of such a type, elongated with elaborate horns and twisted tails, form a distinct group amongst the finials of Luristan. If the most natural ibex finials appeared at the end of Iron Age I (see page 104), these may belong to an advanced date in Iron Age II, late in the ninth century B.C., when many of the bronzes from Luristan developed more exaggerated forms. Despite the dog-like character of the beast on the back of these ibexes, it is most probably a very stylized lion as on more explicit examples.

EQUID

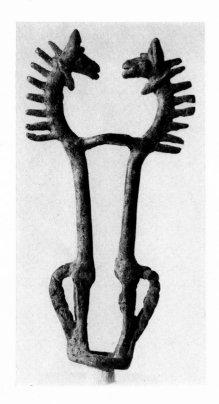

79. Bronze, cast. Stylized equids with disproportionately elongated bodies; each has tall, pointed ears, neck pendant, projecting spiky mane and plaited tail. Rings at shoulder level and below the feet.

13 cm H. 6·5 cm W.

Equids appear much more rarely on standard-finials than various caprids and the lion (compare *SPA*, IV, pl. 45D; *Schimmel*, No. 68; *Bulletin of the Fine Arts Museum*, Minneapolis, March 1962, pp. 4 ff, no. 61.67.4 (plate); unpublished: Ashmolean 1969.648). The stylization of the animal used here is found on some of the cheekpieces for horse-bits cast as animals.

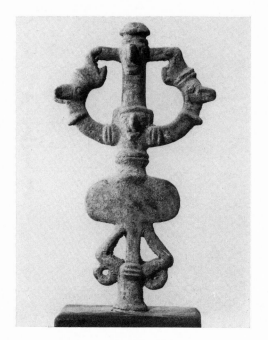

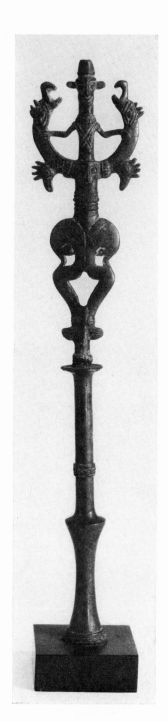

80. Bronze, cast. Squat form of the master-of-animals with two faces on the central tube; the flanking leonine heads are stylized, but unelaborated. Apart from ridges on the animals' necks and a girdle there is no surface decoration. The central figure has no arms, unlike nos. 81 and 82. The modelling is distinguished by the sharp lines and squarish form of the central anthropomorphic tube and flanking animals.

14·6 cm H.

81. Bronze, cast. Elongated master-of-animals set on a tall bottle-shaped support, possibly its original stand. There are two faces on the central anthropomorphic tube, which wears a necklace, and crossing-straps on the chest and girdle. The flanking heads, grasped by the hands of the central figure, have leonine jaws and a cock's comb. A cock's head faces outwards at the base of each neck. Sinuously delineated animal haunches.

36 cm H.

82. Bronze, cast. Elongated master-of-animals with three faces on the central tube, which has bands of encircling ridges between each face. The flanking heads, grasped by the hands of the central figure have very stylized cocks' heads with leonine jaws. A cock's head faces outwards at the base of each neck. A notched ridge runs up each flanking neck, at an angle, from below the lowest face.

20 cm H.

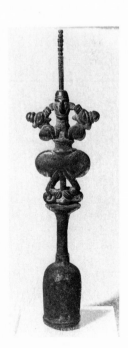

These finials have all the standard features of this series, regularly reported from Luristan (*Oxford*, pp. 153 ff, for references).

83. Bronze, cast. Anthropomorphic central tube with feline legs and haunches. On either side, at shoulder level, are the head and shoulders of a 'gnome-like' creature looking upwards towards the face at the centre of the tube. There is a prominent, central girdle. Mounted on a bottle-shaped support. The pin securing the finial to the support is typical of Luristan with its nut-shaped head and bead-and-reel mouldings, but the association is not ancient.

11 cm H. of finial. 12·5 cm H. of support.

This finial is very like the one in the Ashmolean Museum, Oxford (*Oxford*, No. 183 with references) which has exactly the same creature flanking the central head. Their relation to the usual caprid or feline heads is obscure, since they have no clear animal characteristics.

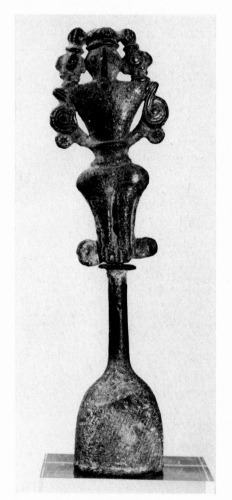

84. Bronze, cast. Mounted, almost certainly in modern times, by a piece of ancient sheetmetal tubing on to a bottle-shaped support. The central tube has a sub-human face, wedge-shaped torso and girdle with animal haunches, legs and tails. Two grotesque heads are set vertically, one on each shoulder, and a leonine head with prominent eye-coils rises from a short neck set on either side of the girdle.

10·5 cm H. of finial. 9·3 cm H. of support.

A very unusual finial, which is clearly related to the 'master-of-animals' series, where a sub-human upper body rises from the haunches of opposed animals; but in this case the flanking leonine necks are greatly reduced in length to allow for other heads on the shoulders.

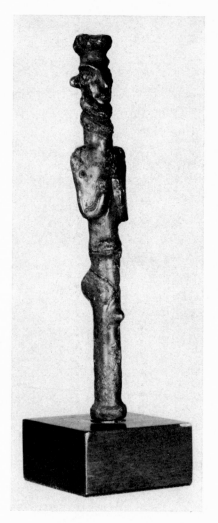

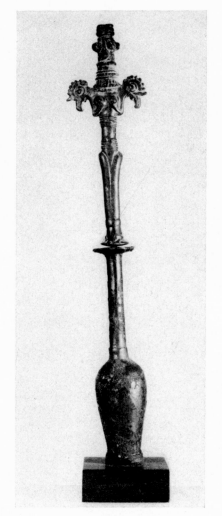

85. Bronze, cast. Figure with arms bent at the elbow, hands held flat on breasts. Double, or coiled, necklace, girdle and clearly delineated pudenda.

14·2 cm H.

86. Bronze, cast. Female figure clasping her breasts; cock's head on each shoulder facing out-wards. Elaborate necklace and double girdle in relief. Set, in modern times, on a bottle-shaped support.

33 cm H. 16·5 cm H. of finial.

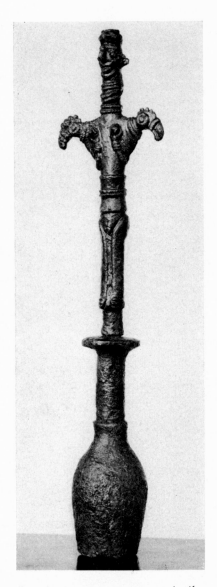 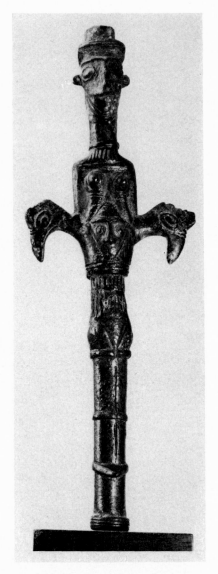

87. Bronze, cast. Very similar to the previous example, varying only in the shape of the necklace and girdle. Floral pin of ancient manufacture used to secure the finial to a mount in modern times.

33 cm H. 16 cm H. of finial.

88. Bronze, cast. A slightly more elaborate version of the design represented by nos. 86 and 87. In this case, a second face appears on the abdomen of the central figure and the back is decorated with a double ridged device.

15·6 cm H.

Decorated Tubes

These tubes belong to a group well represented among the bronzes from Luristan ever since the earliest days of clandestine excavation in the region (*Oxford*, pp. 161 ff). The only unusual feature is the second face on no. 88. Multiple faces appear on 'master-of-animals' finials, but are rarer on these anthropomorphic tubes (for discussion see page 105).

IV

Pins, Personal Ornaments and Cosmetic Equipment

———

Although the objects assembled in this chapter are miscellaneous, taken together they illustrate well the often random selection of material yielded by clandestine excavators. Simple pins and personal ornaments were amongst the earliest objects to be made of metal in western Persia and deposited in graves from the early third millennium onwards. They were particularly numerous, both in Luristan and Gilan, between about 1200 and 800 B.C., but survive even when the range of metalwork placed in graves conspicuously declined from the Achaemenid period onwards. With personal ornaments, notably the plainer bracelets, anklets and torcs, it is often impossible to decide whether they were made in Luristan or in provinces northwards to Azerbaijan and Gilan. Scattered evidence from controlled excavations throughout western Persia indicates that they were used in many places over a long period of time.

PINS

As straight *pins* occur in western Iran in considerable quantity and with a great variety of forms and decoration their chronology is of outstanding interest for the history of local metalworking. Only very slowly and intermittently are controlled excavations inside Iran providing a closely dated series of pin-types. Unfortunately, unlike the equally common and various weapons, this may not easily be supplemented with comparative evidence from the west, since there

also it is still relatively meagre and widely scattered in time and place. The problem is complicated by the numerous richly decorated pinheads from western Persia for which there are no parallels to the west.

Three main groups of pinheads have regularly been reported from western Persia:

I. *Heads cast as geometric forms (disks, domes, cones etc.), floral or zoomorphic devices (nos. 89 to 95).*

Unlike the following two groups these pins are distinctive neither of Luristan nor of Amlash alone, nor with rare exceptions are they as yet very closely dated. Western Persia, notably Luristan, is remarkable for the range and elaboration of decoration found there on bronze pinheads, particularly in the earlier Iron Age. Only Caucasia it seems supported a comparable, if distinct, range. Though the geometric forms may often be paralleled to the west, the floral and zoomorphic designs are generally unknown outside Persia. Within that wide area it is usually impossible to localize them accurately. It is only with the appearance of stylistic traits evidenced on other bronzework from Luristan that the products of local workshops may be securely identified (see for example no. 94). With the introduction of *fibulae* (safety-pins) from the west in the eighth century B.C. straight pins slowly passed out of production.

II. *Large openwork cast bronze heads, usually on an iron shank, with semi-human figures and animals set in square or crescentic frames (nos. 96 to 99).*

Pins of this type were found in some quantity in levels of the eighth and seventh centuries B.C. in the shrine at Dum Surkh.[1]

III. *Flat heads, normally circular, of hammered sheet bronze or copper with chased and repoussé designs.*

These pins are again particularly characteristic of Luristan in Iron Age II–IIIB and were found with pins of group II in the shrine at Dum Surkh. No. 100 illustrates the cruder pins of this type. The most elaborately decorated are among the finest examples of the Luristan bronze-smiths' craft: no. 101 is one of these.

[1] M. van Loon, *Bibliotheca Orientalis*, XXIV, 1967, 23 ff.

West Persian pins served a number of roles. Most of them were garment fasteners, though a few of the lighter ones may have served as hair-pins. Some pins with elaborate cast (see no. 99) or hammered disk heads have a shank rising from the upper edge. These, as clay figurines from Susa show, were worn with the design on the breast and the point passing through folds on the shoulder to emerge near the face. The function of long-shanked pins in securing the finials to their mounts has already been discussed (see page 104). Pins, particularly of groups II and III, were deposited in shrines as votives.

PINS, GROUP I

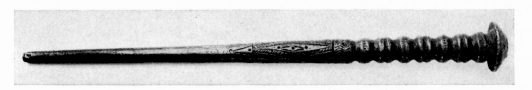

89. Bronze, cast. Flat domed head; upper shank decorated with bead-and-reel mouldings elaborated with traced linear patterns which extend below the moulded part of the shank; point missing.
 33 cm L.

This enormous object, perhaps of Iron Age II–IIIB, is unlikely to have been a garment pin; it is better described as an ornamental peg.

90. Bronze, cast. Conical head; concave neckbroad moulding; triple reel; traced patterns on upper shank.
 18·8 cm L.
 cf. *Oxford*, Nos. 260–70.

91. Bronze, cast. Stylized floral head; plain shank.
 19 cm L.
 cf. *Oxford*. No. 301 (a pair).

Nos. 90 and 91 were probably made in Luristan in Iron Age I–II.

92. Bronze, cast. Five pins virtually identical save in size; double-spiral heads. The upper shank has been hammered slightly, split and then coiled round on either side. Moulded and traced linear decoration just below each head.

7·7 cm, 8·7 cm, 11·3 cm, 11·4 cm, 15·5 cm L.

These spiral-headed pins belong to group 'C' in Huot's recent scheme, though he publishes nothing exactly like them (*Syria*, XLVI, 1969, pp. 57 ff). Examples from Iran usually have heads more heavily hammered into sheet before the spirals are cut into them than do these which may be from a site in northern Iran, where Caucasian cultural influences were strong in the late Bronze and early Iron Age.

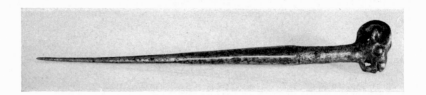

93. Bronze, cast. Upper shank is of rectangular section and terminates in a goat's head the horns curved round to meet the shank. Incised decoration on the upper shank.

16·7 cm L.

cf. *Oxford*, Nos. 337–8.

A similar type of pin from the cemetery at Marlik (*Marlik*, fig. 131) indicates that this is of north Persian origin, manufactured in early Iron I.

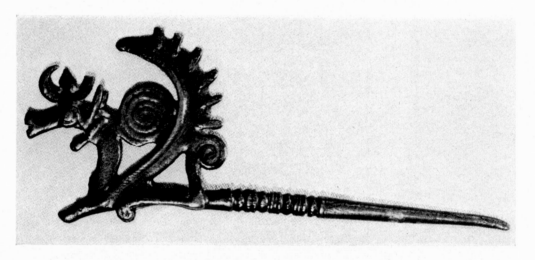

94. Bronze, cast. The upper part of the shank is decorated with bead-and-reel mouldings. The head of the pin is modelled as a winged monster; the wing is boldly curved with prominent ridges set at regular intervals; a back lock curls round to fill the space between neck and wing. The animal wears a collar with bells or pendant; on its head is a pair of horns with a central protuberance very similar to that sometimes worn by the master or mistress-of-animals (cf. no. 96).

14 cm L. 5 cm H.

A number of such pins have been reported as being from Luristan (*Oxford*, Nos. 328–32). The bead-and-reel decoration is commonly found on plainer

pins manufactured in the region in the earlier first millennium B.C. The creature represented is possibly of Elamite origin, as it appears on glazed bricks at Susa (E. Porada, *Ancient Iran*, p. 69, lower). The date of the bricks and the baroque style of the casting suggest that this pinhead belongs to the final phase of the Luristan bronze industry in the later eighth or earlier seventh century B.C.

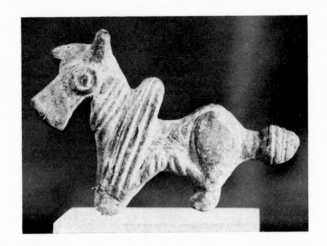

95. Bronze, cast. Head in the form of a winged equid couchant with legs drawn in under the body; originally on an iron shank. Prominent forelock, pointed ears, ribbed collar, heavily striated wings; casting fount below rear legs. The eye is rendered by a blob within a circle as on the cheekpiece no. 42.

 7 cm L. 4·5 cm H.

Pins of this form are regularly reported from Luristan though they vary in details (*Oxford*, Nos. 324–7). The existence of exactly the same type of pinhead entirely in iron indicates that these pins belong to the later ninth or eighth century B.C.

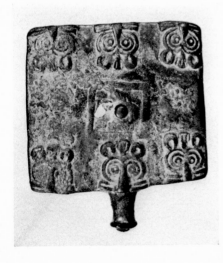

95A. Bronze, cast. Solid square head with a central blob set in a square frame marked out by a ridge; here a small casting fault. Three lion masks of the most stylized linear form favoured in Luristan are set along the upper and lower edges facing outwards; shank originally iron.

 7·3 cm L.

 Weill, No. 228 (*Amiet*, 175).

The use of the linear lion mask on this pinhead associates it directly with a series of bracelets (*Oxford*, pp. 223–4) and pins (*Oxford*, pp. 194–6) on which such designs decorate terminals and heads, sometimes cast onto iron hoops or shanks. They are a typical product of Luristan metalsmiths in Iron Age II–IIIB. Solid cast, square pinheads from Luristan are uncommon and there is no exact published parallel to this one.

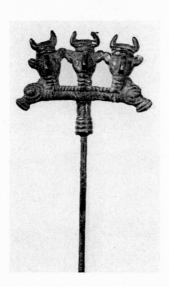

95B. Bronze, cast. T-shaped pinhead with three grotesque faces, each with a pair of horns, set on a groundline terminating in profile lion heads with prominent eye coils; exceptionally long shank.
　62 cm L.
　Weill, No. 230 (*Amiet*, 177).

This pinhead, of most unusual form, combines two motifs particularly frequent in the imagery of the Luristan smiths in Iron Age II–IIIB. The horned devil appears singly on horse-bits (*SPA*, IV, pl. 29B), on bottle-shaped supports for finials (*BL*, pl. LI. 192), on figured tubes (*SPA*, pl. 46D), and on a wide variety of pins, whilst the lion heads with linear eye coils are so common as to constitute a hallmark of the classic Luristan bronze style between the ninth and seventh centuries B.C. The two motifs quite often appear together when the horned devil appears as a 'master-of-animals' flanked by rampant lions, almost always highly stylized, on occasion even winged. The great length of this pin's shank may be taken to indicate that it was designed to pass down the tube of a finial securing it to a bottle-shaped support and then, originally, to the ground upon which the whole mounting was set (see no. 84 here; for mounting, page 112).

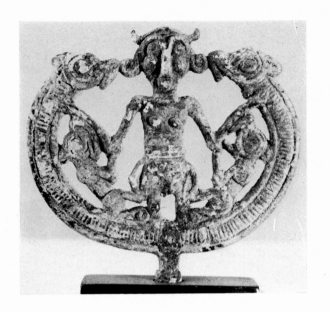

96. Bronze, cast. Openwork crescentic frame terminating in feline heads with prominent eye-ridges; originally on an iron shank. The whole of the frame is regularly ribbed between inner and outer margins. Central female figure with crescentic horns and curling side-locks; ribbed necklace and girdle, otherwise naked; elongated arms extended to touch the frame. A rampant lion with prominent eye-ridges is set on either side between the frame and the central figure's arms.

8·5 cm H. 8 cm W.

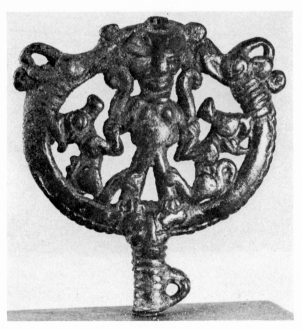

97. Bronze, cast. Original shank of iron. Openwork crescentic frame terminating in the heads of horned animals, probably wild goats, with ribbed collars, which threaten a central sub-human female figure with crescentic horns flanked by small rampant goats. The central figure is very crudely rendered with arms extended upwards to touch the haircurls. There is also a crudely rendered grotesque face at the junction of shank and head. Loop on the upper shank to right.

6·7 cm H. 6·3 cm W. (head only)

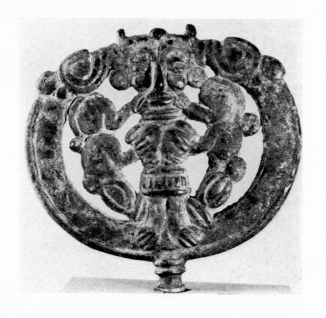

98. Bronze, cast. Originally on an iron shank. Openwork crescentic frame terminating in feline animal heads, with prominent eye-ridges, which threaten a central sub-human figure, with crescentic horns and curling side-locks, flanked by inverted feline animals with almond-shaped eyes. The central figure has no arms and wears a knee-length tunic.

7·5 cm W. 7·5 cm H.

A whole series of pinheads from Luristan are cast as a 'master-(or mistress-) of-animals' flanked by rampant or inverted lions within a crescentic frame with zoomorphic terminals. They are particularly associated with the Dum Surkh shrine in the eighth century B.C. The basic theme, however, is subject to infinite variations of modelling, decorative detail and proportion, well illustrated by these three examples. Though a lion mask often appears at the junction of shank and head, no. 98 shows that it is not an invariable part of the imagery. The zoomorphic terminals also vary; sometimes as on no. 97 they are caprids, or as on nos. 96 and 98, felines. Though no explanation is possible, it may be noticed that this is exactly the variation found on the finials. There may be little doubt that the more elaborate pinheads of this type were also designed primarily to serve as icons, not garment fasteners.

99. *See colour plate opposite.*

This pinhead, no. 99, like many of the type reported from Luristan, has the shank rising from the top of the design not the base as might be expected. It seems too large to be anything but a votive pin similar to the more elaborate ones found in the Dum Surkh shrine. Although very much more elaborate the theme of the design is exactly that on the previous three pinheads. Not one of the large pinheads of this type so far reported from Luristan is quite like another,

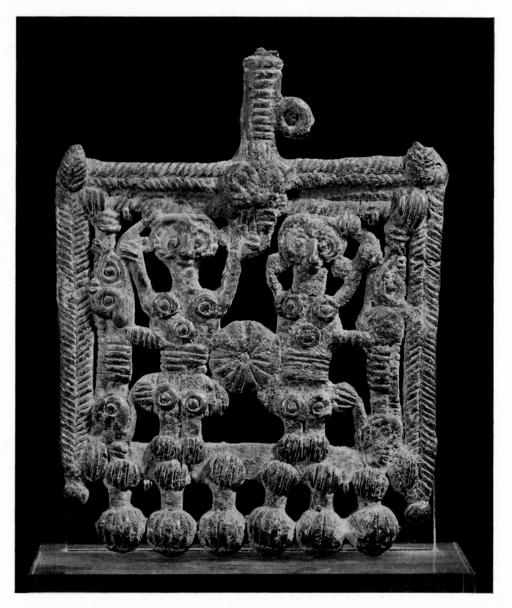

99.　Bronze, cast. Originally set on an iron shank rising from the upper edge of the frame; one side loop on upper shank. Elaborate square frame of plaited design with a linear lion-mask cast at the juncture of head and shank. Within the frame two sub-human creatures with raised arms flanked on the outside by rampant feline creatures modelled in the highly stylized Luristan manner. The casting of these creatures is distinguished by the prominent concentric circles marking breasts, navel and knee-caps. Six pendant blobs, boldly striated, along the lower edge may simulate fruit or berries of some kind.

　　13·5 cm H. 10 cm W.

though they all use the same basic combination of figures and animals (cf. *BL,* pl. XXXVII. 158–9; *SPA,* IV, pl. 40B; R. Ghirshman, *Iran: Parthians and Sassanians,* 1962, figs. 330–1).

PINS, GROUP III

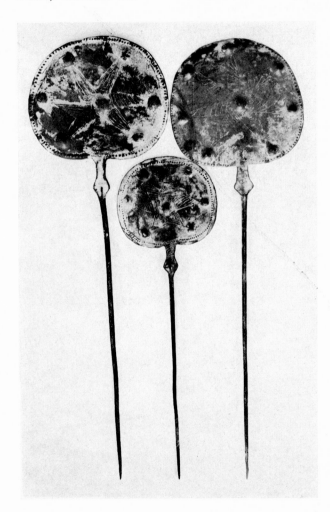

100. Bronze. Hammered disk head with plain shank; oval swelling just below the head; three pins with heads of varying size all with crudely chased six-pointed stars, with repoussé blobs at the end of each arm and one in the centre.

 Disk: 9 cm H. 10·5 cm W. 23·9 cm L. of shank.

 Disk: 9·7 cm H. 10 cm W. 23·6 cm L. of shank.

 Disk: 6·5 cm H. 7·5 cm W. 17·3 cm L. of shank.

Among the more crudely decorated disk-headed pins manufactured in Luristan in the earlier first millennium B.C. this is a favourite design (*Oxford,* Nos. 354–5), perhaps because, as elsewhere in western Asia at the time, the star was a symbol of the local fertility goddess.

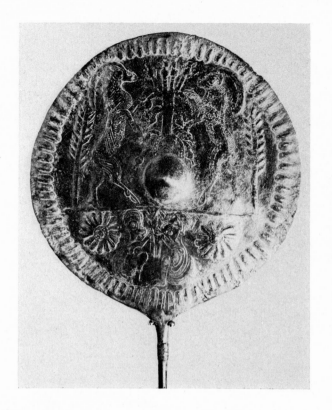

101. Bronze. Hammered disk head with plain shank; conical central boss. The margin is decorated with a stylized repoussé frieze of leaves or petals. The main field is divided into two unequal registers by a horizontal line set just below the boss. Above: rampant goats flank a central plant with buds springing from it; behind each goat is a further leafy branch or stylized tree. Below: rosettes flank a pair of facing semi-human creatures squatting on their haunches and proffering floral tributes or branches to one another. Iron staining on edge and back.

24·6 cm L. 10·3 cm D.

Although a number of such pins as this have been reported from Luristan, their heads decorated with animals rampant on either side of a tree, they normally occupy the whole field of the pinhead (*Illustrated London News*, 6th May 1939, p. 791, fig. 2; A. Godard, *L'Art de l'Iran*, 1962, figs. 39–40; R. Ghirshman, *Bichâpour*, 1956, II, fig. 27b; *Berytus*, XIV, 1961, pl. I (2); Herzfeld, *AMI*, 8, 1937, fig. 118, top right; S. Lloyd, *The Art of the Ancient Near East*, 1961, fig. 193 rt.; Brussels, Musée Cinquantenaire o.2165, o.2193; Israel Museum M.5742.9–53). The central tree is characteristic of such devices on these pinheads, with plain vertical trunk and random branches, and has Elamite precursors. The patterned goats' bodies and the rosettes are also common enough, but a conical boss is much rarer than a patterned round one or a semi-human face at the centre of the pinhead. Although the squatting creatures appear singly on other pinheads of this form (Ghirshman, *Bichâpour*, II, fig. 28, rt.; Potratz, *AFO*, XV, 1945–51, p. 49, fig. 4; Dussaud, *Syria*, XXVI, 1949, fig. 7; *AAAO*, fig. 103) their significance remains totally obscure. Pins such as this were made in the eighth to seventh centuries B.C.

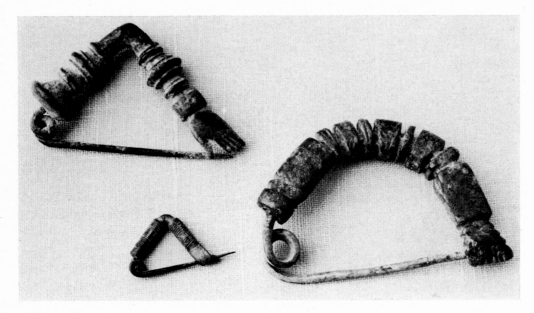

102. *(right)* Cast, bronze. Semi-circular bow decorated along its entire length with heavy rectangular and disk mouldings; complete pin and catch-plate.

 4·5 cm H. 6·9 cm W.

 cf. Stronach, *Iraq*, XXI, 1959, pp. 189–90, fig. 5·3.

103. *(top left)* Cast, bronze. Elbow-shaped bow with prominent circular mouldings on each arm; complete pin with catch-plate cast in imitation of a human hand.

 3·7 cm H. 6·4 cm W.

 cf. *BL* pl. XXIX. 10; Stronach, *Iraq*, XXI, 1959, pp. 197–200.

104. *(bottom left)* Cast, bronze. Tiny triangular shaped bow with cylindrical, striated moulding on each arm; complete pin and catch-plate.

 1·6 cm H. 3 cm W.

 cf. Stronach, *Iraq*, XXI, 1959, p. 195, fig. 7·6.

All three of these fibulae belong to large groups of comparable form used widely in the Near East from the seventh to fifth centuries B.C., in some cases even later. Fibulae have been excavated from Iron Age IIIB levels at Baba Jan and War Kabud in Luristan.

PERSONAL ORNAMENTS AND COSMETIC EQUIPMENT

The following objects are a varied selection of the bronze personal ornaments used in western Iran in the earlier first millennium B.C. and cosmetic equipment from Achaemenian and Parthian sources.

ANKLET

105. Bronze, cast. Very heavy open-ended ring with flat, flared terminals; linear cavity on the inside of the hoop; hemi-spherical section.
14 cm W.

Exactly this type of anklet has been reported from clandestine excavations in the Hulailan Plain in central Luristan (*IA*, IV, 1964, pl. VII. 2), but no reliable information on their date yet exists. If the supposed associations in this case can be relied upon the later second millennium B.C. is indicated. It is still not at all clear when these objects are found out of context whether they were primarily personal ornaments, some kind of currency passing by weight, or even just ring-ingots (see *Oxford*, pp. 227–9).

BRACELETS

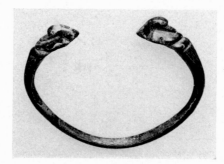

106. Bronze, cast. Open-ended with terminals in the shape of resting ducks, their heads turned back to lie along their spines. Incised lines and pendant triangles immediately behind the bird. Hoop of rhomboid section.
7·4 cm W. 7 cm H.
cf. *Oxford*, Nos. 374–80.

This finely cast bracelet is typical of a large group commonly reported from Luristan with terminals cast as sleeping ducks. They do not appear distinctive of the region since the same design appears further north. They may be regarded as a typical product of Iron Age II–IIIB in central western Iran. An example was found in tomb 64 at Bardi-i Bal (*BCHI*, 1971, fig. 34) in Luristan.

107. Bronze, cast. Open-ended with terminals cast in one with the hoop as simply modelled lion-heads; strong circular-sectioned hoop, iron stained.

 8·5 cm D.

 cf. *Oxford*, No. 386.

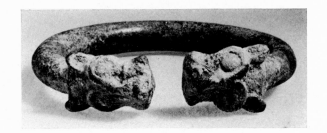

These are among the more natural lion-headed terminals represented on the bracelets reported from Luristan, where a more stylized form of this animal's head was much favoured. The fashion for bracelets with lion-head terminals was popular both in Assyria and Urartu from at least the ninth century B.C. (*Oxford*, pp. 220–1; K. R. Maxwell-Hyslop, *Western Asiatic Jewellery c. 3000–612 B.C.*, 1971, pp. 246 ff). This bracelet was probably manufactured in Iron Age II somewhere in Luristan.

108. Bronze, cast. Open-ended with doubled animal terminals, possibly a wild boar, though the details are now very worn. Plain hoop of circular section.

 7·5 cm W.

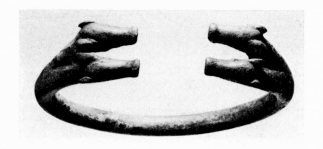

Bracelets with multiple zoomorphic terminals have been reported from Luristan in the past (*BL*, pl. XXVII. 87; *AFO*, IX, 1934, pl. V. 9), but there is nothing to associate this example with any particular part of western Iran, where it was probably made in the earlier first millennium B.C.

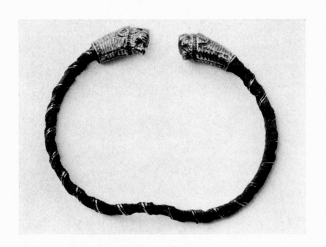

109. Bronze, cast. Semi-circular sectioned hoop with a very slight irregularity in the hoop opposite the opening; the hoop was originally bound round with gold wire, much of which survives. Two finely made and well-preserved lion-head finials in sheet gold form the terminals.

7·3 × 6·1 cm.

The oblong form and the distinctive kink in the hoop of this bracelet indicate a date in the Achaemenian period (P. Amandry, *Antike Kunst,* 1, 1958, pls. 8.5, 9.7). The terminals, though the lions' jaws are open, are not the roaring beasts normally found on Achaemenian bracelets (ibid., pl. 9.9, 11) and long favoured in western Asia. They are a more benign rendering of the beast which is matched on the handle of a gold jug in the Oxus Treasure (O. M. Dalton, *The Treasure of the Oxus,* pl. VII), and on earlier objects from Iran, suggesting a local source. The bracelet was reported to be from Iran and was almost certainly made there, not in a western province of the Achaemenian Empire as were so many of the contemporary bracelets so far known. Another pair of bracelets from Iran, now in Oxford (*Oxford,* Nos. 393–4), with regular hoops, are also made of bronze with sheet gold lion-head terminals and silver wire binding on the hoop. To judge from parallels at Marlik (*Marlik,* fig. 73) these bracelets belong to Iron Age I, about five hundred years earlier than no. 109 here. Though the chronological gap may be exaggerated, there is no doubt that this parallel offers another link in the growing chain of evidence which

suggests that local Iranian jewellers of the Achaemenian period owed much to a tradition which may be traced back to the craftsmen employed by the men buried at Marlik.

TORCS (neck-rings)

110. Bronze, cast. Open-ended with terminals slightly turned back. The hoop swells and has a slight ridge opposite the opening; incised linear decoration on the swelling.

15·1 cm W.

111. Bronze, cast. Open-ended with trumpet-shaped terminals; plain, thin circular-sectioned hoop.

19·2 cm W.

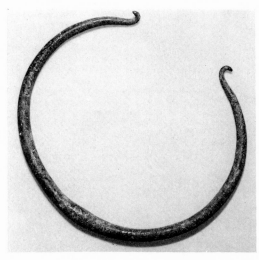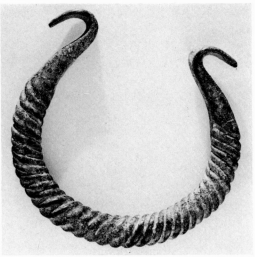

112. Bronze, cast. Open-ended with flat terminals turned back; hoop swelling slightly opposite the opening; incised linear decoration on the swelling.

13·5 cm W.

114. Bronze, cast. Heavy, spirally ribbed hoop; terminals hammered flat and turned over.

13·5 cm W.

113. Bronze, cast. Open-ended with loop terminals; twisted hoop of even width all round; iron staining on the lower part of the hoop.

12·7 cm W.

cf. *Oxford*, Nos. 410, 535–6.

115. Bronze, cast. Light spirally twisted hoop, flat, slightly swollen terminal pierced with a small hole.

15·1 cm W.

116. Bronze, cast. Plain, closed hoop swelling along the lower edge; closed at the top with a simple fitting which allows the ring to be enlarged slightly to pass over the wearer's head.

16·5 cm W.

Archaeological evidence for the history of the torc in western Iran is still scanty. Twisted torcs occurred in cemetery 'B' at Tepe Sialk (*Sialk*, II, pl. XCIII S. 1754) and a variety of plain ones have been reported from sites of Iron Age I in northern Iran (*Khurvin*, pl. XLI. 290; *Découvertes Fortuites*, figs. 32, 44g (Gilan)). No examples have yet been published from controlled excavations in Luristan, though their presence in the province is indicated by a steady flow of examples from clandestine excavations (e.g. *BL*, pl. XXVI. 78–80; *IitAE*, pl. XXX). De Morgan argued that bronze torcs passed from use in Talish with bronze tools and weapons (*LPO*, III, p. 275) in a period which would now be defined as Iron Age II; but at Persepolis both Medes and Persians are shown wearing plain and twisted torcs (*Persepolis*, I, pl. 52).

Nos. 110 to 116 are typical of the torcs revealed recently by clandestine excavations in the Amlash region, where they seem to have been particularly popular from Iron Age I–II.

BELT-HOOK

117. Bronze, cast, corroded. T-shaped hook projecting from a rectangular frame with a bar across the centre; four animals, perhaps goats, are modelled in relief standing on the plaque, their rear legs nearest the hook, their forelegs set on the central bar.

7·5 cm L. 6 cm W.

It would appear that this object was used as the tongue of a buckle-fitting with a leather strap passed through the bar in front of the animals' heads and sewn down. Rather similar objects, decorated with the highly stylized lion which is the hallmark of Luristan bronzework in Iron Age II–IIIB, have appeared on the art market (*Barbier*, Nos. 60–1, pp. 70–1 for illustrations). This example, from the same collection (*Barbier*, No. 157, p. 120), is stylistically more likely to come from Gilan and, if not contemporary with the Luristan examples, is likely to be slightly earlier.

BELTS

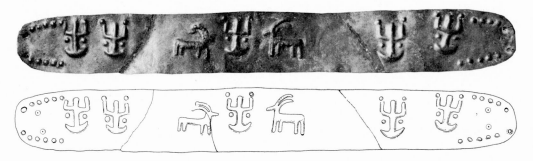

118. Bronze, sheetmetal. Rectangular strip with rounded ends, each pierced with a pair of holes one above the other; very short upper and lower margin of repoussé blobs at either end. At each end set back from the terminal is a pair of very stylized human figures drawn in repoussé lines with arms raised on either side of the head and legs boldly curved as if the figure was squatting on its heels. There is a repoussé blob on either side of the waist and above the fists. An exactly similar figure in the centre of the belt is flanked on either side by a standing goat or mouflon. Repaired.

48·2 cm L. 6 cm W.

The highly stylized figures on this belt suggest a north Iranian source within reach of direct influence from the Caucasus during the earlier first millennium B.C. (see *Oxford*, pp. 241–5).

A figure stylized exactly like the one on this belt appears on a sheetmetal disk found on the island of Samos, off the south-west coast of Turkey. It has been attributed to a workshop in Syria or south-east Turkey, but might well also come from Caucasia whence other artefacts certainly came to Samos in the seventh century B.C. (U. Jantzen, *Samos*, VIII (1972), pl. 56 B.264).

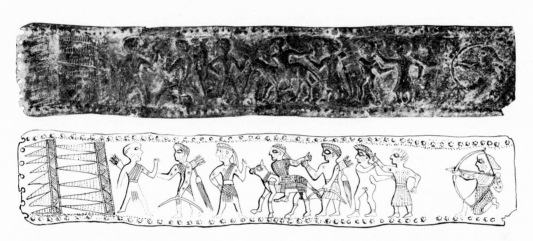

118A. Bronze, sheet. Rectangular strip with one straight end pierced with eight small holes; the other end, and a substantial part of the belt, are lost; upper and lower margin of repoussé dots. Two bands of narrow horizontal triangles, filled with stippled decoration, set on cross-hatched base-lines; then chased in sequence from left to right: standing male figure in profile looking right with left arm raised; facing him a man carrying a bow by his side in his left hand and holding his right extended towards the man before him; he has a quiver strapped to his back and from it dangles what seems to be an animal's tail; then a man moving to right but with his head turned back looking over his shoulder; he holds his right hand on his hip and leads an ass, by a rope attached to a ring in the animal's nose, with his left hand; a man rides the ass, his left hand extended back to be grasped by the right hand of a following archer exactly like the one shown earlier; then a standing nude man facing left, his hair grasped by a dressed man standing behind him; then an archer kneeling to take aim.

5·2 cm H. 29 cm L.

Dussaud, *Syria*, XV (1934), fig. 3, p. 192; *Weill*, no. 252 (*Amiet*, 193).

Among the few decorated sheet bronze belts so far published from Luristan, where they were made in the eighth or seventh centuries B.C., this stands out by virtue of the narrative element in the design; the others merely show animals (*Oxford*, No. 461) or hunting scenes (Dussaud, *Syria*, XV (1934), pl. XXV). Although, in the absence of any text, exact description of the theme is precluded, its general character is not in doubt. It is the group on the extreme right which offers the key. Here a captive, represented nude as always in such scenes, is held ready by a guard for execution by the bowman already kneeling to take aim. On a contemporary, eighth or early seventh century, Neo-Elamite basalt statue-base from Susa is carved a comparable scene of military triumph, though here the detail is greater (Amiet, *Elam*, pl. 410 A–C). In this case bowmen bring forward nude captives for execution, but the job is done by a man wielding an axe, not by an archer. The same method of execution is shown on the enigmatic steatite 'Monument en cloche' found in levels of the earlier first millennium B.C. at Tepe Giyan in Luristan (G. Contenau and R. Ghirshman, *Fouilles du Tépé-Giyan*, pl. VIII, pp. 54–6); an archer appears in the same sequence, but firing at a lion attacking a mouflon. The only parallel I know for execution by archer is shown on a cylinder seal made in Syria in the middle of the second millennium B.C. It shows a mythological hero hunted with dogs and about to be despatched by an archer who takes aim, whilst another figure grasps the hero's hair (Coll. Poche No. 80; Weber, *Siegelbilder*, fig. 268; H. Frankfort, *Cylinder Seals* (1939), pl. XLIVe). Although there is no certainty, it seems most likely that the rest of the scene on this belt shows an earlier stage in the action when the man, later to be executed, is brought on an ass before his captor for judgement. Since in Urartu and Caucasia such metal belts have been found in warriors' graves, it may be assumed that this belt was worn by such a man and may well illustrate an actual incident in his military career rather than a scene from myth or legend. The strange animals and demons, half man, half beast so often found on other decorated sheetmetal objects from Luristan are conspicuously absent here.

Two details are of some interest: the unusual way in which the bow is held when not in use by the two archers acting as escorts (compare the archers on no. 22 in this collection) and the long animal's tail (? a fox's) pendant from their quivers. The style of the figures on this belt may be a provincial derivative from work like that on the well known group of decorated situlae from

Luristan (see nos. 134–5 here; notably the archer on 134).

An X-ray photograph, kindly taken by the British Museum, shows that this belt is restored, accurately save in one instance. There is a straight joint immediately in front of the archer. To the left of this juncture is the raised arm of a standing figure now lost. It is clear that a portion of the belt was lost here, presumably by the clandestine excavators, and the archer moved up to a more forward position in the design. He seems stylistically to be part of the same belt and fits well into the context.

ABDOMEN PLAQUE

119. Bronze, sheet. Sub-rectangular plaque slightly turned back at each end and pierced with a small hole towards each corner for fitting to a fabric or leather backing. A raised border frames a crudely traced figure, with arms raised, flanked by very stylized lions with jaws agape. In the field rings of tiny dots. Cracked and repaired on the back.
7·5 cm W. 19·2 cm H.

Both the theme and the style of its rendering on this fragment are characteristic of Luristan in Iron Age II. It is a drawn version of the 'master/mistress-of-animals' motif so regularly modelled on pins (see nos. 96 to 98) and finials (see nos. 80 to 82).

It appears from its form that this plaque was designed to be sewn onto a belt or comparable piece of equipment as were a number of larger metal plaques reported from Luristan (cf. *Oxford*, No. 488). The motif was used on other

such plaques reported among material from the earliest clandestine excavations in Luristan. The attire of the central figure varies, but in one case at least is definitely male. On one such the lions are rendered rampant in a realistic manner (*SPA*, IV, pl. 56 E: upper register) and on another they are stylized exactly as on this example (*SPA*, I, fig. 61).

GIRDLE-CLASP

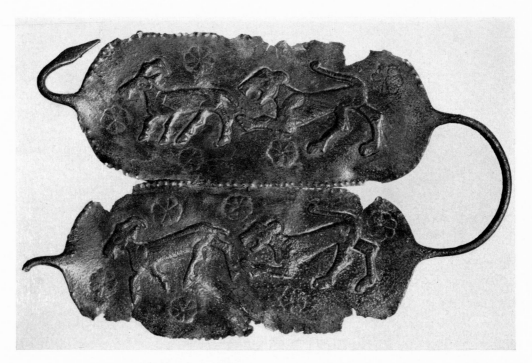

119A. Bronze, sheet. Bronze wire curved round to form a long, narrow loop; the ends, with long tapering points (one lost) are turned back. The almost parallel sides of the loops are hammered flat to form a pair of rectangular plaques, each with a stippled margin. On each is a lion in pursuit of a goat rendered in repoussé with incised details; rosettes in the field. The scene is crudely executed and the setting of the participants varies on the two plaques. Reverse slightly concave.

 10 × 4·5 cm each plaque.

A number of these objects have now been reported from western Iran (*Oxford*, Nos. 456–8 with references; add *Barbier*, Nos. 29–31), where they were manufactured in Iron Age II–III. Many have roughly traced and repoussé

geometric designs, others animal scenes executed with varying degrees of skill and coherence; among them scenes showing a lion in pursuit of a goat are especially popular. The finest example of this scene, formerly in the David-Weill Collection (*BL*, pl. XLVIII. 182), is chased in a style very like that of the decorated goblet no. 136, distinguished particularly by the careful patterning of the animals' body surfaces.

The function of these plaques has not yet been established in any Iranian excavation, but objects of exactly the same form found in European Bronze Age graves served as girdle-clasps.

BEADS

120. Bronze, cast. Necklace of thirty-four beads strung in modern times; made-up as follows: eight cylindrical, with traced linear geometric decoration; fifteen vase-shaped; four moulded barrel-shaped; six biconical; one flanged biconical.

There is as yet no published evidence for metal beads of this type from controlled excavations. The cylindrical beads with traced decoration are very similar to common faience beads produced in early Iron Age I and found in cemeteries like that at Marlik (*Marlik*, fig. 62). The vase-shaped beads recall bronze pendants from the cemetery of comparable date at Khurvin (*Khurvin*, pl. XLIV. 320–2).

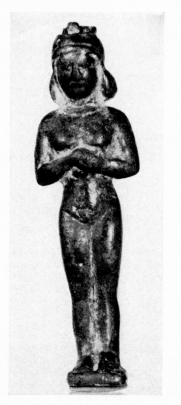

121. Bronze, cast. Nude female figure, with hands clasped just below her breasts, standing on a small rectangular platform. The hair is dressed behind a narrow brow-band and falls in two rounded curls at the nape of the neck. The body is well modelled, as originally was the face, though it is now rather worn. The figure was cast hollow and two cosmetic sticks are still corroded into the cavity. A broken suspension loop is set in the centre of the back.

10·8 cm H.

A bronze figurine like this, long in the Berlin Museum collections, is normally attributed to the Parthian period (F. Sarre, *Die Kunst des Alten Persien*, 1923, p. 29, fig. 7; more recently M. A. R. Colledge, *The Parthians*, 1967, pl. 16; 11.5 cm high), but the hair style and full modelling of no. 121

are most nearly matched amongst the baked-clay, nude, female figurines manufactured in Iraq in the sixth and fifth centuries B.C. (C. Ziegler, *Die Terrakotten von Warka,* Berlin (1962), No. 463, p. 72, pl. 16.242; cf. C. L. Woolley, *Ur Excavations,* IX, pl. 26.4–5, pl. 21 U.456—gold pinhead in the shape of a standing woman in a long dress). This bronze cosmetic jar, said to come from Iran, may have been made there or in Iraq in the Neo-Babylonian or earlier Achaemenian period.

Unguent vases and kohl pots in the form of standing female figures, dressed and naked, made in bone, ivory and metal, were popular throughout the East from at least the seventh to the fifth centuries B.C. (D. B. Harden, *The Phoenicians,* London (1962), figs. 63, 65 (Levant: bone, ivory), figs. 84–5 (Levant: bronze); Budde, *Der Islam,* XXXIX, 1964, pp. 8 ff (Luristan: bronze); R. D. Barnett, *BMQ,* XXVII, 1963, p. 80, pl. XXXId, cf. pl. XXXIa–c (Levant: bronze); Kish, Iraq: Baghdad IM 48694 (excavation no. V. 529) bronze).

COSMETIC STICKS

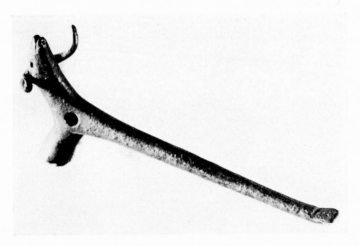

122. Bronze, cast. Tapering shank with flat, spatulate tip; head cast as the barrel-shaped neck and head of a bull with curling horns; pierced with a small hole at the junction of head and shank.

8·1 cm H. 3·5 cm W.

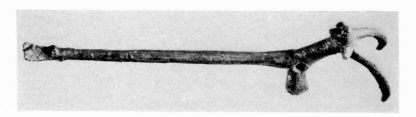

123. Bronze, cast. Tapering shank with flat, spatulate tip; head cast as the barrel-shaped body, neck and head of a bearded wild goat; pierced with a small hole at the junction of body and shank.
 9·6 cm H. 3·1 cm W.

Only one example of a cosmetic stick like these has so far been published from a controlled excavation, though many are reported from clandestine excavations in Gilan (*AANE* (Boston), 1963, fig. 40; *Barbier*, Nos. 132–5, 137–9, pp. 108–10). Tomb 5 at Ghalekuti II in Dailaman yielded a single bronze cosmetic stick of this type with the head modelled as a horse (*Dailaman*, III, pl. XLVII, 4ab; pl. LXXX. 11). Metal cosmetic sticks with variously decorated heads were found in tomb 3 at Ghalekuti II and in tomb D–IV at Noruzmahale (*Dailaman*, III, pl. XLVI. 3; II pl. XLIX. 41). With the meagre evidence at present available it is not easy to date tomb 5 at Ghalekuti. Although the excavators suggest that the zoomorphic cosmetic stick 'gives a near date to the Achaemenian Persian period' (*Dailaman*, III, p. 63), the assembled evidence for these graves suggest the later Parthian, or even early in the Sassanian, period.

'Mirrors'

124. Bronze, hammered. Disk with vertical rectangular, projection.
 15·5 cm D. 23 cm H.

125. Bronze, hammered. Disk with square projection on one side, modified into small contiguous disks at the top.

13·5 cm D. 22 cm H.

Objects like these two have been found in graves in the Dailaman region of Gilan (*Dailaman*, I, pl. XXXI. 3, 4, pl. LXXVI. 98–102; III, p. 39, pls. LII. 4, LXXXVII. 10), but the date of the burials which contain them is not yet clear though it seems to lie between the Achaemenian and Parthian periods.

Although often referred to as 'mirrors', most of these objects do not really seem best suited to such a function. In form they have a marked affinity to a stylization of the female figure found particularly in Anatolia (H. Th. Bossert, *Altanatolien*, Nos. 333–47).

V
Vessels

Unlike much of the cast metalwork considered earlier, most of the sheet copper and bronze vessels from Luristan are often not easily distinguished from those manufactured in Mesopotamia. Indeed certain groups, like the decorated situlae (nos. 134 and 135) and the shallow, cast bronze bowls (nos. 129 to 132), may be imports from eastern Babylonia. Controlled excavations have not yet thrown much light on the sheetmetal vessels used in Luristan before the early Iron Age, but thereafter they become regularly commoner. The simple, undecorated forms have a long history in the region, as in Mesopotamia, but the tall decorated beakers (no. 136) and the spouted vessels (nos. 137 and 138) indicate growing influence from the north in Luristan workshops after Iron Age I. Indeed these vessels may well be specifically Iranian in origin.

What little is known of Achaemenian copper and bronze vessels indicates little or no direct connection with forms used earlier in Luristan. No. 139 is typical of this new range.

BEAKER

126. Bronze, sheetmetal. Beaker with rounded foot, slightly concave sides and flanged lip. A double moulding runs round the waist of the vessel and another round the base.
9 cm H. 7 cm D.
cf. *Oxford*, No. 507 with references.

The plain metal beaker has a long history in western Iran where the earliest excavated examples appear at Tepe Giyan in level IV during the later third millennium B.C. This example, with moulded body ridges, is considerably later in date and may be compared to excavated examples from Tepe Giyan and Guran in the later second and early first millennia B.C. (*Giyan*, pl. 8; J. Meldgaard, *AArch*, XXXIV, 1963, figs. 28–9).

JAR

127. Bronze, sheetmetal. Jar with very tall, slightly concave neck and flanged rim; broad inclined shoulder; squat, ribbed body; flat base.

11·1 cm H. 8·7 cm mouth D.

cf. Calmeyer, Gp. 53, pp. 115–16; *Oxford*, Nos. 503–4.

Although the exceptionally high neck and low body of this jar are unusual, this is only a variant of a group of sheetmetal vessels widely used in Iraq and western Iran in the first quarter of the first millennium B.C. (Iron Age II).

HANDLED JARS

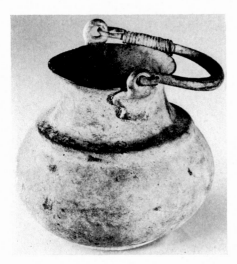

128. Bronze, sheetmetal. Jar with cast bronze loop handle passed through ring fittings one on either side of the neck. Flat foot, rounded body with ridge moulding round the shoulder, concave neck and slightly everted rim. Each ring fitting for the handle rises from a trefoil plaque riveted to the side of the vessel with three rivets. In one case the handle is passed through the loop and folded back, in the other it is much narrower and drawn out into a wire coiled spirally back round the handle for some distance.

9 cm H. 6 cm mouth D.

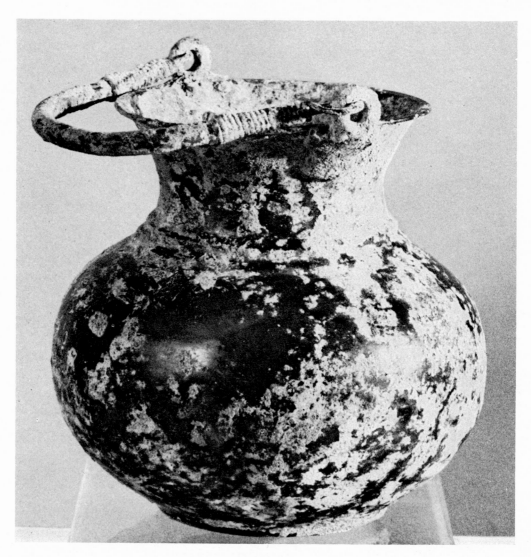

128A. Jar almost exactly like the preceding example but with much finer patination and larger.

14 cm H. 8·7 cm mouth D.

A number of vessels like these have been reported from Luristan (*BMRAH*, 1933, p. 93, fig. 46 (o.1028); Schmidt Collection, Solothurn (J.C.); *Bulletin of the Cincinnati Art Museum*, V(2), 1957, p. 1. fig. 1—1957.225). The most interesting of them is that in Cincinnati: it has wild goat fittings in the style of the finials on the handle, perhaps a modern embellishment (Calmeyer, p. 138,

No. E), and a design chased on the body of the vessel in the style found much more commonly on the decorated situlae reported from Luristan (see nos. 134 and 135). As the situlae are known from their inscriptions to have been made in the tenth or ninth century B.C., this may be taken as the date of these handled jars. The handle plaques on no. 128 are exactly like those on a small ceremonial bucket from Luristan, now in Oxford (*Oxford*, No. 513; Goldman, *JNES*, XX, 1961, pp. 239 ff) of a type commonly shown in ritual scenes on Assyrian reliefs from the ninth century B.C. onwards.

BOWLS

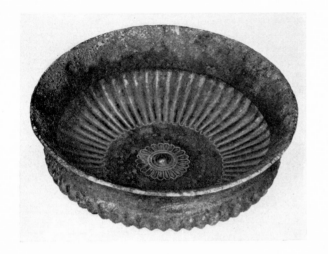

129. Bronze, cast. Bowl with plain, flanged rim; the body decorated with narrow, parallel godroons; flat base with a rosette chased on the inside round a tiny omphalos.

15·4 cm D. 4·5 cm deep.

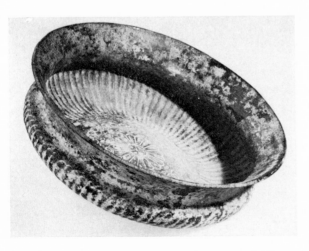

130. Bronze, cast. Bowl similar in form to no. 129 but without the omphalos and with a more varied chased floral frieze round a multi-petalled central rosette on the interior base.

13·7 cm D. 4 cm deep.

A number of bowls very like these have been reported from Luristan (G. Schneider-Herrmann, *BABesch*, XVI, 1941, pp. 1 ff, figs. 1, 14; *ABSB*, pl. 57. 110). Comparable bowls were found during excavations at Sinjirli in north Syria, where they were probably manufactured in the later eighth or early seventh century B.C. (W. Andrae, *Ausgrabungen in Sendschirli*, 1943, V, pl. 56e; cf. H. Luschey, *Die Phiale*, 1939, fig. 3). Another such bowl was found in an early seventh century context at Nimrud (*Nimrud*, I, p. 116, pl. 59). Among the small group of metal vessels with incised inscriptions in Aramaic reported from Luristan, there is a bowl exactly like this, but with plain body. Dupont-Sommer has dated the inscription about 600 B.C. (*IA*, IV, 1964, pp. 115 ff, pl. XXXVII).

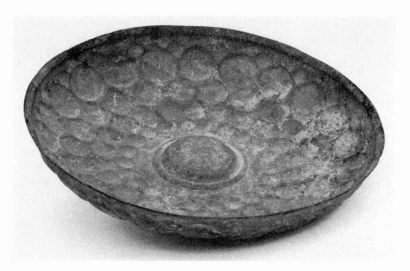

131. Bronze, cast and hammered. Shallow bowl with low, broad omphalos. The exterior, below a low plain rim, is decorated with horizontal rows of low, circular bosses decreasing in size towards the base, hammered up from inside.

19·3 cm D. 3·5 cm deep.

Both the shallow form and the decoration of this bowl are found among metal vessels excavated at Nippur in Iraq (McCown, *Nippur*, 1967, I, pl. 108. 8 for form; pl. 108.13 for decoration). Although the form extends back into the late Assyrian period (H. Luschey, *Die Phiale*, 1939, fig. 6), the decoration

on this bowl is more likely to have been current in the sixth or fifth century B.C. during the Achaemenian supremacy. Similar patterning of the body is found on a slightly more hemispherical bowl, now in the Bröckelschen Collection, also from Iran (*ABSB,* pl. 59. 113—should read 114).

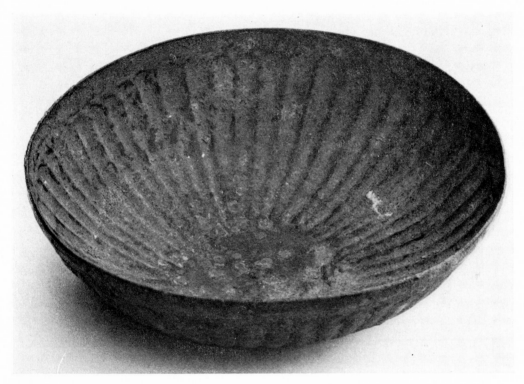

132. Bronze, cast. Hemi-spherical bowl with the whole body, below a low plain rim, decorated with narrow, parallel godroons. The centre is flat and undecorated.
16·5 cm D. 5·5 cm deep.

Bowls decorated in exactly this manner, though not quite so shallow have been found both at Tepe Sialk (*Sialk,* II, pl. LV. 837, XXIV. 7) and at War Kabud in western Luristan (Vanden Berghe, *Het archeologisch . . . Pusht-i Kuh,* I, pl. 33b). This may be taken to indicate that they were manufactured in the eighth century B.C. and perhaps also for some time afterwards.

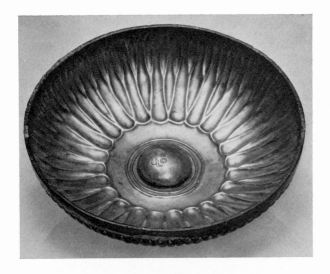

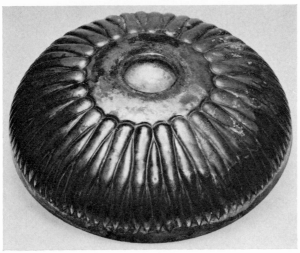

132A. Bronze, cast and hammered. Bowl with flat vertical rim; shallow body with broad low omphalos in the centre surrounded by two concentric ribs; narrow undecorated band round the centre inside, then twenty-four broad-based raised petals radiating up the sides to within a short distance of the rim. Towards the top the main petals are interleaved with triple sets of smaller ones; all have pointed tops. A pair of concentric circles are incised in the centre of the omphalos with a headless human figure, seen in profile, seated to one side of it.

21·5 cm D. 6 cm deep.

This bowl, of a type generally known as the *phiale mesomphalos,* is one of a slowly growing number of western forms reported from Luristan; other decorated examples have been published as from the region (*ABSB,* pl. 59. 114 should read 113; Copenhagen—*Skatte fra det Gamle Persien,* 1968, No. 199, plate on p. 87). The form was particularly popular among the Greeks as a libation vessel, though in origin oriental. The basic shape, undecorated, may be traced back to at least the ninth century in Assyria (H. Luschey, *Die Phiale,* 1939, fig. 9.4–6); late eighth-century examples have been found in the War Kabud cemetery in western Luristan (Vanden Berghe, *Opgravingen in Pusht-i*

Kuh, 1968, pl. 32a, b). The earliest form of decoration, narrow raised petals, their sides parallel, had appeared by the eighth century, even in glass (von Saldern, *Journal of Glass Studies,* I, 1959, pp. 25 ff, figs. 1–2: from Gordion in Turkey). The elaborate form of decoration, more nearly reminiscent of the lotus flower used on no. 132A, was current by the sixth century to judge from examples found in Greece, notably among a whole range of bronze bowls from a votive deposit at Perachora (H. Payne, *Perachora,* I, 1940, pp. 148 ff). The most easterly occurrences of such bowls in archaeological contexts are examples from the fifth-century cemetery at Deve Hüyük near Carchemish on the Syro-Turkish frontier (now in the Ashmolean Museum (1913.673)) and from Ur (*UE,* VIII, pl. 35: *UE,* IX, pl. 23). As there are a number of Greek vases in the Deve Hüyük cemetery, the bronze bowl may also be an import from the West. The design is slightly simpler than on no. 132A, which is more nearly matched by a silver *phiale mesomphalos* from a sixth-century burial at Kameiros on the island of Rhodes (*Clara Rhodos,* IV, 1931–9, pp. 43 ff, fig. 13).

No. 132A belongs to the Achaemenid period, to the late sixth or earlier fifth century B.C., when it probably reached Iran from a workshop in the western Achaemenid Empire. The enigmatic device on the omphalos is certainly secondary and, as it seems to be engraved, with no trace of corrosion in the vicinity, may be a relatively recent addition.

TRIPOD 'LAMP'

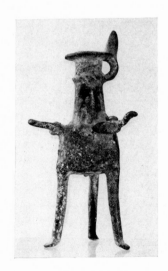

133. Bronze, cast. Jar with squarish body, tall neck and flanged rim set on three feet; projecting piece of metal above each leg and a small loop handle with flared top set high on the neck.

8·3 cm max. H.

These vessels, both in metal and a similar version in baked clay, were found in a number of graves of cemetery 'B' at Tepe Sialk, about 900 to 700 B.C. (*Sialk*, II, pl. XX, pl. XXIV. 1, 5, pl. LXV. 858, LIX. 623, LXVIII. 720, 728, LXX. 900c, LXXIX. 988a, p. 53). They vary only in minor details of form. Ghirshman identified them as lamps. Isolated examples have been reported from other, unknown sites in western Iran (*ABSB*, pl. 48, 100–1).

SITULAE

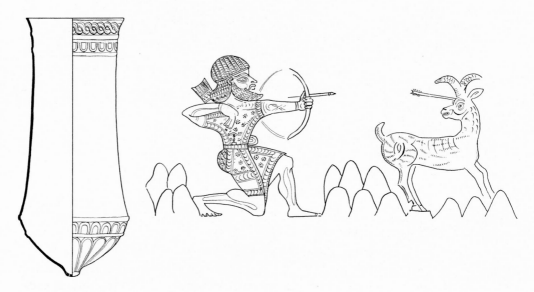

134. Bronze, sheetmetal. Situla with vertical sides, base rendered as a rosette. Upper borders first of guilloche, then of round-based rectangles set side-by-side; lower border of round-topped rectangles set side-by-side. The central panel of the vessel is finely chased with a kneeling bowman firing at a wild goat set in a mountain landscape. The beast turns its head back to look over its shoulders and an arrow passes behind its horns.

16 cm H. 6 cm D. at top.

Calmeyer, *BJ*, 5, 1965, pp. 24 ff, Group F.

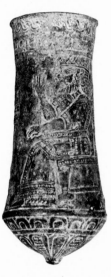

135. Bronze, sheetmetal. Situla exactly like no. 134 in form and decoration save in the central panel where a chased banquet scene replaces the hunter. A male figure seated on a high-backed chair faces a collapsible table set with various items of food. A servant stands behind the chair brandishing a rectangular fan in his right hand, another faces the seated figure across the table and waves a fly-whisk over the food with his right hand. The crossed legs of the table terminate in bulls' hooves and the back of the throne has a zoomorphic terminal at the top. Traces of a bitumen lining inside.

16·4 cm H. ·062 × ·067 cm mouth D.

cf. Calmeyer, *BJ*, 5, 1965, pp. 24 ff, Group A.; P. Amandry, *AK*, IX, 1966, pp. 57 ff; *Oxford*, No. 516A.

These two vessels belong to an ever growing group of decorated situlae reported from western Iran in the last forty years. Their remarkably standard-ized design and execution suggests a single workshop. A small group of inscribed examples reveals that their principal owners were Babylonian princes or aristocrats of the tenth or earlier ninth century B.C. (*Oxford*, pp. 33–4 for list). A 'banquet-scene' situla was reported from clandestine excavations in a cemetery at Zalu Ab, 30 km north-east of Kermanshah (A. Godard, *Gazette des Beaux-Arts*, LXXV (2), 1933, figs. 13—14, 17). It is not yet clear where these

vessels were made, though a workshop in eastern Babylonia seems most likely. The themes of hunting and feasting were also widely used in the arts of Syria and Assyria in the early first millennium B.C. (R. D. Barnett, *The Nimrud Ivories in the British Museum*, 1957, pp. 63 ff; Calmeyer, Gp. 36; see now P. Calmeyer, *Reliefbronzen in babylonischem Stil*, Munich, 1973, pp. 26, 56).

GOBLET

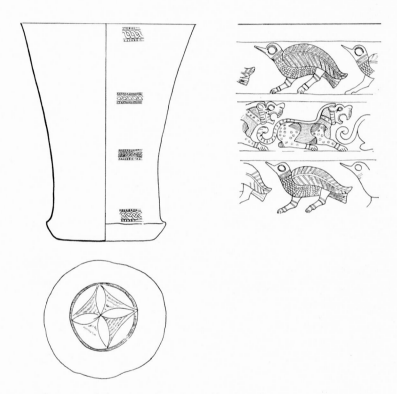

136. Bronze, sheetmetal (*see frontispiece*). Tall, slightly concave sides with gently protruding flat base; rim broken in places and a break in the upper side. Distorted when under pressure. There is an upper and lower guilloche border and the side of the vessel is divided into three horizontal panels, the bottom one slightly larger than the others, by narrower guilloche lines. Three birds are chased in the upper and lower panels, three lions crouching with jaws agape, in the central one. The bodies of both birds and lions are elaborately patterned. On the base is chased a four-petal rosette in a square frame. In places the sides of the vessel have been skilfully restored.

18·6 cm H. 10 cm base D.

cf. *Oxford*, No. 510 (with bibliography of these vessels).

The lower part of a similar bronze goblet was reported with a clandestine excavation in a cemetery at Zalu Ab, 30 km north-east of Kermanshah (A. Godard, *Gazette des Beaux Arts*, LXXV (2), 1933, figs. 11–12, p. 132). As a 'banquet-scene' situla (see nos. 134 and 135) occurred in the same cemetery these vessels probably date between the late tenth and early eighth centuries B.C. The form, and to a lesser extent the decoration, recall the magnificent gold and silver beakers found in the cemetery at Marlik, and on other unknown sites in Gilan, which date to the last quarter of the second millennium B.C. It remains uncertain whether these bronze versions were made in the same region and exported southwards or whether, as at present seems more likely, they were copies in base metal produced a century or so later in south Kurdistan or northern Luristan. They would then have been more nearly associated with the silver beaker found in level IV (about 1000 to 800 B.C.) at Hasanlu in Azerbaijan (E. Porada, *Ancient Iran*, pl. 28 (detail)).

There is a close relationship between the subjects and style of designs on these bronze goblets and those on other more varied pieces of decorated sheet-metal from Luristan, notably quiver plaques, fittings for belts and shields (Graeffe Collection, pls. 19–20, 27). The manner of rendering birds and animals with elaborately patterned bodies and dotted body margins is common in varying degrees to them all. The affinity extends to the finest disk-headed pins associated with the Dum Surkh shrine (see no. 101), many of which are entirely decorated with animal friezes rendered as on this goblet (Graeffe Collection, pl. 7–8). This style of decorated sheetmetal forms a distinct and important aspect of metal working in Luristan and south Kurdistan in Iron Age II–IIIB. Though slightly damaged, this vessel is an excellent example of the craft.

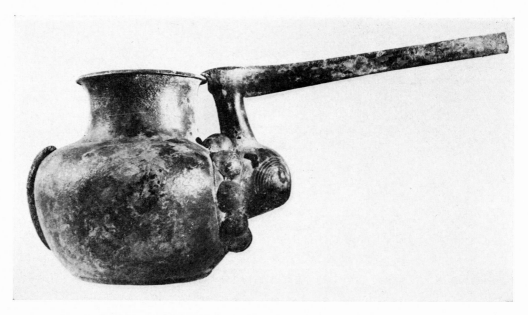

137. Bronze, sheetmetal. Jar with a flat base, rounded body, tall neck and flanged rim. A long channel-spout with base-pouch, decorated with a convoluted linear pattern common on this type of vessel, is riveted to the body by eleven domed split-rivets, not all of them functional. Opposite the spout is a triangular cast bronze plaque riveted to the body of the vessel. Fine condition.

13 cm H. 8 cm D. at the mouth. 18·5 cm length of spout.

138. Bronze, sheetmetal. Jar with a flat base, rounded body, vertical neck and flanged rim. A long channel-spout with base-pouch, decorated exactly like that on no. 137, is riveted to the body by ten domed split-rivets. Corroded.

12·5 cm H. 9 cm D. at mouth. 15·5 cm length of spout.

cf. Calmeyer, Gp. 47, pp. 99 ff; *Oxford*, No. 522.

Sheetmetal jars with long channel-spouts riveted to the body of the vessel by large rivets, some purely decorative, are a distinctive group among the metal vessels of Iron Age I–IIIB produced in Luristan, where examples have only so far been found in controlled excavations at Tepe Guran (*AArch*, XXXIV, 1963, fig. 301). Further east they appear, both in metal and clay, in cemetery 'B' at Sialk (*Sialk*, II, pl. L. 546a, b, pl. XXIII. 5) and in the north, perhaps earliest of all, at Marlik (*Marlik*, fig. 32). In Luristan the linear decoration on the pouch is standard and the form varies little save in the changing proportions of neck and body. A now well-known vessel of this type found in an early seventh-century context on the island of Samos off the southern coast of Turkey is almost certainly an import from western Iran, but whether from Luristan specifically is an open question (Calmeyer, Gp. 47).

The ritual use of these vessels, suggested by the pouch for regulating the flow of a liquid, is confirmed by the existence of a series of baked clay vases shaped as men and women pouring libations with such vessels. They appear in the plain, burnished fabrics of northern Iran in Iron Age I (*Marlik*, pl. XI) and are reported in the painted pottery style of Luristan in Iron Age II, notably an example found during controlled excavations at Baba Jan (C. Goff, *Iran*, VII, 1969, pl. III). A bronze figure pouring a libation with a similar spouted vase is reported from Gilan (*Barbier*, 117). Dealers in Iran report that these vessels are sometimes found in graves with the spout actually placed in the mouth of the skeleton.

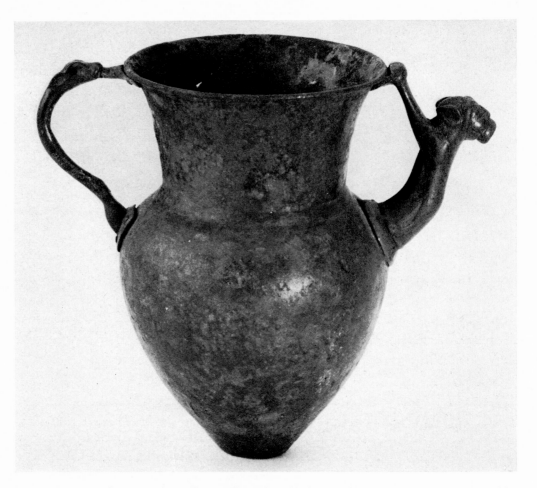

139. Bronze, sheetmetal. Tall vessel with rolled rim, high concave neck, shoulder moulding and body tapering downwards to a relatively narrow flat base (restored). On one side a cast bronze handle, decorated with a calf's (?) head, is rivetted at either end to the upper neck and the shoulder. Opposite to it is a spout cast in the form of a lion rampant with head turned back over its shoulders, jaws agape to form the aperture. The front paws are riveted to the vessel just below the rim, and the lower legs are traced on the base of the spout, which is riveted to the shoulder of the vessel. Base restored.

18·5 cm H. 12 cm mouth D.

This vessel is a rare bronze version of the magnificent gold and silver spouted amphorae shown in the hands of Armenian tributaries on the Persepolis reliefs (G. Walser, *Die Völkerschaften auf den Reliefs von Persepolis,* 1966, pl. 10. 38–9, pp. 74–5). A few actual examples have been reported from the Near

East, but displaced handles and spouts are commoner than the complete vessels (Amandry, *AK*, II, 1959, pp. 38 ff, pl. 22–4). The closest parallel to this bronze example is found in a hoard of objects, dating to the fifth century B.C., found in the region of Masyaf in Syria (Amandry, *AK*, II, 1959, pp. 44–6, pl. 23.1). The form of the vessel is exactly the same, though the cast bronze spout and handle are different, more nearly resembling their counterparts in precious metals.

TRIPOD VESSEL STAND

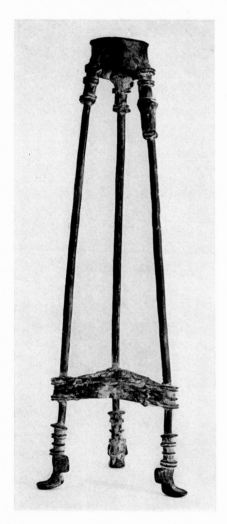

140. Bronze, cast. The structure is complicated and the technique often crude. Basically it consists of the following parts: upper sheetmetal ring, three cast mouldings (upper), three cast mouldings (lower), three metal strips joining the lower mouldings, three cast feet and three cast rods for the main struts. The feet and the mouldings are cast-on to the rod supports; the rectangular strips which unite the lower mouldings are ineptly cast-on to them. Three flat rivets emerging at each junction of rod and upper ring suggest that these were in some way riveted before being brazed together. The lower part of an upper moulding has a crude cast bronze sleeve, which may be the repair of a break in the rod at this point.

62 cm H. 8 cm upper D. 17 cm L. triangular struts.

What little comparative evidence there is suggests that tripods of this type were made and used in western and northern Iran in Iron Age II, if not earlier. In level IV at Hasanlu the excavators found two small, plain bronze tripod stands with human shod feet (*Archaeologia Viva*, I, Sept. to Nov. 1968, p. 90, lower fig.) and a large double tetrapod stand with low relief designs on the struts (*SPA*, XIV, 1967, pl. 1486A). No other such stands have been reported from controlled excavations, though their wider currency is reflected in a variety of baked-clay tripod stands, some also found in level IV at Hasanlu. Closer in form to this stand is an example which has long been in the Louvre, said to have been found in Iraq (E. Pottier, *Catalogue des Antiquités Assyriennes*, 1924, No. 153, pl. XXXI). As both the upper and lower rings uniting its legs are decorated with projecting grotesque human heads very like the male head-protome modelled on a baked clay tile from level IV at Hasanlu (E. Porada, *Ancient Iran*, pl. 30, colour), this stand may have reached Iraq from a west Persian workshop of the ninth century B.C. (P. R. S. Moorey, *Iran*, X, 1972, p. 145).

INSCRIBED BOWL

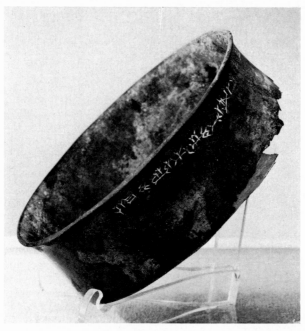

141. Bronze, hammered. Vertical sides, slightly everted rim and flat base. Cuneiform inscription cut in a single line just below the lip; body damaged.
15 cm D. 5·5 cm depth.

Professor W. G. Lambert has kindly provided the following transliteration of the cuneiform text: *níg* ᵐ*ma še ta ḫu zi na ni a na* ᵐ*da da a? ra? lam diš?* He notes that the sign forms are Babylonian rather than Assyrian, of the late second or early first millennium B.C. Although there are no clear grounds for suspecting the authenticity of the inscription, it has not been possible to offer a translation. The formula is apparently the standard one 'Belonging to (strictly "of") X, son of Y' or something similar, but no names can be confidently recognized here. Dr. I. Gershevitch has suggested that '*da-da-a?-ra?* possibly represents an Iranian name **dadāra* meaning "possessor" (or the like), cf. Av. *dādari*'.

The significance of the inscribed bronzes from Luristan is still a matter for discussion. A large number, like the two arrowheads in this collection (see nos. 20 and 21), bear Babylonian or Elamite royal inscriptions which are intelligible, if not always completely accurate, and may well have been made in Babylonia or Elam (for lists see Calmeyer, pp. 161–8; *Oxford*, pp. 28–34). On other subjects locally made (P. R. S. Moorey, W. G. Lambert, *Iran*, X, 1972, pp. 161–2) the inscription has clearly been engraved by an illiterate smith unaware of its true meaning, and often incapable of copying it correctly. Such inscriptions may have been added as property marks or just for some magical power supposedly endowed by cuneiform letters irrespective of meaning.

VI
Statuettes and Pendants

The chronology and exact attribution of these statuettes and models present a whole host of problems which remain largely unresolved in the present state of knowledge. Although bronze animal pendants and figurines, with small models like nos. 171 and 172, have occasionally been reported from controlled excavations, such is not the case with the rather crude human figures catalogued here. Many are reported from clandestine excavations, supposedly in Azerbaijan and Gilan, mainly no doubt on sites of Iron Age I–II (about 1200 to 750 B.C.); but their great variety suggests that no single source, nor a short period of time, produced them all and some may be more recent than the range of date suggested here. It is possible that one or two of the male and female statuettes are not from Iran.

HUMAN AND SEMI-HUMAN FIGURES

STANDING FIGURES

A. *Female*

142. Bronze, cast. Crudely modelled naked woman with bold facial features carrying a relatively large baby set rigidly in her arms.
 6·4 cm H.
 cf. *Barbier*, Nos. 187–8, fig. on p. 133: 'Amlash'; G. G. Belloni, *Iranian Art*, 1969, p. 11. fig.

Although thematically linked with no. 153, this figurine has a much closer stylistic affinity with the following male figures with which it no doubt shares a common origin.

143. Bronze, cast. Nude woman with arms raised on either side of her head, fists clenched. Compared with the crude features of the head, the body is relatively sensitive in its modelling.
10·7 cm H.

This figurine is extremely like another, said to be from Luristan, now in the Cinquantenaire Museum, Brussels (Graeffe Collection, 232, pl. 14). A northern source would seem more likely as free-standing figures like this are not normally reported among well-authenticated groups of bronzes from Luristan.

Though this posture is often used for anthropomorphic mirror handles, there is no sign that the hands of this figure, or its head, were designed for such a role.

144. Bronze, cast. Standing woman, very flat, with loop behind her head; arms held out on either side of the body, palms open; hair dressed in two prominent round curls above the temples and then brought round to frame the face. Ankle-length dress with prominent collar round the neck, neck-line plunging to the waist.
Iron stain on the heels.
8·6 cm H. 4·4 cm W.

A figurine exactly like this one, but with more elaborately rendered spiral hair curls and richly patterned skirt, in the Barbier Collection (*Barbier*, No. 112, pl. on p. 97), was attributed to Amlash. The date is unknown.

163

B. *Male*

Piravend Figurine

144A. Bronze, cast. Crudely cast and highly stylized figure of a nude standing man (?) with arms raised; triple pointed headdress; large face with prominent brow ridge, deep eye sockets and rounded cheeks; no ears shown (see comment below), eyes stamped circles and eyebrows marked with incised lines. Double raised lines mark a necklace and a girdle; blobs of metal the breasts, genitals, knees and feet.
 9·1 cm H.
 Weill, No. 208 (*Amiet*, 235).

Such figurines as this were first reported in some quantity about fifty years ago supposedly from the region of Piravend, about five miles north of Taq-i Bustan in Kurdistan.[1] They are virtually all, in marked contrast to the classic 'Luristan bronzes', very crudely made with little attention to form in the modelling or fine finish in the casting. No reliable archaeological information is yet available to indicate their date or function, though there seems no good reason to doubt the original suggestion that they belong to the earlier first millennium B.C. (Iron Age II) and were votive figures. Many of them are cast, like this one, with raised arms. When the figurine is clearly female, particularly if shown squatting, this may be taken to denote the act of childbirth; when the figure is male or androgynous, as here, a gesture of worship or mourning is more likely (*Oxford*, pp. 168–70). As many of the Piravend figurines have a single central protuberance on their heads, it may be that the flanking points here are not horns, but rather pointed ears set exceptionally high on the head.

[1] Professor Vanden Berghe has suggested to me in conversation that the source may have been a village of the same name in Luristan, not Kurdistan. Though forgeries of these figures have been made in recent years, there is no reason to doubt the authenticity of the original find to which this example belongs.

145. Bronze, cast. Very crudely modelled figure standing with legs slightly apart, hands clasped at waist level; a pendant.
 4 cm H.
 cf. *Oxford*, nos. 429–30; Iron Age II.

146. Bronze, cast. Very crudely modelled and poorly cast; standing with legs apart and hands clasped at waist level.
 6·1 cm H.
 Iron Age I–II.

147. Bronze, cast; extensive traces of sheet gold overlay. Crudely modelled with legs set as if intended to be set astride an animal, arms held forward to grasp the reins.
 4·6 cm H.
 cf. baked clay figure from Khurvin (*Khurvin*, pl. XXXIII. 224); for a set of rather similar crude figurines see *ABSB*, pl. 62. 120–122. Iron Age I–II.

148. Bronze, cast. Crudely modelled figurine; standing with arms bent and hands held close to the chest; dagger at waist (?).
 7·7 cm H.
 cf. 7000 *Years of Iranian Art*, USA, 1964–5, No. 107, p. 133, No. 383, p. 138; *Barbier*, No. 115, pl. on p. 100; G. G. Belloni, *Iranian Art*, pl. 35; cf. figure on a baked clay model from Marlik (*Archaeologia Viva*, I, Sept.–Nov. 1968, p. 76, fig. 92). Iron Age I–II.

149. Bronze, cast. Bearded male figure in ankle-length robe, with pointed shoes, set on a narrow, rectangular platform; wearing a 'crown' with three points. In his right hand he holds a shallow bowl and in his left a tapering pyramidal object.
6·5 cm H.

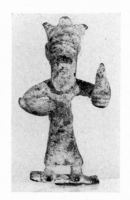

The close similarity between the face of this object and a tile protome from level IV at Hasanlu (Porada, *Ancient Iran*, pl. 30) may indicate a date in the ninth century and a workshop in Azerbaijan.

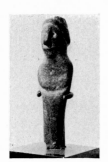

150. Bronze, cast. Standing man wearing a cap with broad brim, tight fitting ankle-length robe, hands clasped on his stomach. Large nose, prominent lips and deep eye sockets.
4·5 cm H.

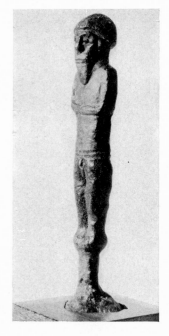

151. Bronze, cast. Bearded standing figure set on a long casting spout; skull cap and waist-length tunic (or belt); genitals clearly shown, hands clasped at the waist.
10·3 cm H.

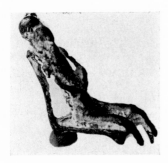

152. Bronze, cast. Crudely modelled figure seated on a high-backed chair with long seat.

 3 cm H.

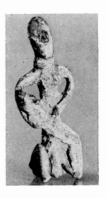

153. Bronze, cast. Crudely modelled female wearing a double necklace, seated on a low stool nursing a baby held rather awkwardly across her lap.

 5·2 cm H.

Other figures of this kind, often equally crude in modelling and casting, are among the many metal statuettes reported from Gilan: *AANE* (Boston), fig. 31, upper right; *Oxford*, No. 218; Samadi, *Arts Asiatiques,* VI, 1959, p. 188, fig. 240 (chair alone). Iron Age I-II.

STAGS

154. Bronze, cast. Standing stag with boldly tined antlers; suspension loop on the shoulders.

 ·045 m H. ·040 m L.

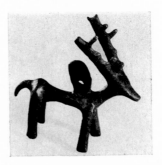

155. Bronze, cast. Standing stag considerably more stylized than no. 154 and with less boldly tined antlers; tall, flat protuberance on the shoulder is pierced through.

 ·061 m H. ·062 m L.

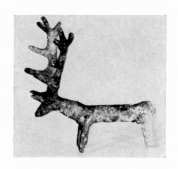

156. Bronze, cast. Standing stag with elongated cylin-
drical body and richly tined antlers; pierced through above
the front legs for suspension.
 ·075 m H. ·065 m L.

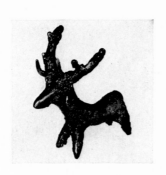

157. Bronze, cast. Standing stag; poor castings; pierced
at the shoulders.
 ·058 m H. ·055 m L.

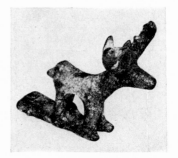

158. Bronze, cast. Simply modelled stag standing
towards the front of a small rectangular platform.
 ·040 m H. ·045 m L.

159. Bronze, cast. Standing stag very like no. 158
standing on a small platform; iron corrosion.
 ·043 m H. ·037 m L.

Bronze stags (Persian fallow deer) are particularly associated with clandestine excavations in Gilan. They do not appear among the Luristan bronze animal pendants. Nos. 156 and 157, pierced through the body, are most like the stag pendants from Marlik manufactured in Iron Age I, about 1250 to 1000 B.C. (*Marlik*, fig. 96; *Archaeologia Viva*, I, Sept. –Nov. 1968, p. 78, figs. 95, 97, 100). An animal pendant, perhaps a bull, with suspension loop on its shoulder was found in a tomb of Iron Age I–II in Dailaman (*Dailaman*, I, pl. LXXIV. 27), and a stag with a similar loop in the Kaluraz cemetery (*Archaeologia Viva*, I, Sept.–Nov. 1968, p. 80, fig. 106). A pendant very like no. 155 has been reported from clandestine excavations in the Amlash region (*AANE* (Boston), fig. 31). Nos. 158 and 159 differ slightly in the style of modelling, but also in having platforms rather than a suspension loop or hole. They might have been designed to fit on elaborate horse-collars like those used by the occupants of the Kaluraz cemetery in Iron Age I–II. Numerous stag pendants and figurines have been reported from Gilan (*AANE* (Boston), fig. 31; Porada, *Ancient Iran*, p. 104, upper; Buhl, *Skatte fra det Gamle Persien*, No. 192, fig.; *Art Iranien Ancien*, No. 293, plate; *Barbier*, Nos. 160–1, pls. 122–3) from unknown sites.

Many years ago de Morgan said that animal pendants were first produced in Talish at the beginning of the local Iron Age (*MSP*, IV, 1896, fig. 103, pp. 101–2) and more recent evidence has shown nothing to contradict this view. How long they were in production after about 800 B.C. is not yet clear. Evidence from controlled excavations in Dailaman shows that in some cases human beings wore these pendants suspended from their belts (*Dailaman*, I, pl. VI 3).

HORSES

160. Bronze, cast. Standing horse with squarish head looking directly downwards; high, curved mane.

3·5 cm H. 4·6 cm L.

161. Standing horse very like no. 160, but with a more tapered head held slightly forward.
 4·2 cm L. 3 cm H.

The date and origin of these horses may only be established at the moment through a single bronze cosmetic stick, found in a tomb in Dailaman (see nos. 122 and 123), decorated with a horse in exactly this style. This would suggest a source in Gilan and a date in the early first millennium A.D. Similar pinheads have been reported from Gilan with heads cast as other animals (*Barbier*, No. 136, zebu).

162. Bronze, cast. Statuette of a horse with narrow cylindrical body and tall curving neck; blobs of metal on the neck, rear legs and rump.
 7 cm H. 7 cm L.

A horse very like this has been reported as from clandestine excavations at Sakkizabad (*Art Iranien Ancien*, 1966, No. 106, plate). The archaeology of this site, in default of scientifically obtained evidence, is obscure. As both distinctive polychrome pottery of the second millennium B.C. and early Iron Age grey wares have been found on the site it is only possible to date this horse figurine within very broad limits from about 1600 to 1000 B.C. (R. Dyson, *The Archaeological Evidence of the Second Millennium B.C. on the Persian Plateau*, pp. 24–5).

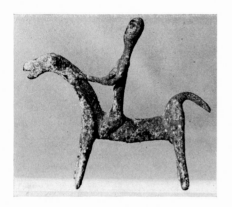

163. Bronze, cast. Very stylized horse with long neck and tall, straight-backed rider sitting well forward with hands held high on either side of the animal's neck.

5·3 cm H. 6·6 cm L.

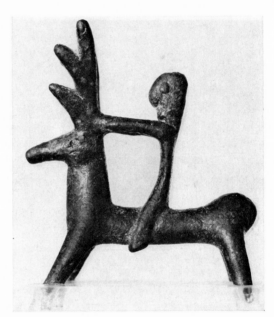

164. Standing stag with a tall straight-backed rider set in the centre of its back with his hands resting on the base of the horns.

c. 4 cm L. 7 cm max. H.

These figurines share many of the stylistic traits of the numerous animal statuettes and pendants reported from Gilan. Indeed other rider figurines, usually on horses, have been reported from the region (*Sept Mille Ans,* No. 130, pl. XIV; *AANE* (Boston), fig. 31, upper right; *Barbier,* p. 113, No. 143; *Bomford,* pl. XXI. 236). The stag with a rider is more unusual and raises the question whether the animal was partially domesticated in this region in the late second or early first millennium B.C. when these two statuettes are most likely to have been made.

165. Bronze, cast. Dog with tail curling up and over; double collar and some kind of strap passing round the shoulders. Body hollow.

 5 cm H. 6 cm L.

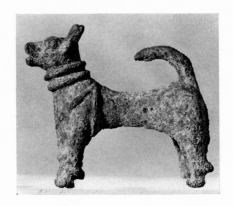

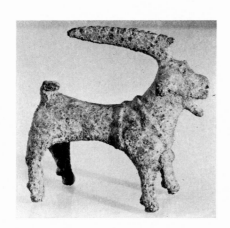

166. Bronze, cast. Unidentified animal with body formed exactly like no. 165, but with a single serrated horn projecting backwards in a straight line over most of the body; head appears as if muzzled, and straps again pass round the shoulders. Body hollow.

 5·8 cm H. 6·5 cm L.

A number of other animal statuettes reported as from 'Amlash' may be associated stylistically with these two (cf. *Sept Mille Ans,* Nos. 123, 125, pl. XV; *Barbier,* No. 163, pl. 123). There is no published example from a controlled excavation which allows for a certain chronological attribution; but as there is some affinity with the more stylized animal statuettes of Marlik (*Archaeologia Viva,* I, Sept.–Nov. 1968, p. 78, fig. 96; *Marlik,* figs. 97–8) they may have been made in Iron Age I–II.

167. Bronze, cast. Highly stylized quadruped with elongated neck projecting forward; cylindrical body and flattened rump.

4·5 cm L. 3 cm H.

168. Bronze, cast. Goat with upright, plain sabre-like horns, cylindrical body and flattened rump; pierced vertically through the shoulders.

3·5 cm L. 4 cm H.

The cylindrical form of these animals' bodies and their flat rumps are characteristic of the animal statuettes found in the cemetery at Kaluraz in Gilan (*Archaeologia Viva*, I, Sept.–Nov. 1968, p. 80, fig. 106, p. 81, pl. XXXVII) in Iron Age I–II.

BIRDS

169. Bronze, cast. Stylized body and head decorated with incised lines; tripod feet; loop on the back.

10 cm L.

cf. *Barbier*, No. 165, pl. on p. 125. Possibly north-west Iran, Iron Age I–II.

170. Bronze, cast. Three very stylized birds with fanned wings, knobs on their crests and tails; pierced vertically through the centre of the body.
 5 cm H. 6·2 cm L.
 cf. *Barbier*, Nos. 175–6, pl. on p. 127. Islamic?

MODEL PLOUGH

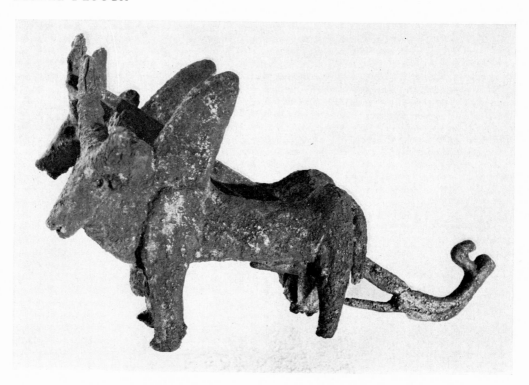

171. Bronze, cast. Pair of zebu yoked up to a simple plough.
 8 cm H. 10 cm (zebus). 13·5 cm L. of plough.

A more elaborate model of exactly the same kind, found in the cemetery at Marlik (*Marlik,* fig. 100), indicates that this model was made in Gilan in Iron Age I (cf. *Barbier,* No. 164, pl. on p. 124 for yoked zebus without a plough).

MODEL CART

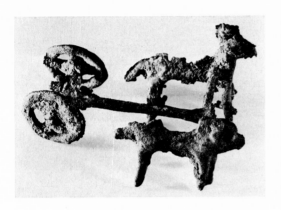

172. Bronze, cast. A pair of equids yoked to a very simple platform set on an axle with a pair of four-spoked wheels. The casting is very poor and superfluous metal has not been cleaned off.

3·1 cm H. 7·5 cm L.

A number of models of this general type have been reported from Gilan (*Oxford,* p. 104), some, like this one, not cleaned down after casting. To judge from finds at Marlik, they were made sometime in Iron Age I, possibly to decorate the extremely elaborate bronze horse-collars of the type found at Kaluraz. The four-spoked wheel appears on models at Marlik (*Marlik,* fig. 94). Although it is not very common in western Asia on chariots after about 1000 B.C. (*Oxford,* p. 104), it may have survived longer in Iran and to the north, for it appears on an ivory from Hasanlu IV in the ninth century B.C. (*AJA,* 75, 1971, pl. 63.1), on a chariot incised on a bronze belt from Akhtala (Hancar, *ESA,* IX, 1934, p. 73, fig. 22) and on the drawing of a chariot on a stone cist slab at Berekey in Dagestan, north-east Caucasus (Sulimirski, *AA,* XVII, 1954, pp. 291–2, fig. 2). In the latter case an eight-spoked wheel, which did not appear in Urartu until the early eighth century B.C., is drawn alongside the chariot. Indeed a model of this general type with eight-spoked wheels has appeared on the London antiquities market (*Sotheby,* 1st February 1971, lot no. 85 (not illustrated)).

173. Bronze, cast. Coiled disk with suspension loop; on the circumference a pair of stylized birds, a pair of circular loops and at the base a solid, oval blob.

 6·5 cm W. 4·5 cm D.

 cf. *Barbier*, No. 191, fig. on p. 134: Gilan, Iron Age I (?).

'FLORAL' PENDANTS

174. Bronze, cast. Six solid circular blobs, their stalks converging upwards to a horizontal bar on which perch three birds, one at each end and one in the centre; hole pierced through at the junction of bar and support.

 9 cm H.

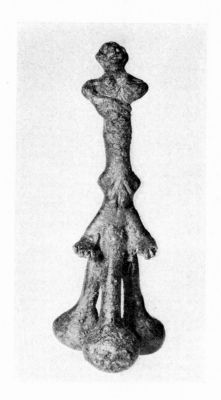

175. Bronze, cast. Three solid circular blobs, their stalks converging upwards to support an extremely crude female figure of columnar form with head tilted back. Arms bent with outsize hands resting, the left on the neck, the right on the breasts. Elongated body, bulging hips, with genitals and slightly splayed feet clearly modelled and incised.

 11 cm H.

 cf. *Barbier*, Nos. 148–9, pl. on p. 117; No. 153, pl. on p. 118, which has the same globular supports. Probably from a site of Iron Age I in northern Iran.

STAMP-SEALS

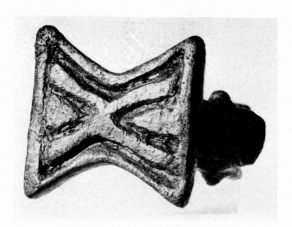 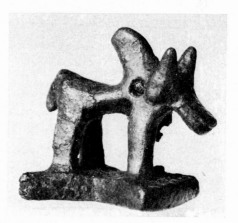

176. Bronze, cast. Base plaque with concave upper and lower edges; handle cast as a standing zebu with one foreleg broken; hole pierced through at the base of the hump with traces of iron in it. Design a capital 'X'.

 3·5 cm H. 3·7 cm base L.

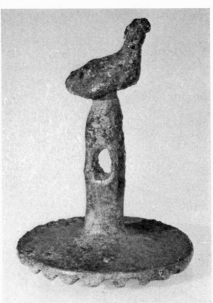

177. Bronze, cast. Circular base plaque with vertical handle pierced through towards the top; stylized bird perched on the apex. Design: central cross within geometric borders.

 5·5 cm H. 3·7 cm base D.

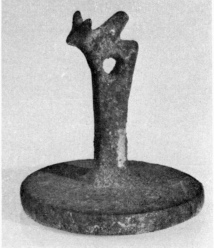

178. Bronze, cast. Circular base plaque with a vertical handle, its top modelled as a standing zebu, the gaps between its legs forming a suspension hole. Geometric design.

 5 cm H. 5 cm base D.

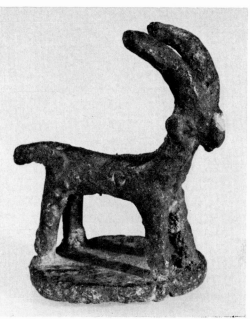

179. Bronze, cast. Circular base plaque; handle cast as a standing mouflon; hole pierced through the body.
 5 cm H. 3 cm base D.

Like the animal pendants from the region these zoomorphically decorated bronze stamp-seals belong largely to Iron Age I (about 1250 to 1000 B.C.) in the south-west Caspian region. Although no direct link may be established as yet in either direction two areas might be crucial in their development. Away to the east copper stamp-seals with small loop or relatively short, plain vertical handles were found in the upper levels of Tepe Hissar (*Hissar*, pp. 199–200, fig. 118) at the end of the third millennium B.C., whilst in Anatolia to the west metal stamp-seals were regularly used in the third and second millennia B.C. In Mesopotamia stamp-seals passed out of use in the third millennium B.C., not to be revived for almost two thousand years, and even when in use they were only exceptionally made of metal. Although stamp-seals like nos. 176 to 179 have become available through clandestine excavation (M.-L. Erlenmeyer and H. Erlenmeyer, *IA*, V, 1965, pl. VII. 38–9, VIII. 40–1, 43–4; *Barbier*, Nos. 178–81, pp. 129–30), the only examples from a controlled excavation in the south-west Caspian area are those from Marlik (*Marlik*, p. 24) and they have yet to be illustrated. As the type of animals and birds on nos. 176 to 179,

and the manner in which they are cast, so closely resemble the animal figurines of Marlik and Kaluraz about 1250 to 1000 B.C., this is almost certainly the period and region in which they were made.

APPENDIX A

Gold and Silver Objects

GOLD

Plaque

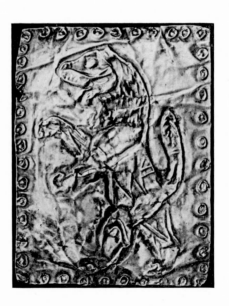

180. Gold, sheet. Rectangular fragment with the edges folded back; border of repoussé concentric circles; in the centre a repoussé rampant lion with simple linear body markings on its haunches.

4·5 cm W. 5·5 cm H.

The body markings on this lion are not the formal geometric patterns most regularly encountered on Achaemenid work. It is unfortunate that the forepart is too damaged for the details to show, but the haunch has a forked mark which

looks almost like a wing tip. It is not the normal vertical flame pattern used on the haunches of many of the animals shown on objects in the Ziwiyeh hoard, perhaps adopted from Syria (Moorey, *Levant,* III, 1971, p. 91), but a horizontal variant found on one of the silver harness-trappings from the Ziwiyeh hoard (Godard, *Le Trésor de Ziwiyè,* fig. 109). This might be taken to indicate that the plaque is slightly earlier than the Achaemenid period. Technically comparable plaques were included in the Oxus treasure (Dalton, *The Treasure of the Oxus,* 3rd ed., 1964, pls. XIV–XV), but on these human beings are usually shown. Achaemenid silhouette lions decorated in repoussé with linear body markings appear in a hoard of gold jewellery now in Chicago (Kantor, *JNES,* XVI, 1957, pp. 7ff, pls. III, VA), but they are clearly different from this one.

SILVER

Samples from all the silver objects, except pin no. 185, were kindly subjected to neutron activation streak-analysis by Dr. A. A. Gordus of the Department of Chemistry in the University of Michigan, with the following results:

Object number	% silver	% gold	% gold/100% silver
181	96·2	0·36	0·37
182	99·5	0·27	0·27
183	92·7	0·26	0·28
184	93·2	0·16	0·17

Although Dr. Gordus has considerable comparative data already for the Sassanian period in Iran (A. A. Gordus in *Methods of Chemical and Metallurgical Investigation of Ancient Coinage,* ed. E. T. Hall and D. M. Metcalf, London, 1972, pp. 127–48), very few results are available for Achaemenid and pre-Achaemenid silver objects of known date and certain authenticity. These must be awaited before the analyses given here can be critically assessed. The low level of gold impurity in the silver of no. 184 could, by comparison with Dr. Gordus's results for Sassanian silver, be taken to indicate that this enigmatic object is of relatively recent manufacture. Tests conducted in the laboratory of the British Museum left no reason to doubt the authenticity of no. 181.

181. Shallow bowl, cast and chased. Plain central disk inside; relief ornament based on the lotus flower; lines radiating from the interior centre terminate at the apex of fourteen oval lobes framed by 'leaves'; between each lobe is a smaller one of comparable shape. A long inscription in the cuneiform script runs round most of the inside lip.

28·9 cm D.

In 1935 Herzfeld published an inscription of Artaxerxes I (about 465/4 to 425 B.C.) found on four very similar silver bowls, whose place of origin and owner were not then given (*AMI*, VII, 1935, pp. 1 ff, pls. I–III). Sometime later three of these dishes, of which this is one, passed into the Kevorkian Collection. The fourth dish went to the Metropolitan Museum, New York, in 1947, from the Joseph Brummer Collection (*BMMA*, March 1949, p. 197). The authenticity of the inscription was challenged in print soon after it was first published, and a shadow has hung over it, and the bowls, ever since. Kent, who clearly accepted it as ancient, cited the inscription in his standard work *Old Persian* (New Haven, 1950, pp. 113, 153) and translated it :'Artaxerxes the Great King, King of Kings, King of Countries, son of Xerxes the King, of Xerxes (who was) son of Darius the King; in whose royal house this silver saucer was made'.

Herodotus and other Greek writers make amply clear the quantity of gold and silver plate which formed the table-services of the Persian monarch and his generals when campaigning. At home their equipment was even more splendid. It is then not surprising to find a series of dishes, varying only in size, marked with the same proprietary inscription. They are standard items from a royal table-service. The decoration on this dish is an elaboration of a design much favoured by makers of bowls in the Achaemenid Empire. It is inspired by the shape of the lotus flower. An ever growing number of such silver bowls, some gilt or partially gilt, in a variety of related forms is reported from all over the Empire and beyond its frontiers (P. Amandry, *Collection Hélène Stathatos III: Objets antiques et byzantins*, Strasbourg, 1963, pp. 260 ff).

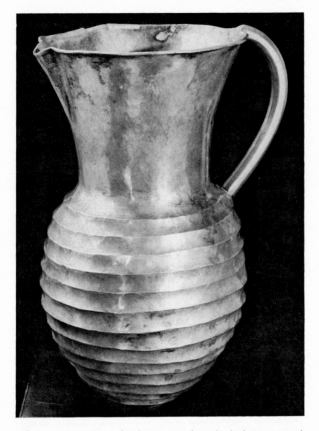

182. Hammered sheetmetal. Slightly everted
rim with tiny pinched spout opposite the handle;
tall, concave neck, ovoid body decorated with
prominent horizontal corrugations. Cast handle
of hexagonal section rivetted to the lip and upper
body.

20 cm H. 12 cm mouth D.

Trésors de l'Iran, Geneva, 1966, No. 367.

This vessel is a simple and much larger version of a type of jug represented
by the Achaemenid gold jug in the Oxus Treasure (O. M. Dalton, *The Treasure
of the Oxus*, 3rd edition, 1964, pl. VII.7). Horizontal ribbing was a decorative
technique particularly popular in this period. The extreme purity of the silver
used in this jug questions its antiquity.

185

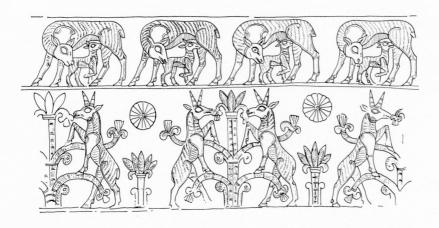

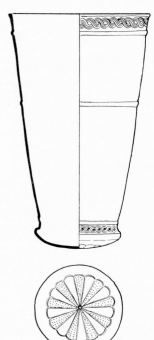

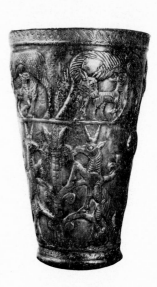

183. Hammered sheetmetal. Cylindrical, tapering to a slightly rounded base. Chased guilloche margins at top and bottom. In the upper register, which is narrower than the lower, a frieze of four goats suckling their young set on a thin groundline. In the lower register, two pairs of goats rampant on either side of a stylized tree with vertical trunk; rosette above a floral motif between goats. Base rosette of eighteen petals, alternately stippled.

14·3 cm H. 9 cm D.

The iconography of this beaker is closely paralleled on a superb gold goblet from the early Iron Age I cemetery at Marlik which appears to show, in three registers, the life-cycle of a goat (*Marlik,* fig. 113); first, in the lowest register, suckled by its mother and then browsing on a tree—exactly as here—before falling victim to predatory beasts and birds. The animals and the floral motifs are carefully chased, with particular attention to the elaborate overall patterning of their bodies. The present condition of this goblet's surface suggests that when found it was crushed and has subsequently been carefully opened out again and the worst damage skilfully repaired. Indeed the larger part of the present surface may be modern.

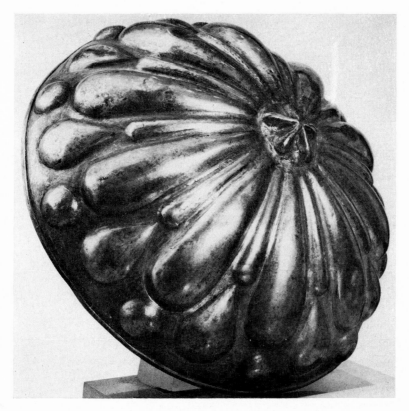

184. Silver, cast. Hemi-spherical bowl-shaped object with go-drooned surface and central, pinched nipple; narrow folded edge; considerable traces of rust or iron staining on the inside.

16·3 cm D. 6·5 cm max. H.

Neither the date nor the exact function of this finely made object is clear. Though decorated in a manner akin to that found on Achaemenian *phialai* it was almost certainly not designed as a vessel. It seems more likely to have been a decorative boss of some kind fitted to armour or to harness-trappings.

PIN

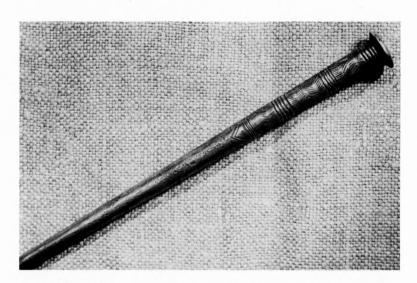

185. Silver, cast. Flat head; bands of roughly incised herring-bone patterning between bands of horizontal encircling lines on the upper shank.
18·6 cm L.

Various silver pins of this form have been reported from Luristan. Silver is so rarely reported from there that the pins may be imports from northern Iran, where the metal is more commonly used, if they were not indeed actually found there. There is no clear indication yet of their date (*IitAE*, fig. 272, 3rd from left; *Sumer*, XIX, 1963, pl. 6.66570–1; *Oxford*, No. 236).

APPENDIX B

Pastiches

It is increasingly common for modern craftsmen to be employed in the antiquities market to produce objects made up of two or more ancient objects or parts of ancient objects to produce a single object unknown in antiquity. Though these are of no interest in themselves, the parts sometimes are. The following examples illustrate the variety of this type of conflation, some skilful, others very crude.

DAGGERS

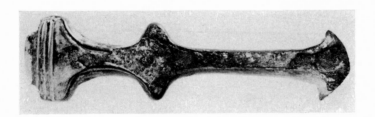

186. Bronze, cast. Originally made up of two disparate pieces:
a. Flanged dagger hilt of bronze inlaid with iron; vestiges of an iron blade.
12·3 cm L.

This hilt belongs to the transitional phase in the history of the simple flange-hilted dagger when such weapons were already largely made of iron, but bronze

was still used for casting the frame of the hilt which is subsequently inlaid with iron. It was probably made about the tenth century B.C. (compare no. 23).

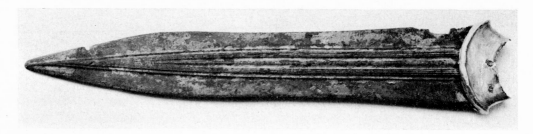

b. Bronze blade with very prominent ridges down the centre flanking the midrib; sheet gold guard cover.
20 cm L.

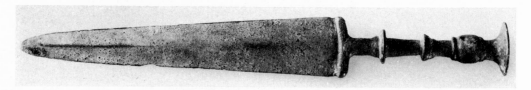

187. Bronze, cast. Tapering triangular shaped blade with plain, narrow rectangular guard; disk pommel; moulded grip.
34 cm L.

Although there is no reason to doubt the authenticity of the early Iron Age I bronze blade, the hilt seems to be a modern concoction.

188. Bronze, cast. Disk mirror with
slight vertical edge set on an anthro-
pomorphic handle.
 23 cm H. 14 cm D. of disk.

The disk of this mirror is ancient, probably Seleucid or Parthian, but made
to be used without a handle. Certainly the existing handle is ineptly fitted to it
in modern times and may well not be ancient.

Short Select Bibliography

(Reference is made only to books, not to articles in journals and periodicals; a full bibliography of these up until 1970 will be found in *Oxford*, pp. 322–7.)

1. GENERAL STUDIES OF ANCIENT PERSIAN ART AND HISTORY:
 Ghirshman, R., *Iran*, Penguin Books, Harmondsworth, 1954
 Ghirshman, R., *Persia from the Origins to Alexander the Great*, London, 1964
 Pope, A. U. (Editor), *A Survey of Persian Art from Prehistoric Times*, vols. I and IV, Oxford, 1938
 Porada, E., *Ancient Iran; The Art of Pre-Islamic Times*, London, 1965

2. ARCHAEOLOGICAL BIBLIOGRAPHY AND EXCAVATION REPORTS
 Vanden Berghe, L., *Archéologie de l'Iran ancien*, Leiden, 1959
 Vanden Berghe, L., *Het archeologisch onderzoek naar de bronscultuur van Luristan: opgravingen in Pusht-i Kuh, I, Kalwali en War Kabud (1965 en 1966)*, Brussels, 1968

3. TYPOLOGICAL STUDIES OF METALWORK
 Calmeyer, P., *Datierbare Bronzen aus Luristan und Kirmanshah*, Berlin, 1969
 Deshayes, J., *Les Outils de bronze de l'Indus au Danube (IVe au IIe millénaire)*, 2 vols., Paris, 1960
 Potratz, J. A. H., *Die Pferdetrensen des Alten Orient*, Rome, 1966

4. COLLECTIONS OF LURISTAN BRONZES (FULLY ILLUSTRATED)

Calmeyer, P., *Altiranische Bronzen der Sammlung Bröckelschen*, Berlin, 1964

Godard, A., *Les Bronzes du Luristan, Ars Asiatica*, XVII, Paris, 1931 (largely in the Louvre and private collections in Paris)

Hansford, S. H., *The Seligman Collection of Oriental Art*, I, London, 1957*

Legrain, L., *Luristan Bronzes in the University Museum*, Philadelphia, 1934

Nagel, W., *Altorientalisches Kunsthandwerk*, Berlin, 1963 (objects in public and private collections in West Germany)

Moorey, P. R. S., *Catalogue of the Ancient Persian Bronzes in the Ashmolean Museum*, Oxford, 1971

Moortgat, A., *Bronzegerät aus Luristan*, Berlin, 1932 (collection now in the Pergamon Museum, East Berlin)

Potratz, J. A. H., *Luristanbronzen. Die Einstmalige Sammlung Professor Sarre Berlin*, Istanbul, 1968

van Wijngaarden, W. D., *De Loeristanbronzen in het Rijksmuseum van Oudheden*, Leiden, 1954

5. SPECIALIST STUDIES

Calmeyer, P., *Reliefbronzen in babylonischem Stil*, Munich, 1973

* Now in the British Museum.

Provenances and Adam Collection
Reference Numbers

Note

(1) Ch. = Christie's sale (followed by date and catalogue number)
 S. = Sotheby's sale (followed by date and catalogue number)
 B. = Barbier Collection sale, Paris, 27th May 1970, catalogue number
 D. = David-Weill Collection sale, Paris, 28th/29th June 1972, catalogue number

(2) X = Purchase details not recorded, some bought at sales, some in personal visits
 to Iran

(3) All purchases marked 'Iran' were bought on personal visits to the country

Catalogue Number	Adam Collection Number	Provenance
CHAPTER I—WEAPONS AND TOOLS		
1.	203 B	S. 26.4.65, 180
2.	359	Dealer
3.	312	Iran
4.	344	Dealer
5.	270	Ch. 9.12.68, 152
6.	203 A	S. 26.4.65, 180
7.	247	Iran
8.	355	Dealer

Catalogue Number	Adam Collection Number	Provenance
9.	260	Ch. 9.12.68, 44
10.	377	S. 25.10.71, 100
11.	354	Dealer
12.	261	Ch. 9.12.68, 46
13.	378 F	S. 25.10.71, 108
14.	378 D	S. 25.10.71, 108
15.	378 A	S. 25.10.71, 108
16.	378 C	S. 25.10.71, 108
17.	378 E	S. 25.10.71, 108
18.	240	Iran
19.	378 A	S. 25.10.71, 108
20.	225 A	Iran
21.	225 B	Iran
22.	264	Ch. 9.12.68, 51
22 A.	383	S. 6.12.71, 36
23.	188 C1	X
24.	347	S. 8.12.70, 131
25.	254	Dealer
26.	188 C2	X
27.	262	Ch. 9.12.68, 47
28.	252	S. 22.10.68, 102
29.	320 A	S. 22.12.69, 92
30.	320 C	S. 22.12.69, 92
31.	231	Iran
32.	232	Iran
33.	284	Iran
34.	324 A	Ch. 10.3.70, 49

Catalogue Number	Adam Collection Number	Provenance

CHAPTER II—HORSE-HARNESS

Catalogue Number	Adam Collection Number	Provenance
35.	256	Dealer
36.	376	S. 25.10.71, 97
37.	305	Ch. 8.7.69, 46
37 A.	398	D. 289
38.	230	Iran
39.	227	Iran
40.	213	Israel
41.	226	Iran
42.	341	S. 13.7.70, 14
43.	228	Iran
44.	271	Ch. 9.12.68, 155
45.	279	Iran
46.	219	Ch. 11.6.68, 174
47.	281	Iran
48.	276	Iran
49.	229	Iran
50.	356 A/B	Dealer
51.	319 B	S. 22.12.69, 88
52.	319 A	S. 22.12.69, 88
53.	345 A/B	S. 8.12.70, 122 (Kevorkian Collection)
54.	339	Ch. 7.7.70, 160
55.	319 C	S. 22.12.69, 88
56.	272 A/B	Ch. 9.12.68, 156
56 A.	390	Dealer
56 B.	396	D. 263
57.	187 B	X
58.	332 A	Ch. 23.6.70, 1

Catalogue Number	Adam Collection Number	Provenance
59.	332 B	Ch. 23.6.70, 1
60.	188 F.11	X
61.	266	Ch. 9.12.68, 55
62.	188 F.15	X
63.	188 F.16	X
64.	188 F.16	X
65.	188 F.9	X
66.	188 F.7	X
67.	188 F.6	X
68.	188 F.10	X
69.	238	Iran
70.	188 F.8	X
71.	311	Iran
72.	239	Iran
73.	285	S. 17.3.69, 191
74.	236	Iran
75.	237	Iran

Chapter III—Finials, Mounts and Decorated Tubes

76.	216	S. 19.2.68, 88
77.	282	Iran
78.	369	Dealer
79.	348	S. 8.12.70, 187 (Kevorkian Collection)
80.	187 A	X
81.	274	Ch. 9.12.68, 163
82.	235 B	Iran
83.	340	S. 13.7.70, 13
84.	304	Ch. 8.7.69, 39

Catalogue Number	Adam Collection Number	Provenance
85.	235 A	Iran
86.	296	Iran
87.	269	Ch. 9.12.68, 150
88.	286	S. 17.3.69, 195

Chapter IV—Pins, Personal Ornaments and Cosmetic Equipment

89.	320 D	S. 22.12.69, 92
90.	259 B	Ch. 9.12.68, 41
91.	364	X
92.	318	Ch. 2.12.69, 195
93.	224	Iran
94.	302	Ch. 8.7.69, 32
95.	188 F.13	X
95 A.	394	D. 228
95 B.	397	D. 230
96.	273	Ch. 9.12.68, 156A
97.	259 A	Ch. 9.12.68, 41
98.	316	Ch. 2.12.69, 164
99.	328	B. 44
100.	188 D1, 2, 3	X
101.	357	Dealer
102.	329 A	
103.	329 B	B. 69
104.	329 C	
105.	215 F	S. 19.2.68, 82
106.	303	Ch. 8.7.69, 34
107.	375	Dealer
108.	253	Dealer
109.	370	Parke-Bernet 25.2.71, No.23

Catalogue Number	Adam Collection Number	Provenance
110.	215 C	S. 19.2.68, 82
111.	215 A	S. 19.2.68, 82
112.	215 E	X
113.	215 D	S. 19.2.68, 82
114.	188 D4	S. 19.2.68, 82
115.	215 B	S. 19.2.68, 82
116.	188 D5	X
117.	331	B. 157
118.	313	Dealer
118 A.	395	D. 252
119.	379	S. 25.10.71, 114
119 A.	391	Dealer
120.	191	S. 7.12.64, 1 (Fred Olsen Collection)
121.	297	Dealer
122.	337 A	Ch. 23.6.70, 10
123.	337 B	Ch. 23.6.70, 10
124.	324 G	Ch. 10.3.70, 49
125.	324 H	Ch. 10.3.70, 49

Chapter V—Vessels

126.	188 A2	X
127.	327	B. 17
128.	188 A1	X
128 A.	384	Dealer
129.	188 B1	X
130.	325	Ch. 10.3.70, 63
131.	188 B2	X
132.	188 A3	X

Catalogue Number	Adam Collection Number	Provenance
132 A.	389	Dealer
133.	310	Iran
134.	248	Iran
135.	326	Iran
136.	343	Dealer
137.	306	Ch. 8.7.69, 60
138.	223	Iran
139.	277	Iran
140.	265	Ch. 9.12.68, 52
141.	368	Dealer

CHAPTER VI—STATUETTES AND PENDANTS

142.	295	Iran
143.	258	Ch. 9.12.68, 17
144.	335 B	Ch. 23.6.70, 7
144 A.	393	D. 208
145.	245	Iran
146.	195 A	S. 21.12.64, 156
147.	294	Iran
148.	244	Iran
149.	241	Iran
150.	293	Iran
151.	335 A	Ch. 23.6.70, 7
152.	242	Iran
153.	243	Iran
154.	334 A	Ch. 23.6.70, 5
155.	336 C	Ch. 23.6.70, 8
156.	336 A	Ch. 23.6.70, 8
157.	336 B	Ch. 23.6.70, 8

Catalogue Number	Adam Collection Number	Provenance
158.	334 B	Ch. 23.6.70, 5
159.	334 C	Ch. 23.6.70, 5
160.	333 A	Ch. 23.6.70, 3
161.	195 B	S. 21.12.64, 156
162.	195 C	S. 21.12.64, 156
163.	288	S. 17.3.69, 217
164.	210	Israel
165.	283 A	Iran
166.	283 B	Iran
167.	188 F. 14	X
168.	188 F. 12	X
169.	292	Iran
170.	338	Ch. 23.6.70, 13
171.	220	Ch. 11.6.68, 175
172.	240	Iran
173.	188 E	X
174.	330	B. 148
175.	287	S. 17.3.69, 212
176.	333 B	Ch. 23.6.70, 3
177.	188 F. 4	X
178.	188 F. 5	X
179.	188 F. 1	X

APPENDICES

A. GOLD AND SILVER OBJECTS

180.	360	Dealer
181.	371	S. 8.12.70, 141 (Kevorkian Collection)
182.	317	Ch. 2.12.69, 188

Catalogue Number	Adam Collection Number	Provenance
183.	267	Ch. 9.12.68, 81
184.	280	Dealer
185.	301	Ch. 8.7.69, 30

B. PASTICHES

186a, b.	263	Ch. 9.12.68, 48
187.	320 B	S. 22.12.69, 92
188.	188 G	X

Index

Neither authors nor collections are indexed; site names are listed independently of any such prefix as 'tell' or 'tepe'

205

Index